PARADISE FOUND

By Amy Zerner and Monte Farber

The Enchanted Tarot

The Alchemist (also available on CD ROM)

Goddess Guide Me

The Psychic Circle

Cupid Cards

By Amy Zerner and Jessie Spicer Zerner

Zen ABC

Scheherazade's Cat

The Dream Quilt

By Monte Farber

Karma Cards

PARADISE FOUND

THE VISIONARY ART OF AMY ZERNER

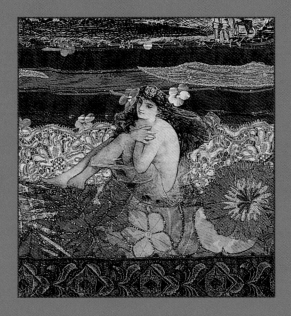

BY MONTE FARBER

With an essay by Rose Slivka

ÆE

JOURNEY EDITIONS

Boston • Tokyo

Published in 1995 by
JOURNEY EDITIONS
an imprint of Charles E. Tuttle, Co., Inc.
153 Milk Street, Fifth Floor
Boston, Massachusetts 02109

Library of Congress Cataloging-in-Publication Data

Farber, Monte.
 Paradise found: the visionary art of Amy Zerner/Monte Farber:
with an essay by Rose Slivka.
 p. cm.
 ISBN 1-885203-11-X
 1. Zerner, Amy—Themes, motives—Catalogs. 2. Spirituality in
art—Catalogs. 3. collage—United States—Catalogs. I. Zerner,
Amy. II. title.
N6537.Z47A4 1995
746.392—dc20 94-41390
 CIP

Monte Farber are © 1990 and 1991, respectively, by Amy Zerner
and Monte Farber and are reproduced by permission of St. Martin's
Excerpts from The Enchanted Tarot *on pages 122–133*
and The Alchemist *on pages 138–151 by Amy Zerner and*
Press, Inc., New York, New York. Excerpts from Goddess Guide Me
on pages 156–170 are © 1992 by Amy Zerner and Mone Farber and
reproduced by permission of Fireside Books, Simon & Schuster,
New York, New York.

Text design by Kathryn Sky-Peck
Case design by Sherry Fatla

FIRST EDITION
1 3 5 7 9 10 8 6 4 2

PRINTED AND BOUND IN HONG KONG

CONTENTS

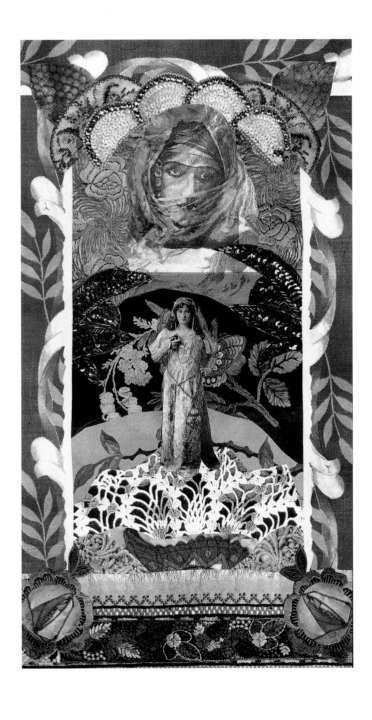

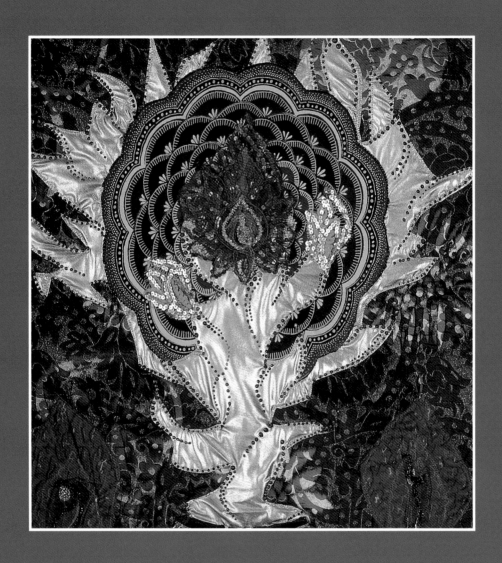

I dreamed marvelously. I dreamed there was an enormous web of beautiful fabric stretched out. It was incredibly beautiful, covered all over with embroidered pictures. The pictures were illustrations of the myths of mankind but they were not just pictures, they were the myths themselves, so that the soft glittering web was alive. In my dreams I handled and felt this material and wept with joy.

Doris Lessing
The Golden Notebook

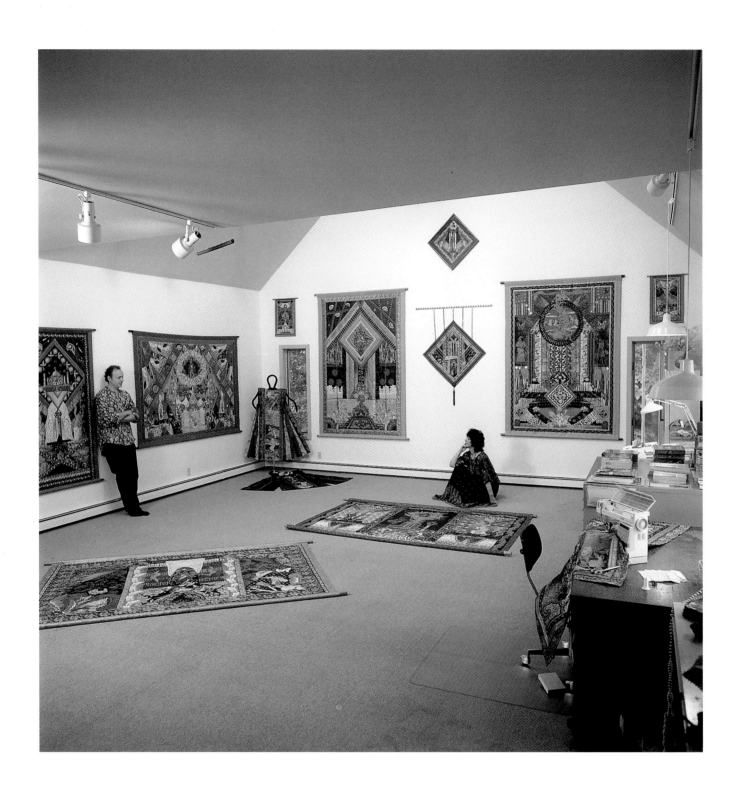

PREFACE

Though *Paradise Found* was conceived as a retrospective look at some of Amy Zerner's more than five hundred works of art, it is also a kind of map that can help us find the treasure of paradise within us. Like her work, it is more than a lovely vision. It tells a story that encourages our dream lives to awaken and set our muses free.

In the pages of *Paradise Found* you will share Amy's vision of the nature and interplay of the worlds within worlds that make up our earthly paradise. You will see that she is as much a collector of ancient truths and wisdom as she is a collector of fabrics, papers, lace, and found objects. You will find that the common thread running through the diverse forms of her work is her desire to artfully adapt the best of what has come before in a new and exciting context that will ensure its survival into the future for the benefit of all.

The dream of a better world leads to the quest for the power to win the struggle to attain it. In a very real way each chapter of *Paradise Found* is not only a mirror of Amy's artistic and spiritual development, but also a doorway to the path of spiritual development itself and the very real power that comes with it.

Art helps us put things in perspective and Amy's art helps us put things in a higher perspective. Her visually rich assemblage style has evolved, not from any preconceived notion, but organically—as an outward expression of her own fruitful inner search for the meaning of her life. The pages of this book contain the images and the essence of her journey and what she has found as well. For readers aspiring to put these ideals into practice, these chapters can be useful in charting a course toward the development of creative spirituality.

Amy's unequaled ability to depict the ordered chaos of Mother Nature in her work is only partially the result of her childhood spent in the mountains and forests around Laporte in rural northeastern Pennsylvania. It is also because of her belief that in our dream life, the spirits of Nature, which often appear in her work, are helping us to dance our lives and to take action to realize our dreams.

Of course, Amy's work also reflects the fact that wherever we go and whatever we do, she and I share a passion for collecting beautiful and unusual materials of all kinds. It should be obvious that in our

house we don't have wardrobes, we have inventory. However, not only our finds but also the personal treasures of many friends and acquaintances find new life in her collages. Like orphaned children, they turn up on our doorstep, sent by people who want to see these souvenirs of departed times, friends, and relatives spring out at them, reborn, at her next exhibition.

Paradise Found is also reflective of the love we share. It has enabled us to create for ourselves, and to share with others, our precious, hard-won paradise. Ever since we first met in October of 1974, Amy and I have encouraged and supported each other in the mutual exploration and development of our dreams and creative abilities. Our meeting coincided with her decision to abandon her lifelong use of traditional art materials and techniques, and to forge ahead with the multi-layered and embellished fabric collage technique displayed upon these pages. Only by creating this art form could she create images as complex and strangely beautiful as she was discovering life to be. I found then, as I do today, Amy's art and her very being to be a unique mixture of the innocence of youth and the wisdom of years.

Since 1988, Amy and I have collaborated—she as artist and I as author—in the creation of a series of unique illustrated book-and-game sets designed to make ancient wisdom available to all in an accessible, enjoyable manner. The series—*The Enchanted Tarot, The Alchemist, Goddess Guide Me,* and *The Psychic Circle*—has enabled us to provide hundreds of thousands of people around the world with beautiful, useful tools to help them in their personal development.

In our case, our unusually close and loving relationship and our commitment to our own personal development has allowed us to learn and help each other grow together. As a major part of that process we have chosen to question and examine our beliefs and all aspects of experience for signs and hidden meaning. The goal is to be so in harmony with life's purpose that we will instinctively know which paths to follow from the many that present themselves to us each day.

We may not know the meaning of life, but we have come to know the meaning of our life, and that is equally important. Amy and I have dedicated our lives to making ancient wisdom accessible to a world that so obviously needs its timeless message. Our artistic statement is a revival of the ancient tradition of using art, sacred objects, and ritual to both remind and enable everyone to directly tap into the energizing and rejuvenating energies of the bliss that is our birthright.

There is a palpable hunger in the modern world for some code of thinking and acting that will produce morals to anchor and protect us as the tidal wave of modern life washes over us. The lessons we have learned, both pleasant and unpleasant, are symbolically applied in Amy's art, in our inner guidance systems, and especially in this book.

We owe a debt of gratitude to pioneers like Dr. Carl Jung, who established the map of mythology, and gave new value and meaning to oracular wisdom with his law of synchronicity, Joseph Campbell, who showed us all the importance of myth, and Professor Arnold Keyserling, who continues this work with a unique ability to synthesize ancient wisdom and modern science. Thanks to them, and many others who have kept the bedside lamp of wisdom lit throughout the centuries, we are discovering the real meanings behind events.

When you see the hidden connections, the world becomes charged with symbolic messages. We are all linked by gossamer threads that spin and weave themselves into the story of our lives. They lead us to each other when the time is right—there are no accidents.

We must all leave footprints to guide those that follow us. It is our sincere desire that this book can guide your own journey to your vision of paradise. It has been carefully cut from the fabric of our life together so that you may keep a piece of our good fortune in your home and in your heart.

We all need to be healers now. To do so requires that we stay focused and be as clear as we can be. This way, you can not only sense but see the connections between all things and all worlds. Like Amy's collages, they are made of bits and scraps of our personal histories. Some pieces reflect the light, they glitter and stand out; some are veiled and mysterious; some are wistful or sentimental; some are reminders of happy times; some are warnings not to repeat mistakes; and some are mistakes covered over, fortunate accidents that lead to needed permutations. Like the multi-colored volcanoes seen in several pieces of Amy's "Paradise" series,

sometimes destructive forces clear away what has outlived its time and provide fertile soil for new growth.

We have learned that living a successful life of quality and meaning does not mean you will never forget what you know in the face of fear, uncertainty, or rejection. What is important is how quickly you recover your equilibrium and get on with the business of living. When you do this, you are walking on what the Native Americans call "The Beauty Way." On this road to Paradise it becomes easy to see events unfolding as if by magic, manifestations of a beautiful divine order that others only see as coincidence. The closer you get, the more you start to notice the daily miracles that serve to remind you that your striving to reach paradise is not in vain. I will never forget how, at a particularly stressful time in our life, Amy and I found ourselves releasing tears of joy and recognition when we discovered a simple, anonymous sentence inscribed on the ceiling of the beautiful Library of Congress in Washington, D.C. It said, "For a web begun, God sends thread."

— MONTE FARBER
EAST HAMPTON, NEW YORK, 1995

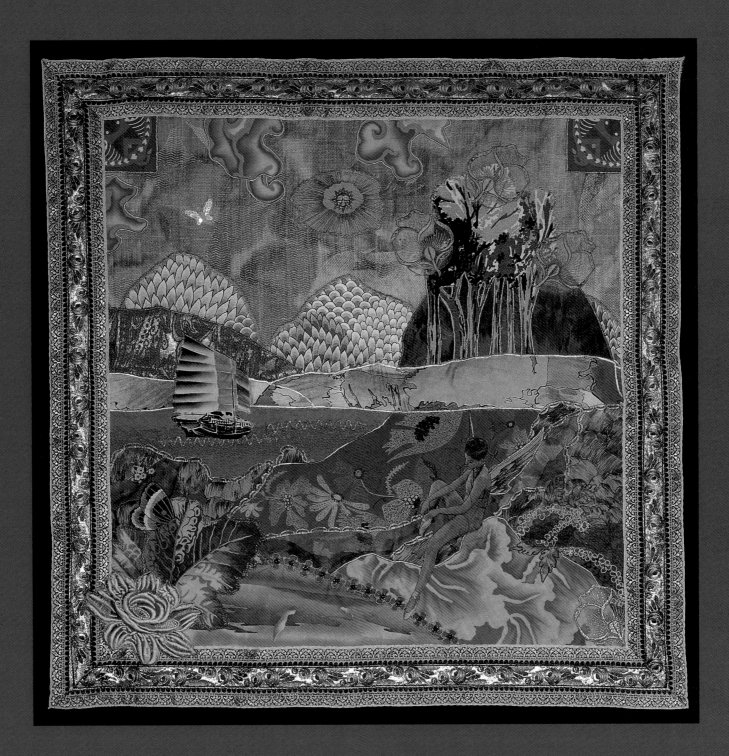

ENTERING PARADISE
36 x 36 INCHES, 1994

ENTERING PARADISE

an essay by Rose Slivka

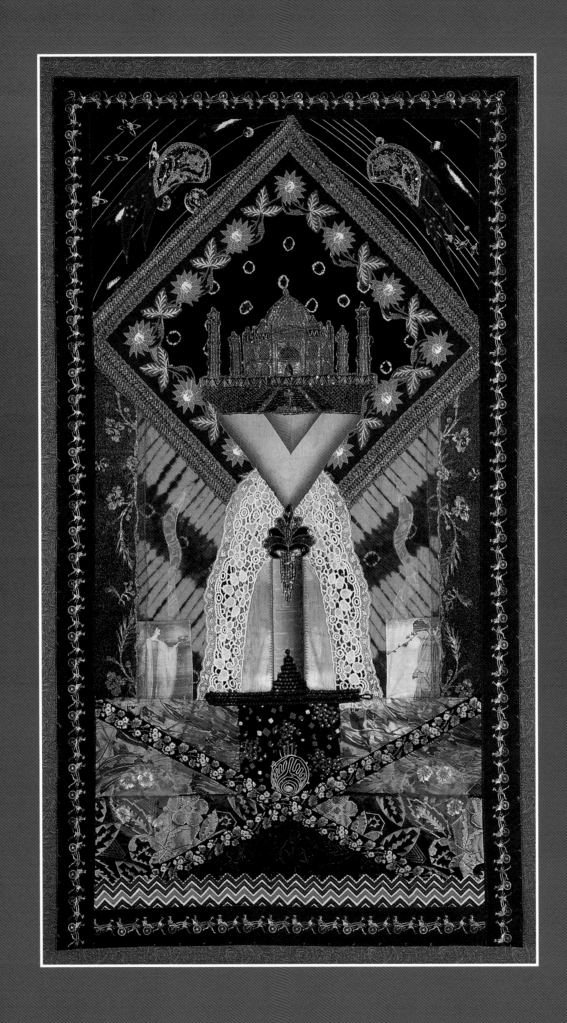

THE ART OF AMY ZERNER

Amy Zerner takes us on a journey of transformation to arrive at "Paradise Found," a place of transcendence. She envisions it as a meditative space, a garden of serenity and beauty with a celestial peak rising to touch its star of fulfillment, as she beckons us to reach toward further heights and insights.

Amy Zerner is keeper of the garden of Paradise Found, with its rich patches of embroidered, painted, printed trees, leaves, flowers, birds, butterflies—stitched appliqué, layer on layer, a fabric collage dense with invention, fantasy and inspiration. In the center, the mountain rises in the violet air to a sky of stars set in their patterned print. At the foot, in the earth and its river, the snake of wisdom undulates in its narrow stream of blue silk brocade.

Amy's work, ancient as well as modern in its cross-cultural sweep, is ultimately a sacred art.

Each work, amazing in its detail, needs to be carefully studied, appreciated in the bits and pieces by which it is made, to truly absorb the power of the entire composition. Her image emerges out of the build-up and, in the end, reveals a picture that is powerfully evocative of dreams, memories, stories, longings.

There is an ancient Persian belief that the creation of art endows the maker with divine powers that are transmitted to the viewer. It is art, André Malraux wrote, ". . . that imposes the presence of another world." We see this divine presence in the Jewish symbols of the holy Torah and the liturgical art of the Church, as well as in the patterns of prayer rugs and prayer shawls of India, the meditative thankas of Tibet. Amy's art evokes the same spiritual root as the nineteenth-century kalagas of Burma, elaborately appliquéd and embroidered hangings of astrological power and mythological significance.

Amy's collages, both in paper and in fabric, now number over 500 works made over the last twenty years. Like the medieval alchemist turning lead into gold, she turns base materials into the gold of art, transcendence, and, ultimately, self-illumination.

Her alchemical "laboratory" is her studio. It is filled with fabric, beads, and an assortment of decorative paraphernalia of every kind, from every place and every decade in the last one hundred years: prints, silks, velvets, laces, sequins, metallic threads. They come to her as she searches flea markets and antique shops wher-

ever she goes, and they somehow appear at her door, by way of both friends and unknown admirers.

Amy's way of working is as intuitive and mysterious as her end product, the densely assembled and collaged "illuminated tapestries." Her "Paradise Found" is composed of landscapes of the soul: dreamscapes, sacred spaces, temples, tabernacles, and grottos for spirits, goddesses, and the Vision Quest for self-realization.

Cutting, sewing, balancing, placing and replacing, she also paints, dyes, and colors directly, using whatever technique works at the time. In Amy Zerner's collage process, the image is found in the process, built up by bits and pieces, ribbons and shreds. The metamorphosis goes from risk to revelation, from rag to realization.

"More things in Heaven and Earth than dreams are made of" inhabit the tapestries, scrolls, banners of Amy Zerner. Her unworldly visions of other worlds—images juxtaposed to contrast, polarize, confuse, clarify, and ultimately, create balance and harmony—come to life in her art. From her fabric collages, often structured on the grid, a key centering image emerges miraculously out of the layering of multiple and varied textile fragments, which include machine-made synthetics as well as rare Victorian trimmings and the finest old silks. She uses direct painting and dyeing, color Xeroxes and enamels, as well as embroidery, appliqué and beading.

Instead of being a mere background for painting—as in the work of Matisse—Amy's textiles are themselves the "painting," both as content and as composition, a dense layering of myriad pieces, like a thick impasto of multicolored strokes building the vision.

Amy Zerner's roots as an artist are founded in modernism—most notably through Matisse—and abstract expressionism with its driving energies of improvisation and spontaneity. Her influences also come from surprising sources of the subculture, such as "outsider art," which includes folk art, ethnic and primitive art, child art, "l'art brut," the art of the insane, and religious art with its startling visionary strength, such as that of Russian religious icons. Her inspiration comes also from works of ancient times; there is the presence of Byzantine mosaics, Coptic weavings, and the prehistoric art of the caves at Lascaux.

Like Picasso, she does not hesitate to use anything she needs from any artist and any culture or nonculture, encompassing the range from "low" to "high." As an artist, she knows she lives at a time when the culture knows more about itself than ever before. She uses all the knowledge of the past and the present that serves her purpose.

Amy's early works reflect her interest in fairy tales and mythology as well as her natural gift of using fantasy to provide clues to self-knowledge and transformation. She studied painting in art school at Pratt Institute, and later fell in love with textiles, when she created a patchwork quilt on a job for Tony Walton, the Broadway set designer. It was then that she began her journey from being a painter and printmaker to becoming a fabric collagist. She began a tradition of her own, a unique, new art form.

She is, indeed, a one-woman movement, engaged in the quest of a lifetime. This is her focus, her

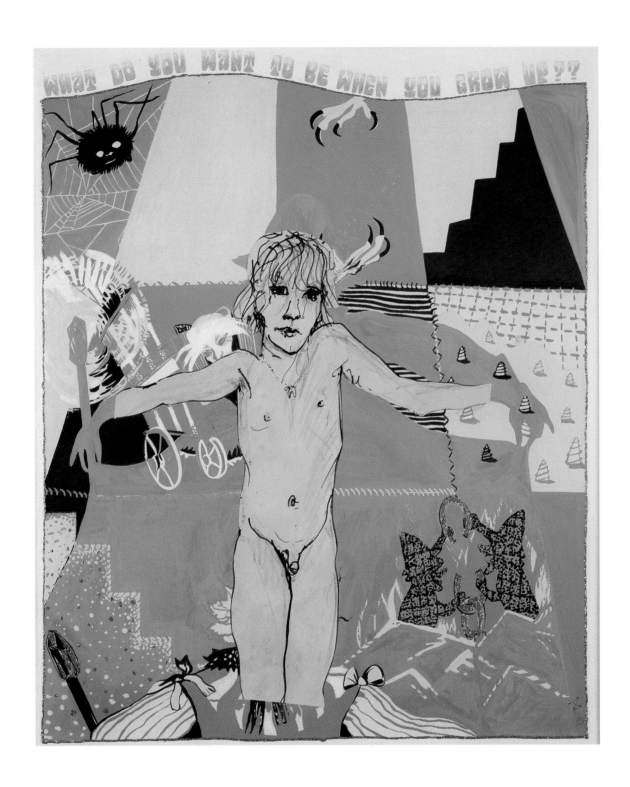

WHAT DO YOU WANT TO BE WHEN YOU GROW UP?
17 x 20¹/₂ inches, 1973

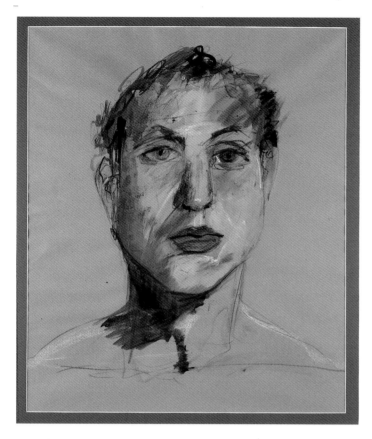

obsession, her life work. Her tapestries, dense and layered, reflect her development as an artist. She has become increasingly captivated by astrology, by the power of the stars, the sun, the moon, and the planets over our lives. While her early works include symbolic representations of the planets, they also speak of her own life, dreams, and ideas.

Neptune, done in 1976, bears a striking resemblance to Amy's 1975 drawing of Monte, her husband-to-be and now her beloved collaborator. Her portrait of Monte, whom she had met the previous year, is a sensitive study in pastel, colored pencils, and watercolor, and reveals her skills as a draftsman and colorist.

In Pluto, also 1976, a woman looks into the self-reflecting pool of the underworld or the uncon-

scious. Like Neptune this piece is largely done in paint and batik, with outlines and sewn black yarn hair. The surreal, the symbolic, the power of the dream as it finds its resonance in conscious reality were among the themes Amy Zerner touches on as she compulsively and intuitively made this large, four-by-six-foot, hanging. At this stage, she was only 25 years old.

Both Neptune and Pluto show the increasing complexity of her technical skills: a combination of printing techniques including batik with painting, drawing, collage elements, and the use of borders.

These techniques further animate the openly flamboyant Wishstar of 1977 (on page 18). A nude goddess rises from the flames, her hand upraised to the phoenix, signifying her power of transformation. Amy's liberal use of collaged birds as rising aerial spirits and reflective materials of sequins, beads, and borders, further enrich the spiritual and aesthetic powers of this early work. At this time, Amy realized she would need a wide array of materials to do what she wanted to do. It was then that she began seriously to hunt for them.

She did her early fabric work on large muslin sheets and used any supplies she happened to have in her house. She did not have a sewing machine at the time and, although occasionally she was able to borrow one, she frequently did her stitching by hand.

In The Rainforest, done in the same year of 1977 (page 23), the grid becomes her structure for defining her elements. She begins to use independent

units of fabric sewn into a work that is both symbolic and narrative. By 1982, with *Witchessence,* she was creating a fabric collage that also incorporated printing and dyeing, batik and Xerox, hand-appliqued shapes and machine-stitched borders.

Witchessence (page 11) is part of a series showing the cardinal points of a woman—as virgin, mother, amazon/witch, sage. It shows the face of a woman at its center, her body and the landscape as one, deer as symbols of shamanistic energy. It is a reflection of Amy's own development as an artist, as a woman, and as a deeply spiritual sensibility searching for her own evolution to the position of sage. The sage is also manifest in *The Hermit* of 1989 (on page 20), one of the seventy-eight tapestries from "The Enchanted Tarot." *The Hermit* is both master and teacher while still always learning. He has come a long way from the first card, *The Fool,* who knows little, and is able to make the mistakes of the young and laugh. Amy, at this stage of her growth, has achieved mastery at the fabric collage with each one of the seventy-eight hangings ultimately pictured on the front of each card, an astonishing feat of stitchery and assemblage.

The year 1989 continued to be rich and productive for Amy, one during which she developed her images for *The Alchemist* (St. Martin's Press, 1991), produced in collaboration with Monte. It is in creating these works that she developed her technique of making paper collages by laser transferred fabric

NEPTUNE
4 x 6 FEET, 1976

segments. This technique allows her to work more rapidly and with greater variety.

In *Transference of Hope,* 1989, the central figure is surrounded by a grid of infinite variety in design, detail, direction, texture. The message is that of the teacher who transmits in many ways other than in words. The word "transfer" has a double meaning here as it also does in *Transference of Power* (also done in

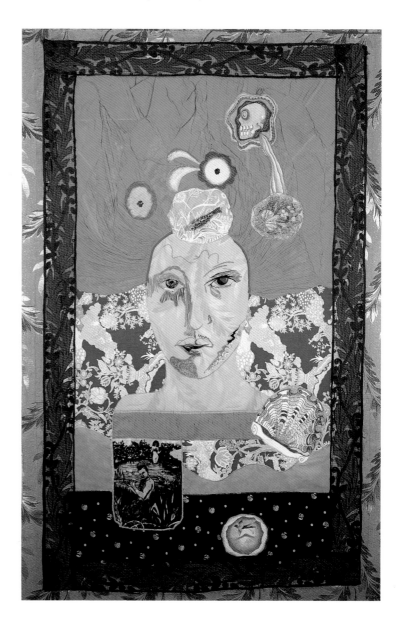

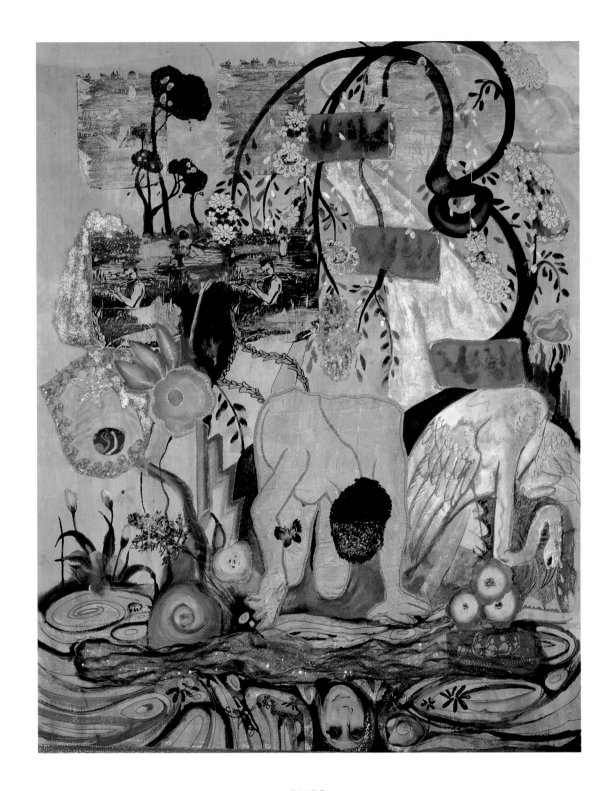

PLUTO

4 x 6 FEET, 1976

1989). In the transfer process, an array of fabrics is reproduced on paper through laser transfer. The laser copy gives the appearance of real materials. It has freed the artist to go further in her explorations by enabling her to shift, juxtapose, and place the laser printed papers with greater ease. *The Transference of Power* shows the man and woman rooted together as they stand in the center of a transforming environment, as they seek spiritual power for themselves and each other.

In a gigantic visual and tactile leap, the hanging becomes a masterpiece of visual enrichment, enigma and meanings in process. The work has the quality of changing before our eyes, with the viewer always at the beginning of seeing, never tiring of looking, of becoming lost in it, of finding himself and being found. It speaks directly of Amy Zerner's arrival at the portal of the *Mystery School* only to face the final wisdom of accepting the mystery.

By the time Amy and Monte came to create their *Goddess Guide Me* divination system and the twelve goddesses, she was ready for the challenge. Each hanging represented an attribute necessary in the journey toward an evolving and transforming self, as well as one with the power to guide and heal. Her authority over fabric collage was unsurpassed, as the fantastic garments of the goddesses testify, and her authenticity as an artist of spiritual powers is clearly and profoundly demonstrated.

In *Romi Kumu* (on page 165), the goddess of willpower, Amy Zerner creates a composite divine force—a combination of classical Greek, ancient Aztec, Hindu, and Egyptian deities—and a strong element of self portraiture. *Romi Kumu*, a quintessential Amy Zerner creation, is a visual mixture of every culture past and pre-

sent, and a rich view of what it means to be an artist—angel and goddess, dreamer and sage.

This work suggests the kind of place that is set aside in certain primitive societies for the making of ritual images. These images are also of our own time and place. They express the anxieties of a society in which the role of art is increasingly problematical. These figures also remind us of the commanding, totemic presence of the sculpture and other works of art that have survived from ancient times.

Amy Zerner's art is the art of radiance and transcendence. It is the odyssey of the fragment as it journeys to infinity. What is truly surprising in her art is that it has the same power to influence us as it has to affect the artist herself. While all art has the power to light the way toward a new enrichment of self, Amy's work provides us with the tools to reach the light within ourselves, to give power to our lives and clarity to our decisions.

Although Amy may begin a work with the spark of an idea, more often the works reveal themselves only after they are completed. Animals, fish, winged creatures, plants, water, mountains, sky are all used symbolically. Water may be a pool of emotion; Air, the realm of idea; Earth, the physical life; Birds and insects may signify spirit.

The tapestry *Immortal Love* (page 2), done in 1987 and made to communicate love's power, pictures the Taj Mahal, the mausoleum built by the great Shah Jahan as a monument to his eternal love for his wife, Mumtaz Mahal. Amy's tapestry began in a flea market

found an embroidered picture of the monument in silver thread. Placed in the center of the diamond shape, symbol of the mystic essence of the universe, *Immortal Love* features a lace waterfall of love that proceeds toward the male and female figures at its base, with ribbons and threads symbolizing the linkage of elements. Altogether it is an astonishing coming together of shreds and threads.

The multiplicity of bits and pieces that Amy uses are from every corner of the Earth. With all its ancient references, Amy Zerner's art could only have happened today, when it is not unusual for a cotton print from the Ivory Coast to appear at Amy's studio in East Hampton on Long Island, as did the lace bit from England, the silk from India, the beads from Venice, and on and on in the galaxy of Amy's materials.

In *Mystery School*, 1989, there are over a hundred different fabric pieces and elements. Egyptian deity figures guard either side of the tabernacle, a shrine entrance. Above each figure is a butterfly denoting the hovering spirit. In front of the portal is a lush garden of patches, borders, floral prints, lace, voiles, all flourishing together inside the geometrically balanced spaces. A shining circle of sequins lining the inner apex of the tabernacle encloses the phoenix, its plumes reaching upwards past streaks of clouds. To look closely at this tapestry is to appreciate the velocity and massing of the fragments as they build together to create its awesome impact.

The scene is a cloister dense with secrets, history, legend, prayer, mystery, wisdom—and a symmetry of repetition and contradictions. The door that is closed will open. The bird that flies in all its ascending plumage is still pinned and sewn to its textile Heaven.

Amy is like the Native American shaman who goes to the edge of the mountaintop alone to meditate and receive messages and stories from the divine forces. Amy's role is to come back to the tribe and tell us what she has seen and heard. This is her work. She feels she has been chosen. "I myself never had the choice as to what I should do," she says.

When we see *Mystery School*, study it in its amazing detail, we see the world more intensely afterward, as if we were now able to see under the skin, and beyond the horizon. The work enables us to take in more reality, empowers us to live within its own present, at the same time that it recognizes a particular future and illuminates a particular past.

Mystery School deals with time—present, future, and past—as a unity. The past is always new, always changing with the present in life. Parts that may once have seemed to disappear may emerge again, while others vanish—and then reappear. Yet other parts vanish without a trace as if they had never been.

To watch Amy Zerner begin a new tapestry is to watch her begin a predestined journey to a place she does not yet know. She knows only that the way will discover itself as she moves with it and that it, in turn, will become the road to her own self-discovery. She moves in an anxiety of possibilities mixed with the free floating impulses of the dreamer in trance—a mixture of

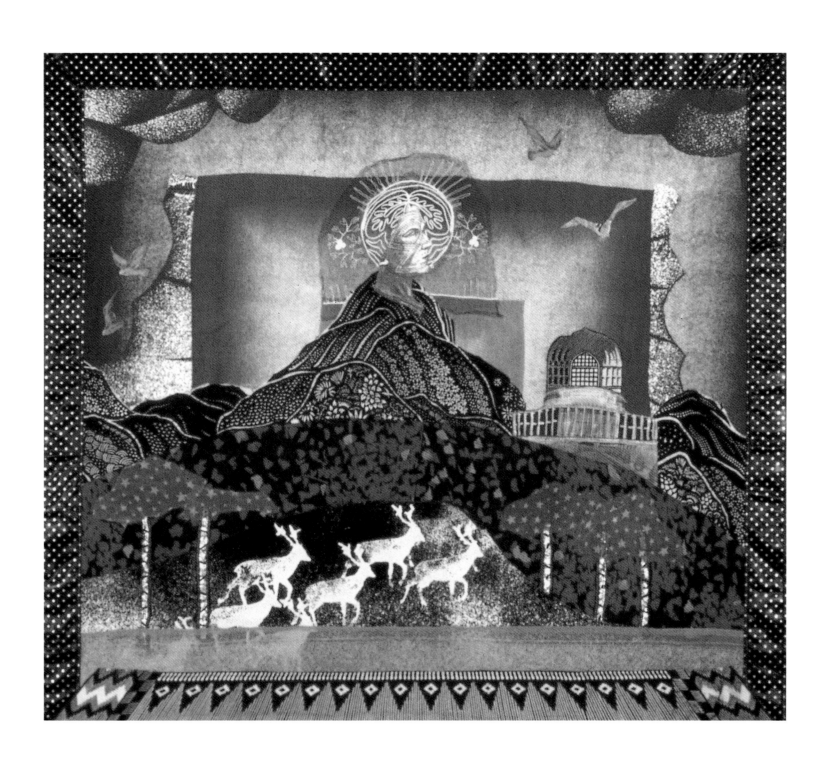

WITCHESSENCE

40½ x 37½ INCHES, 1982

chaos and consciousness, confusion and clarity, the dreamer and the dream at one in a state of total awareness, wakefulness, and light.

She begins her complex accretions of fabric with trust in the fragment. She goes to her little trunks or bags or boxes, haphazardly pulling out this little clump of remnants, that wisp of lace, those shreds of metallics and threads. She is performing a ritual act, an incantation, a ceremony that was decided a long time ago, for which she is the medium.

She scatters her pieces in heaps in a ring on the floor. She sits down in the center of it all and waits for the first impulse. The first move will set free the many others that follow. Suddenly she rises and goes like a sleepwalker straight to one of her piles of textile fragments. She picks a piece of iridescent netting, takes up her scissors, and cuts a shape. She has already prepared her "canvas," the rectangular fabric backing with the outer border already sewn in as a frame. She places the first fragment in the middle of the lower portion of the backing. She does not know what she is going to do next, which of the hundreds of fragments or rags she will turn to, separating it from its own little heap of related pieces (not similar scraps, but pieces related through source or time or some other association). It is all decided intuitively, on the spot, layer on layer, as she goes along. She is not aware of any conscious thinking as she moves from one piece of cloth to the next. She is totally in her own world, at one with her obsession, unaware of anything else going on around her.

She spreads each fragment on the backing, putting this one on that one, this next to that, silently for hours. Gradually, miraculously, images begin to emerge. They are as surprising to Amy as to those watching her work. Generally, she is entirely alone during the process of composition, sitting and rising from the floor, pausing, bending to place this patch and that piece, turning and reaching in the midst of her multitude of bags and boxes.

She moves constantly, unaware of anything else around her, gradually building detail. Many of these fragments are old, precious, and costly. She will risk them for the spiritual treasure she pursues. She has no preparatory sketches. She simply recognizes what happens as it is happening, without really knowing how it happened. It is amazing, even to the artist.

Each work emerges the way Robert Frost, in a letter to Louis Untermeyer, described the emergence of a poem: "A poem is never a put-up job, so to speak. It begins with a lump in the throat, a sense of wrong, a homesickness. It is never a thought to begin with. It finds its thought and succeeds, or doesn't find it and comes to nothing. It finds its thought and the thought finds the words."

In *Vision Quest*, 1990, for example, a figure, as if in a trance, stands inside the portal of a sanctuary, within the dynamics of a changing landscape. Her eyes, closed to the outer world, are searching her inner self. Two angels guard the geometrically segmented accumulation of detail and symbol. In her evocation of spiritual forces, the artist layers her images from the center, as if from the soul. All the random events and complexities of life revolve and balance around that sacred center.

Amy is not afraid to explore her unconscious as a source of art, inviting its raw energy into the

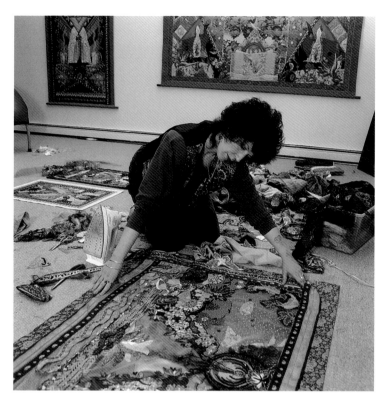

process of its own ultimate transformation from the very beginning.

Here the dreamer is the artist and the images of her powerful dream state are no more separable from her than the dance from the dancer. Here is a mixture of figures and shapes, symbols and markings, mountain peaks, gardens and rivers, eyes, birds, butterflies, rabbits, snakes, flora and fauna dense and layered, worthy of the jungle of Jung's collective unconscious.

Amy's way of putting things together is to work randomly as well as by careful choice. Her tapestries encompass a multitude of inexplicable combinations calling forth new associations and ancient fears. Extremely personal and private, they demonstrate again the courage of the artist searching for her own way.

creative process. We feel the power of the pent-up dream as it spills loose into the jungle of the dream, as in *Paradiso,* made in 1991, a precursor to *Paradise Found* of 1993. Each tapestry belongs in her series of mystic visions on the journey toward transformation. The eyes of the figure in *Vision Quest* are closed as she searches for what she cannot see, but can only feel in her trance. She is looking for her own myth and for what she can learn in the course of suffering to find it.

In *Paradiso,* a golden butterfly, the traditional symbol of the soul's transcendence, emerges from the top of the mountain peak and ascends to the sky, its metamorphosis from egg to larva to cocoon to butterfly signifying transformation. The butterfly, which appears frequently throughout Amy Zerner's work, is a symbol of her conviction that the human soul contains the

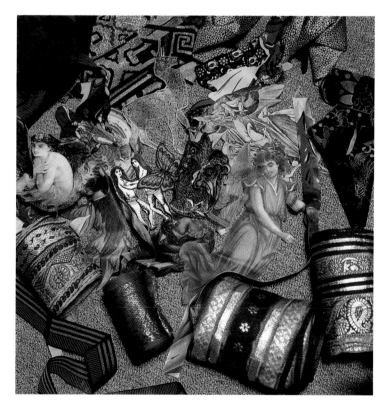

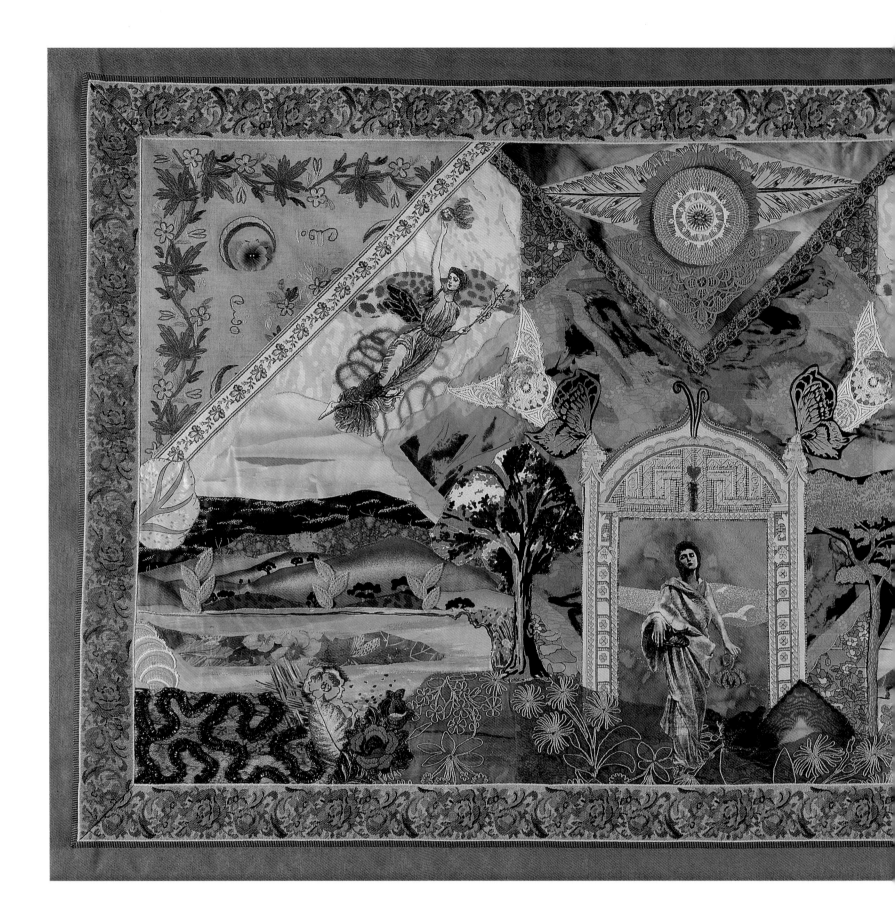

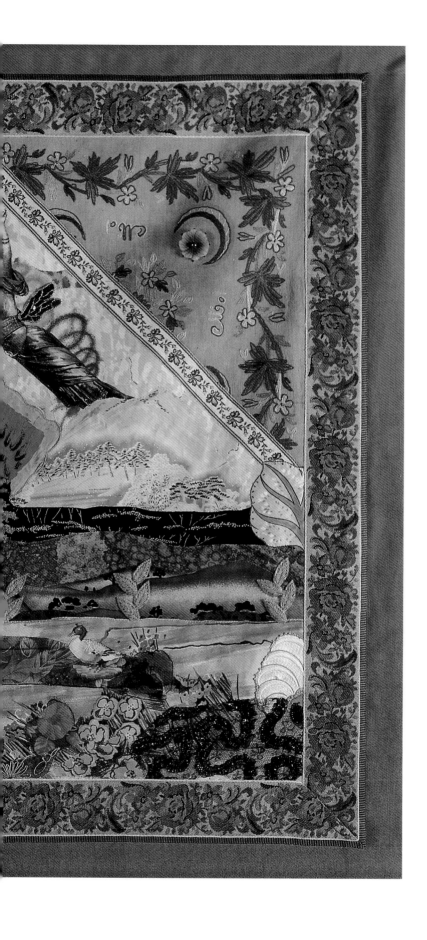

VISION QUEST
74 x 45 inches, 1990

In her arrangement of fragments, Amy presents a maze of meanings from which both artist and viewer must extricate themselves. To find her way, Amy first must get lost, and then pick her way through the labyrinth of choices. She mixes combinations of found and natural objects in a cacophony of coloristic particulars—buttons, shells, jewels—to create an object as shrine and icon, ultimately religious, leading to mystery, mystification, and wisdom.

In all her work, Amy has a teammate: Monte Farber, her husband. He, too, is a visionary. He discovered his powers when he met Amy. A musician by instinct and training, he heard, above the inaudible, the music in Amy's landscape. They are an inseparable team.

At one time not too long ago, when they were receiving no encouragement for their work—he as a musician and songwriter, she as a painter and collagist—they experienced a moment of despair. "We looked at each other and we said, 'Let's give this up.' But then we looked at each other again and we said, 'We don't know how to do that.'" In their life and their work, visionaries and their vision, they are the same, each one separately and together. How each one experiences the world, how each one makes it new—with a new ear, a new eye, a new hand—alone and together, is the story of Amy and Monte.

When they met in New York City in 1974, Amy had left Pratt Institute where she had studied painting and printmaking, and was working as a prop designer and commercial artist. All that time she was also continuing to pursue her own personal expression. She had begun

her study of astrology, which she found rich with the archetypes, symbolism, and mythology that she already knew she needed for her art. Monte, a deeply gifted musician and songwriter who later worked in the film industry, was a committed student of comparative religions and philosophies and was able to help Amy widen the scope of her spiritual and artistic quest. She found inspiration in the Zen teaching of discipline in spontaneity and spontaneity in discipline.

"My spiritual studies teach me what I know inside already. They help me to realize myself," she says. At the same time, through Amy, Monte became involved in astrology. Together, they used the study of the heavens as an arena for mutual and individual growth.

From the beginning, Monte and Amy found that each had what the other needed—intellectually, emotionally, and spiritually. They were married in 1978 and moved out to East Hampton to live in Amy's family home, where she could have her own studio space for the first time. They still live there, with Amy's mother, Jesse, and Amy's 96-year-old Scottish grandmother, Lillias.

Taking inspiration from astrological symbols, Amy began to make her early fabric paintings and prints, heightened with embroidery and other forms of stitchery, and gradually moved more and more into the genre of fabric collage, for which she is internationally recognized today. Monte, while still involved in his music as art, continued to develop, along with Amy, his astrological learning and spiritual disciplines.

Between then and now, an amazing number of things have happened for them. Not only do they

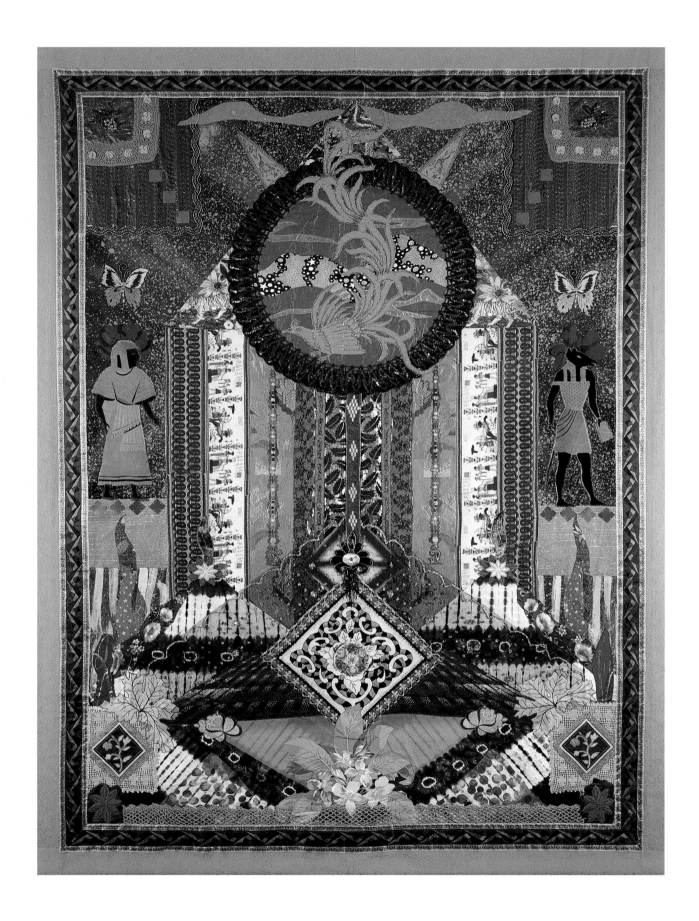

MYSTERY SCHOOL
65 x 92 inches, 1989

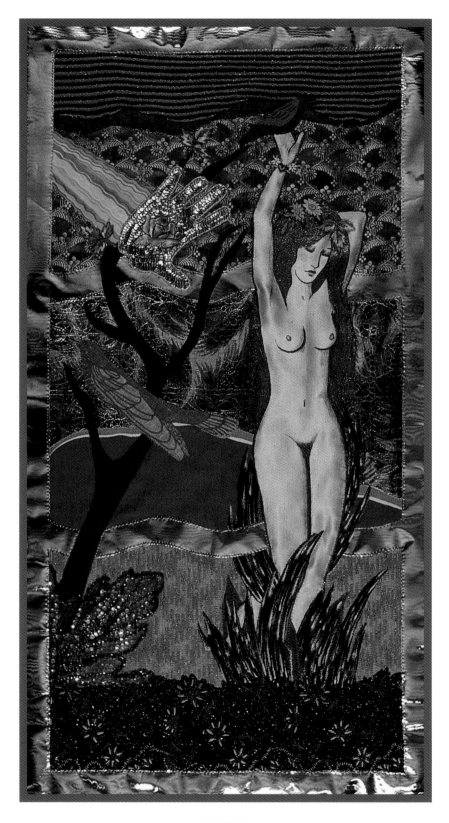

WISHTAR

25¹/₂ X 45¹/₂ INCHES, 1977

enjoy an engrossing marriage, but they are also a productive team, working efficiently together to execute an amazing variety of projects. After twenty years of marriage, they say they do not analyze what takes place between them. "We just know," says Amy, "that we can work anywhere as long as we work together."

Monte says: "Amy and I want to take responsibility for our own states of mind, states of health, the state of our relationship. And what is considered New Age is really so old age. Astrology is so ancient, the idea of self-realization is so ancient, Indian and Buddhist religions and their practice are so ancient. I really believe in discipline and practice. It's a discipline because you must practice to maintain a state or a balance. You can't just brush your teeth once. Yoga and mindfulness are the whole idea of meditation—to be aware of our thoughts and states of mind. That is the only way we can really rid ourselves of things that become negative patterns, that fester and hurt us and hurt our psyches."

"I'm always trying to purify and clarify the imagery in my work, and I hope, in turn, the imagery itself communicates this purifying and clearing effect," says Amy. "Monte and I feel we want to apply our art to help heal the Earth, as we are trying to heal ourselves. When I study ancient wisdoms that teach us more about true natures, I get so enthusiastic, and out of this love, some wonderful synchronicity happens. Somebody will come to my door with a bag of fabrics that will have just the right piece that I need at the time, so I kind of learn to let go, knowing that everything will be there at the right time, the materials I need or the images I run across. It is not premeditated. It is

pretty spontaneous—I don't sketch out before I start a piece."

Amy collects a "whole pile" of fragments, which become her palette. "For instance, I am making a whole pile of special materials now, a palette that triggers a theme that I want to investigate, but I will investigate it while I am in the process of creating it. I knew I wanted to do a series of temples based on Fire and Water and Earth, but I didn't know how they would shape themselves until I delved into the pile in front of me, all the multitude of fabric pieces and textures. And I pushed and pulled and cut and assembled until the pieces of the puzzle fell into the perfect formation."

Monte and Amy collaborated on *Goddess Guide Me: The Oracle That Answers Questions of the Heart*, published in 1992 by Simon & Schuster, with each of twelve goddesses in lavish robes surrounded by symbol and scepter. Amy created each figure and hung them up in Monte's studio to inspire the text for the book. "We picked goddesses and broke them down into different archetypes. Then I would create the tapestries and Monte would illustrate my work with his words. Everything would always be right, the bird I chose or the flower. He would always see that the symbolism made sense even though I hadn't analyzed it, but more or less let it come through me." They worked the same way on *The Enchanted Tarot* in 1990 (St. Martin's Press). "It's a very balanced collaboration because I am a right brain and Monte is the left brain—female and male," says Amy.

At the core of their relationship is their interest in and concern for each other. Each wants for the other what the other wants for himself or herself. They have become so tuned into each other's presence

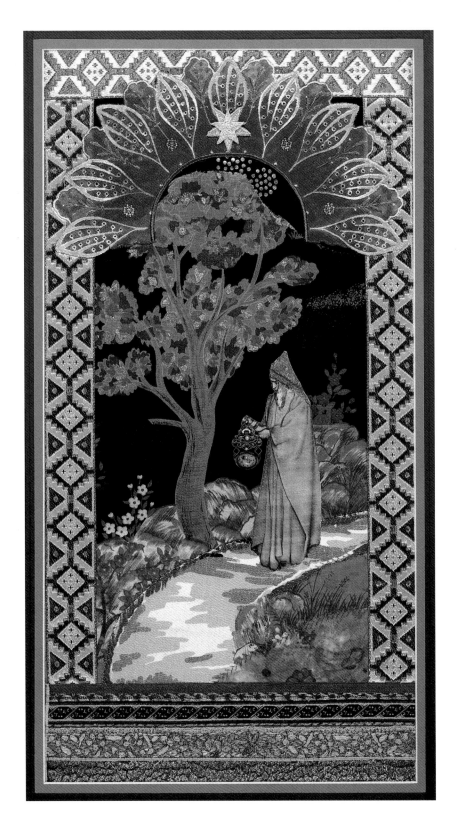

THE HERMIT
12 x 24 INCHES, 1989

that they are almost like two streams merging into one river. It is as difficult for those who know them to think of one without the other as it is for Amy and Monte to think of themselves without the other. As Monte says, "We are each other's best friend, lover, parent, and child."

Working together as artists, they have avoided the familiar pitfall of competing with each other. Instead, each tries to fulfill the role to which each is best suited—Amy as the creative artist, feeling her way among her materials to make her collages; Monte the writer, composing the narrative and adding insights to the works.

As a couple, they live within an organized and integrated family, where mutual caring and support resonates. To watch Amy's mother communicating with her own mother, and then to watch the dynamics between Amy and her mother, is to see the power of the genetic chain. Each member of this family genuinely listens to the other, actually hears what each one is saying, and is able to react in full consciousness to the other's meaning.

In 1986, after some ten years of working with the encouragement of only her family, friends and a few of her peers, Amy was awarded a National Endowment of the Arts grant in the painting category. She was the first artist working in fabric to be so awarded. It provided confirmation for the direction her art was taking her.

In 1988, Monte's brilliant *Karma Cards: A New Age Guide to Your Future Through Astrology*, was published by Penguin Books to immediate international success. It was that work which led to *The Enchanted*

Tarot in 1990, seventy-eight cards for which Amy made seventy-eight new fabric collages, especially created for the tarot deck. More than half a million people throughout the world have enjoyed developing their intuition by looking at reproductions of this tarot, asking questions of the cards, and reading the accompanying book.

Other such joint projects, with Amy doing the artwork, production, and manufacturing and Monte the writing, agenting, and promotion, include *The Alchemist: The Oracle for Turning Your Life to Gold* (1991, St. Martin's Press); *Goddess Guide Me: The Oracle That Answers Questions of the Heart* (1992, Simon & Schuster), and *The Psychic Circle: The Magical Message Board* (1993, Simon & Schuster).

Monte and Amy soon realized that the divination systems they created using their own spiritual and astrological convictions could be used to help and heal a large audience in need of clues, keys, and tools of empowerment in a confusing and overwhelming world. "When we started, we had no idea that we would be in the business of publishing and creating for others what we love best to do for ourselves," says Monte.

Amy's relationship with her mother Jesse, a strongly supportive presence as she was growing up, is illustrated by a story she tells. "My mother really always encouraged me to do my own thing and I always appreciated that. In fact, when we came to East Hampton and I started to go to school here, it was sort of a hippie time, in the late sixties. I was new and I wanted to make an impression. I wanted to paint my face with tattoo designs every morning; my mother

helped me. Every morning I would get up an hour early and she would help me paint birds and flowers and stars on my face." Mother and daughter began their latest collaboration two years ago, producing a series of children's books with Charles E. Tuttle publishing: *Zen ABC* (1992), *Scheherazade's Cat* (1993), and *The Dream Quilt* (1995).

Amy is a third-generation artist. She learned to paint literally at her grandfather's knee, where she recalls sitting at the age of three, filling in the green of leaves in the landscape he was working on. Amy's mother studied to be a painter and worked as a designer and illustrator. Amy grew up guided by family artists; she has never worked at anything other than art.

Her family moved to the tiny, idyllic farming town of Laporte, Pennsylvania, with a population of 175 people, when Amy was five. "It was a perfect little town,"she says. When she returned there for a visit two years ago, she found that nothing had changed. It was the same as it was when she was growing up there—still isolated by mountain ranges, still a forty-minute drive from movie theaters. The intimacy of her childhood community inspired her love of protected spaces, her love for enclosed gardens with birds and butterflies. "All that influence, as if from Persian miniatures, you see in my work, may well have come from my early environment," she says.

The traditional painting techniques she studied at Pratt Institute did not satisfy Amy's needs. She found herself developing her own methods and materials. She began finding inspiration in alternative sources—primitive and folk art, sacred images in the religious art of all cultures, and in tarot and alchemy. She was inspired, too, by child art and art by people isolated from the mainstream of culture, people who were uncorrupted by schools, status, money, or power, for whom the *will to art* manifests itself as a pure drive out of the unconscious.

Amy's early work is characterized by the prevalence of a figure centered in the landscape and by areas of texture. Painted at first, the images increasingly came to be formed by textile insets. Her last straight painting, in 1973, before she turned exclusively to fabric was, prophetically, the painting of a patchwork quilt, even to the stitches. The gouache was created to illustrate a childhood fairy tale about a little boy and his quilt. He picked a different square of the quilt to go to each night—the land of the yellow square, the land of the blue square, and so on. She has since made the actual quilt out of fabric. This quilt was exhibited in one of Amy's gallery shows and is at the heart of *The Dream Quilt*, one of the children's books she collaborated on with her mother.

At the core of Amy's art is the dialogue between visual representation and abstraction. In a sense, as painting, it's all a question of abstraction. Yet that dialogue appears as an active, ongoing, fresh dynamic, resulting in a fusion of tight structure with a tension of energies between opposing weights and polarizing forces. Amy Zerner's goddesses, representing a real breakthrough in iconography, clearly celebrate the new balance she seems to have found between sight and insight, material and metaphor. On the other hand, she also still allows us to see the chaos of energies and choices which, conversely, generates the right move every time.

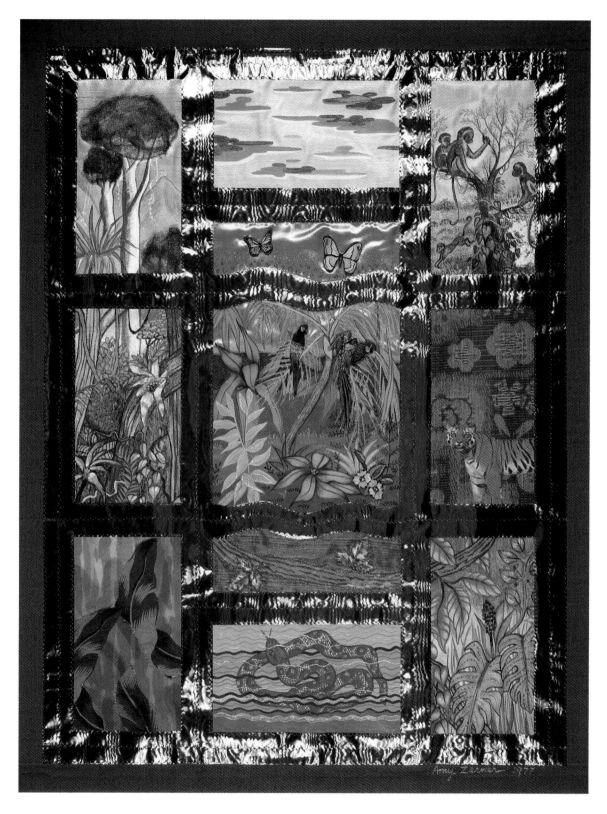

THE RAINFOREST
28 X 37 INCHES, 1977

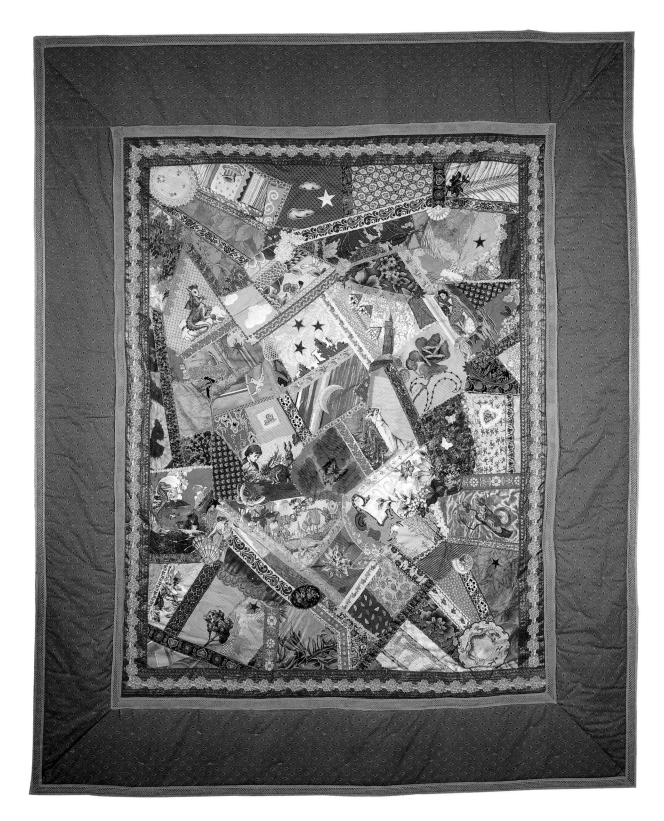

THE DREAM QUILT
80 x 98 INCHES, 1993

Her struggle for her art is both inspiring and exalting. She is unafraid to reach down into the deep blind unconscious within, for help in reaching new heights in the outside reality, in the material object. *Mystery School*, furthermore, spans the gamut from the geometric to the organic, with Amy's aspiring forms reaching upward, soaring in composition.

Artists today seem more excited about being heroes and heroines of art history than in being involved in the search for clues to the making of art. Amy seeks to go outside art history, creating the network of the now, and placing herself squarely in the spotlight of daily life, albeit with extraordinary objects possessing striking visual and tactile power. She has an ear for the oracle as well as a taste for habit and surprise, mode and myth.

At a time when our culture often appears to be irreparably isolated, one can see in Amy's work the unity art enjoyed in earlier ages and cultures. Art then was less jealous of its autonomy, and more willing to share its functions with religion and magic, more alive to the invocations of the spirit from which it originally sprang forth.

Amy's work gives rise to the question: Is it art or is it craft? The fact is, it is both. One of the most exciting aspects of her art is its fresh infusion of energy into the old arts/crafts dialogue and dilemma. Individual idiosyncrasy is in the work of the hand as much as in the hand itself.

Amy's textile world is a balance of art and craft. Art is identified with contemplation, with ideas, with the acts of wonder and mystery. Craft, which renders an object with consummate skill and material dexterity, incorporates use as an aesthetic. Craft is identified with domestic functions—tools, containers, furnishings for cooking, storage, eating, sitting, sleeping. At a time in American culture when the pressure to make art, to sell art, to buy art, to be art, has never been greater, Amy Zerner dares to create her own aesthetic of independence.

The essential difference between art and craft goes back to the very dawn of the human race when a genius of the species, perhaps hiding from an animal larger and fiercer than him/herself, decided he/she needed something more than strength and speed, something that would be the equivalent of the mountain peak touching the stars, the mobility of the snake on the ground, and the winged creatures of the Air. In the course of reaching beyond animal strengths and body skills, early man aspired to the powers of the spirit, the mysterious enlightenment that would give him or her the key to flight, safety, and serenity. In short, our early predecessor longed for the qualities Amy Zerner envisions and symbolizes in *Paradise Found*—the aspiration of the peak toward the stars, the wisdom in the Earth, the mystery in the coexistence of all forms.

Art was the beginning of de-animalization, of humanization and an intelligence separate from the physical body, for powers of the magical, the spiritual, and for a belief system that expressed needs beyond those of the body, beyond the animal. It was the beginning of the separation between body and mind, mind and spirit, body and soul, craft and art.

All art is visionary in its ability to see and reveal realms beyond and beneath the surface. In the silken strata of *Paradise Found*, we find ascension from

Earth to Heaven and then again descent to Earth. It is the union of the powers of Heaven and Earth. At the core of Amy Zerner's vision, art and spirit are so inextricably bound to each other that they are the same. This is the ultimate revelation in *Paradise Found*. It is at the heart of all of Amy's work with the goddesses, the tarot, alchemy, mystic places, sacred spaces.

Amy Zerner, as artist and visionary, teaches us to extend the impossible, to enlarge ourselves beyond understanding, on a journey toward transformation. It is a self-perpetuating journey in a constant state of flux and discovery. In the end, the secret of the journey is that there is no end.

PARADISE FOUND
60 x 36 INCHES, 1993

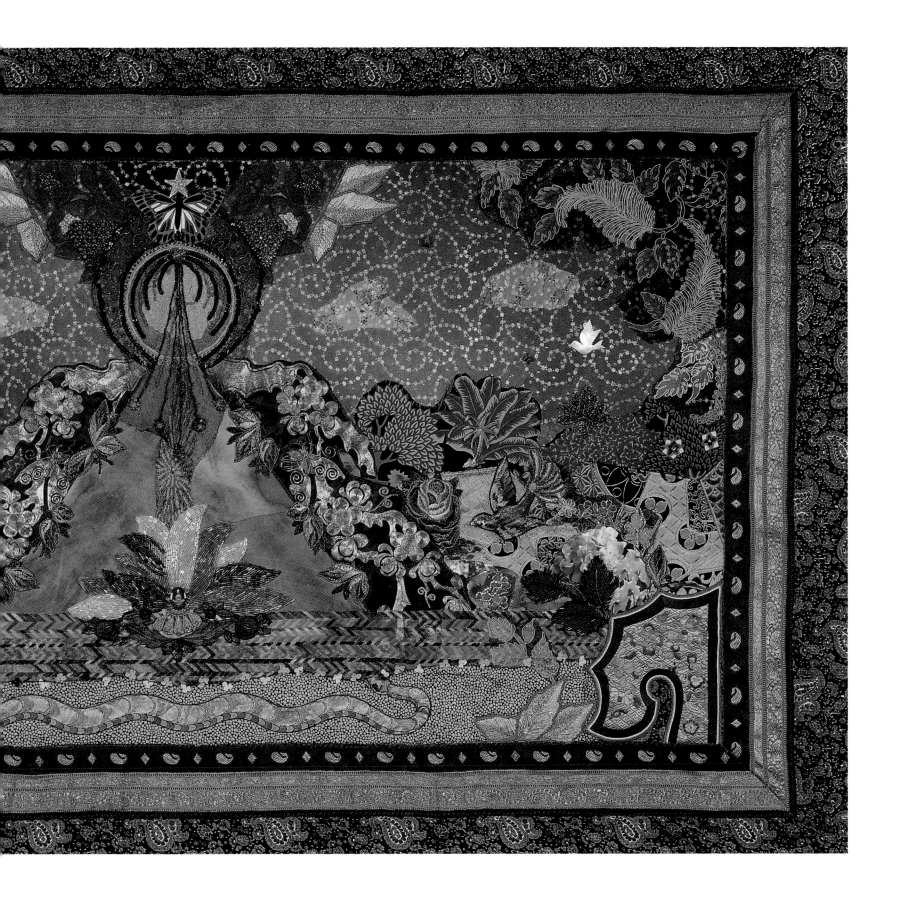

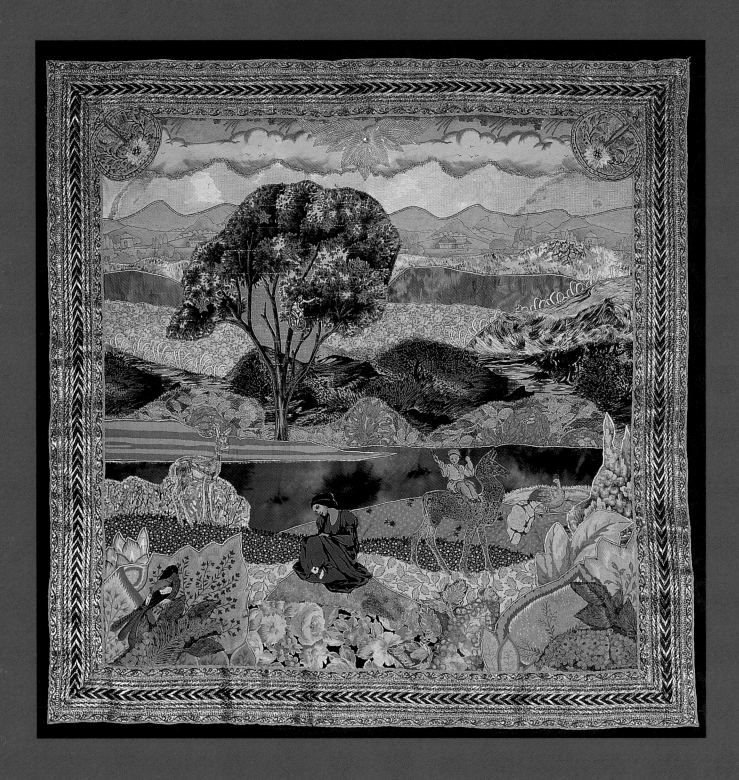

EXPLORING PARADISE

36 x 36 INCHES, 1994

EXPLORING PARADISE

by Monte Farber

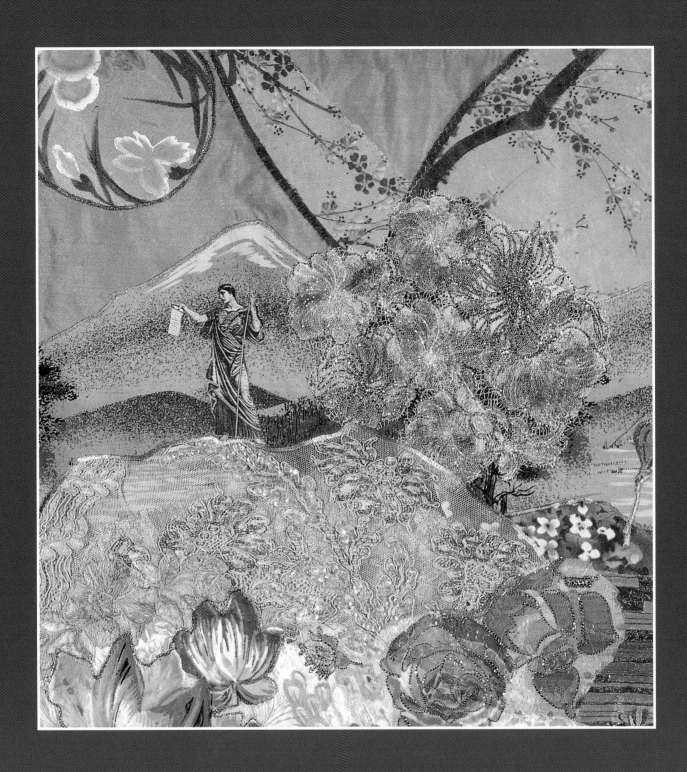

THE PROPHET (Detail)

DREAMSCAPES

*T*he land of our dreams. There is nothing in our lives more magical yet more common to us than this land where we each spend a third of our lives. Each night our waking thoughts and our hearts' desires are symbolically materialized along with our past, present—and maybe even our future—to create dream-dramas that instruct, nurture, and renew us. Refreshed, we come back to the other side of the landscape—the waking world—where time and space rule.

In most cultures, dreams are respected as real experiences, and with good reason: our dream world *is* real. When reason goes to sleep and intuition comes awake, we seem to be living fully in our own dream world. Yet, the "real" waking world does not go away. In the land of our dreams, the incredible intuitive power of what many call the Higher Self is alive and communicating with us.

So much of the stuff our dream world is made of is borrowed liberally and creatively from our waking world. In the same way, dream symbols and cryptic feeling-messages from dreams intrude upon our waking minds at the oddest times and for no apparent

reason. These experiences are not just curiosities. They represent the most visible examples of the continuous transfer to our waking consciousness of important information from our subconscious mind. This is accomplished in symbolic imagery—the "language" of our dreams. In this and many other ways, our dreams help to create our material reality as surely as our material reality helps us to create our dreams.

Amy Zerner has pioneered a unique style of multidimensional collage art. Although the history of collage appliqué and the layering of fabric on fabric goes back to the days of ancient Egypt, her surreal, dreamlike images are both timeless and timely. Their underlying philosophy reflects and expands upon her continuing discoveries about how to make her life a work of art and her art a work of life.

In this series entitled "Dreamscapes," you can see images of some of the many ways in which our dream world coexists with and affects our material world through the vehicle of our imagination. In a very real way, all of Amy's collages are informed by her unshakable belief that our dream world does not exist

"only" in our imagination. Rather, it is an important tributary source of our imagination, which is, in turn, the seed-source of everything we create in our lives.

It is not unusual to feel a sense of wonder, reverence, and awe when looking at Amy's collages. It is the experience we had as children, when a picture of a castle or faraway land could transport us into the unlimited world of imagination. We see everything as if for the first time and we are able to imagine possibilities and solutions we would not usually dream of. This childlike joy is at the heart of the creative process itself.

The "Dreamscapes," with their wonderfully naïve and decorative qualities, work their magic upon us. The "Dreamscapes" affect us with their sublime healing images. On the all-important subconscious dream-level, the images speak universally to us all. These pieces are an important revolutionary statement of our time, for they defy both the prevailing art fashion and the sense-numbing overload of negativity that bombard us daily. Fortunately for us all, the cross-pollination of these inspiring seed images does occur to every viewer.

When Amy is asked, "How long did it take you to make that?" she usually replies, "About a hundred years." It is quite common to hear viewers sigh deeply and say in a far more relaxed voice that they would love to just step into them and rest awhile. A few even realize they have just done so. However, everyone comments on the "fairy tale" or "mythic" quality of the work.

Our society is beginning to understand how important myths and fairy tales really are. People are beginning to remember what our not-so-distant ancestors knew beyond a doubt: we need fairy tales and myths to help us create our reality.

Like our dream world, the world of myths and fairy tales is real and quite important to our everyday life. Studies have shown that children who do not grow up with fairy tales are less likely to let themselves feel happy when they grow older. It is not so much the story of the fairy tale that is important as it is the secrets it reveals that will affect us all of our life. Traditional myths offer us guidance through our life's journey, even if we appreciate the myths as just made-up stories. In a very real way, we not only have to explain the myth, we have to enact it as well. As Professor Arnold Keyserling tells us in *Chance and Choice: the Myth of Science,* our life's journey is really to find our own myth, for myths help us make sense of our life and the world around us.

Many people feel that Amy's idyllic "Dreamscapes" of sanctuaries, primeval grottoes, and other utopias must be the result of a completely happy life. However, the pieces in this chapter were born from the same artistic process that created some of the more arresting, almost abstract images displayed in other chapters—the ones that seem to bear less of a relationship to the outer, waking world. The "Dreamscapes" are the result of the harmonizing of her waking, logical mind with the intuitive power of her dream-state—therein is the heart of her artistic and spiritual development.

Amy's harmonious integration of the human form into the beauty of her "Dreamscapes" is her affirmation that human beings can coexist harmoniously with nature. The belief in benign and even protective forces outside of ourselves is essential if we are not to

feel alone and insignificant. For twenty years, Amy has included images of angels in her pieces to remind us that we are surrounded by many loving helpers and we can call upon them when we need their help. These angelic messengers gently remind us of the interconnection between all living things and the unseen worlds of our dreams and beyond.

In a very real way, when we sing our children's song of "Merrily, merrily, merrily, merrily, life is but a dream," we are stating a high metaphysical truth.

We create our own realities as surely as we create our dreams. Often, the greatest changes that occur in our lives are not the result of external events but are the result of our changing the way we believe and feel about our situations. Amy's "Dreamscapes"can remind us about the powerful function of our dreams. Like our dreams, they can transmit to us the childlike wonder that empowers our will to create our waking world. They attain this power for the simple reason that each of her collages is a dream come true.

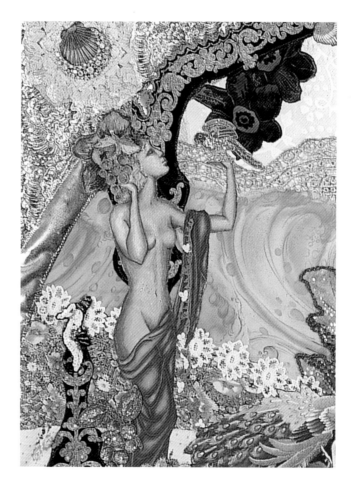

SIREN'S GATE (Detail)

ARCADIA

Arcadia was the mythical birthplace of the god Pan, the shepherd's deity, goat-horned and hooved, who loved all the wild places and forests. Here at Arcadia, Pan was at home and content and played his reed pipes from which he could coax the sweetness of a nightingale's song.

In Arcadia, two Greek columns stand at the entrance to an abandoned temple, each supporting the upward spiral of a vine. Flowering plants have found a home in their ancient marble crowns. The old shrine itself is broken but still standing, a testament to the enduring power of the oracle, who once dispensed the word of the gods from its sacred chamber. Now, all that remains is a statue of a golden-winged goddess, unaffected by time and so revered that no mere mortal hand would dare to touch her.

Humans have left their mark on this place, but Pan and nature have triumphed over their architecture. Now deer are at home here among the music of the birds, butterflies, and flowers. It is a scene of indescribable peace and tranquillity, a refuge for us all, frozen in time.

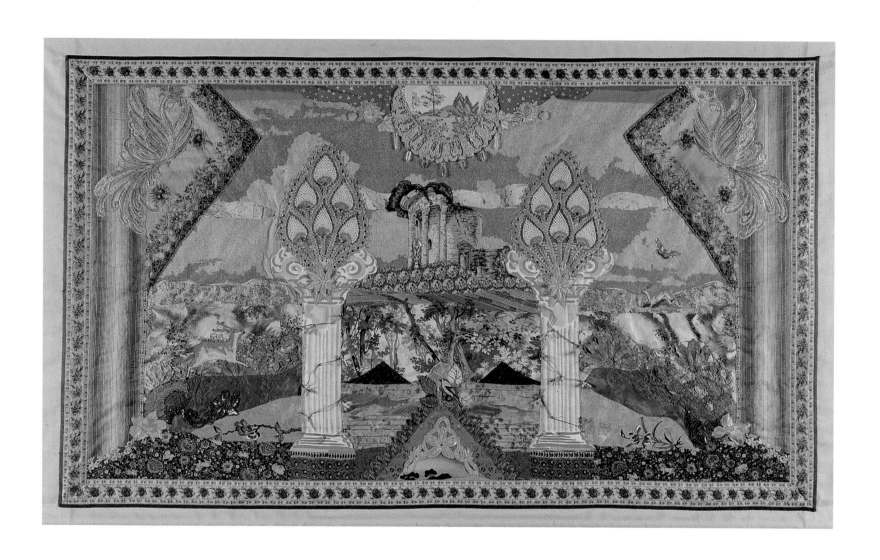

ARCADIA

74 x 45 INCHES, 1990

AURORA

Aurora, the Dawn, and the infant, Hope, bring two different kinds of light to the Earth and mortals. Without them both, it would be a dark world, indeed.

Making their way across the rosy landscape, greeted by awakening birds and opening flowers, they are figures of gentleness, nurturing, and compassion. They move in silence, choosing to listen to the quiet symphony being played in their honor.

Across the dewy great lawn behind them stands a castle where sleepers are just beginning to come to the end of their night of dreaming. Some open their eyes and give thanks for another day of life. Others choose to allow the business of the new day to cascade into their delicate awareness, filling it completely and preventing nurturing thoughts to work their magic.

The appearance of Aurora and the dawn is a promise—much as the rainbow was a sign to Noah—that a new day is arriving in which all things may be put right. At this and every moment, everything good is possible. This covenant is signed and sealed with every blade of grass rippling in the fragrant morning breeze and carried around the world on softly rustling wings.

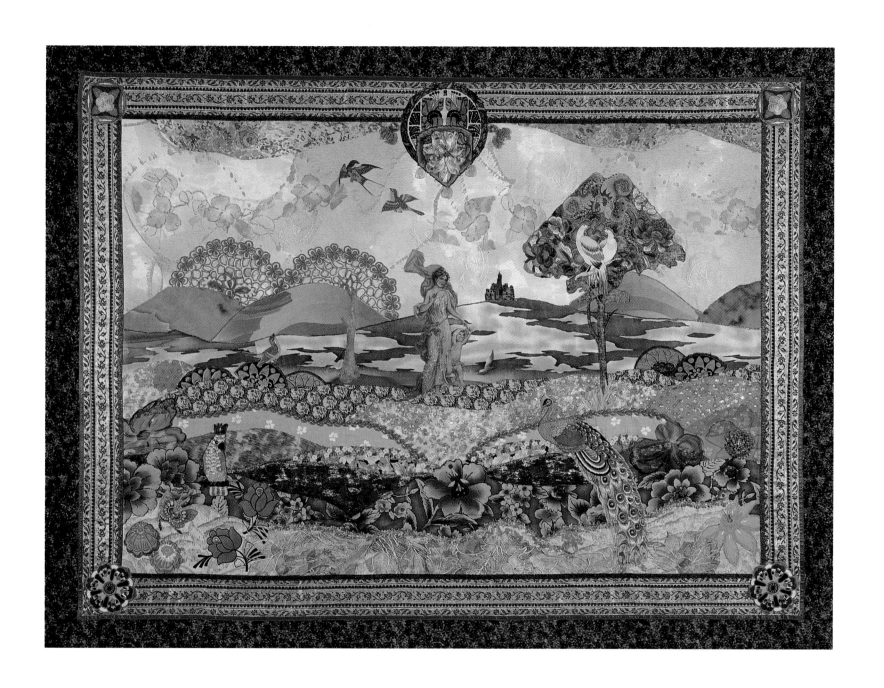

AURORA

63 x 47 INCHES, 1990

THE PROPHET

A prophet has come down from the high, snow-capped mountains and brought forth a tablet to show the people he had left behind. However, as we sometimes find in dreams, there are no other humans in this scene. Has he found the truth in the old saying, "A prophet is respected, except in his own land"? Perhaps he is prophesying to a group of people who are out of our view. Or is he reluctant to leave this idyllic place and begin the difficult task of alerting people to a new way of thinking?

This is the fundamental question we all must face when we feel we have discovered a significant truth about life and consider sharing it with others. It may be a new way of doing an old job, or it may be the realization that it is necessary to take action to help someone to help himself. Are we willing to go through such a great expenditure of time and energy and endure the inevitable misunderstandings and rejections that invariably greet those who exhort others to change their ways? This is a dream to prepare us for that experience.

The deer and birds look upon this human with great interest. They know he has a good heart, but they know more is needed to survive. They are hopeful he will stop on his journey and let the beauty of this dreamscape heal him from his ordeal to gain the wisdom of the mountaintops. Then he can feel refreshed and ready to fulfill his destiny.

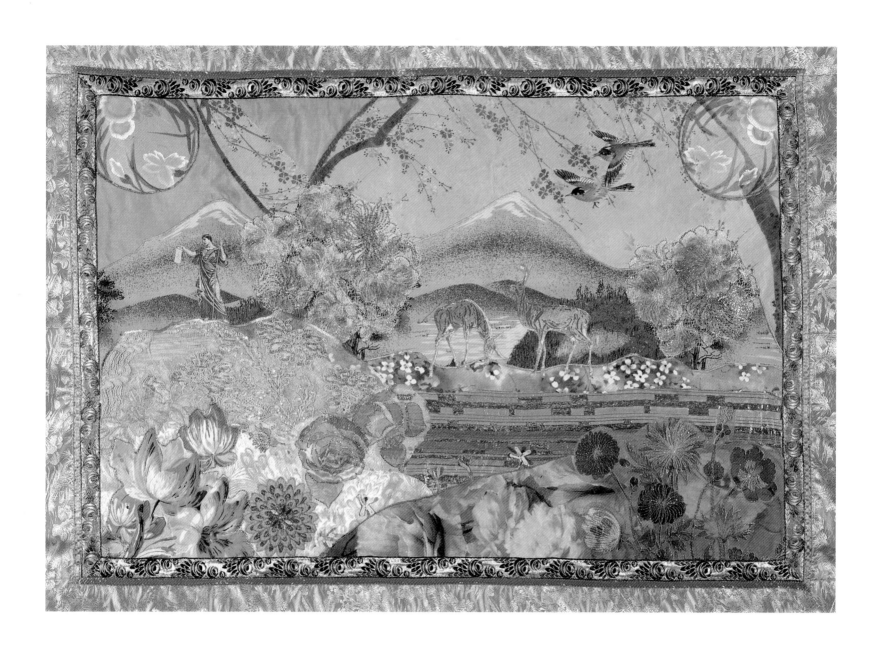

THE PROPHET

42 x 29 INCHES 1994

SIREN'S GATE

The unknown lies beneath the ocean's waves. All limits seem absurd when confronted by its immensity. A great blue wave swells and crashes on the shore outside the Siren's Gate, overflowing the channel where unwary sailors have docked their boat after hearing the Siren's irresistible call.

Across the strait an ancient castle seems to promise refuge, but this is no ordinary place. There is an unpredictable dream energy in the air, and the striped fish leaping on either side are soaring a bit too high. There is magic in these isles. An ancient boat is left below, perhaps wrecked seeking the treasures rumored to abound in these waters. Pearls and jewel-encrusted birds are said to be found by those who dare search. But hanging from the arch of the Siren's Gate is a necklace of skulls, the chained memories of those who could not control their longings. A peacock spreads its tail of eyes that see all in warning to the boat below.

These Sirens do not always live beneath the foam, but beckon with promises to reveal nature's secrets and foretell the future. Their voices and harps, though sweet and haunting, will lure unknowing sailors to their doom with promises of wisdom and fantastic treasure. Close your ears to their cries, all who wander in Neptune's kingdom, for though life once crawled from sea to land, beware of attempting to reverse the journey.

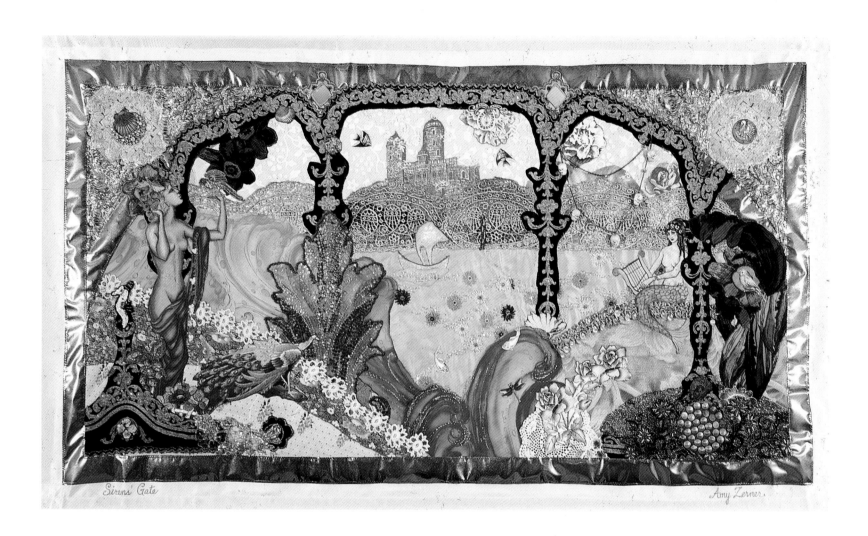

SIREN'S GATE

38 x 72 INCHES, 1978

THE MOUNT OF VENUS

For me, the image portrayed in this piece is so reminiscent of my recurring dream of a very special childhood place bordering Prospect Park Lake in Brooklyn, New York, that I no longer dream about the actual place but dream both Amy and myself into this most enchanted landscape. In my dream, the door on the charming, cunningly crafted lace-collar "cottage" has welcomed us home after many a night spent in a romantic tryst in one of the two rowboats pictured. It is as if those boats are our bodies, joined together and waiting for our souls to take them for a trip around our lovely domain. Perhaps that is why I feel this piece is more a portrait of the landscape of our life together than any other.

Venus is the planet of love, and the glistening copper-beaded mountain at the center of this piece is symbolic to me of the love that rises above our life together, protecting us and giving us the ability to gain perspective from its privileged viewpoint. Soaring even higher is a "hot air balloon," suggested by a crocheted piece suspended from a circular enamel emblem of a five-pointed star-like pentacle, so at home among the twinkling stars.

This piece is a prime example of Amy's skill at creating the illusion of depth in her work by using foreground elements that come right up to the bottom edge of the border, allowing us to feel that we are quietly peering through the leaves that guard a magic place.

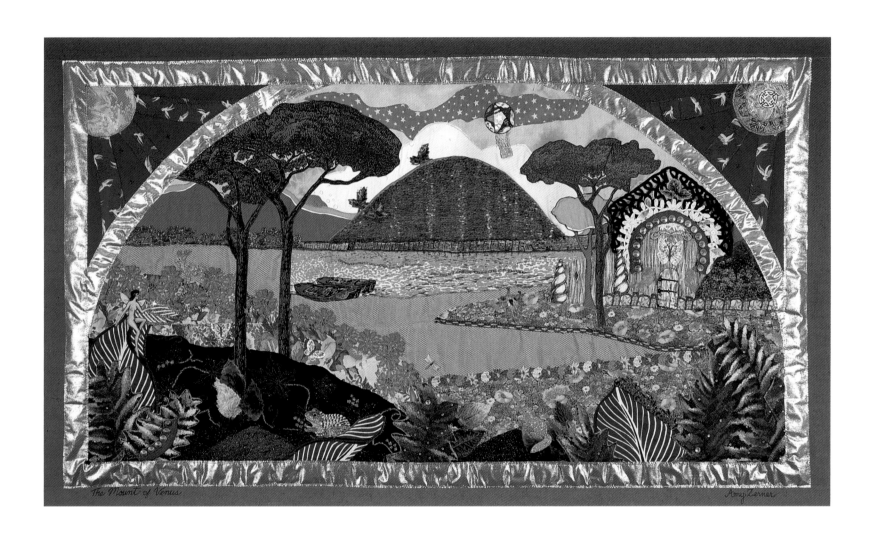

THE MOUNT OF VENUS

78 x 40 inches, 1978

THE WELL AT WORLD'S END

World's End is a beautiful state park in the Endless Mountains of Pennsylvania where Amy grew up. However, this image is of another wild and unspoiled place isolated from the world not only by distance, but by time and intent. It lies at the base of a cascading river that nurtures a fertile valley between two towering peaks that may have been volcanoes ages ago. Here all differences are resolved in a sublime experience of the pure harmony of Nature.

The many-petaled lotus flower, symbol of love and the ever-unfolding flower of consciousness, floats serenely on the surface of the well. The ever-changing salamander, the wise snake, the brave lioness, and the gentle deer are cautiously approaching this fountain of life, but somehow without fear of each other. Water, the symbol of emotions and empathy—whether in the clouds, river or well—is truly the life-blood of our Mother, the Earth.

The foothills below the two mountain peaks present us with a puzzle. They each seem to have a single species of plant growing upon their slopes. Is this the sign of human cultivation? Or is it a sign that, through Nature's innate wisdom, each species grows where conditions are best? One thing is certain: any being entering this place must do so with care and reverence for this supreme state of peace and natural order.

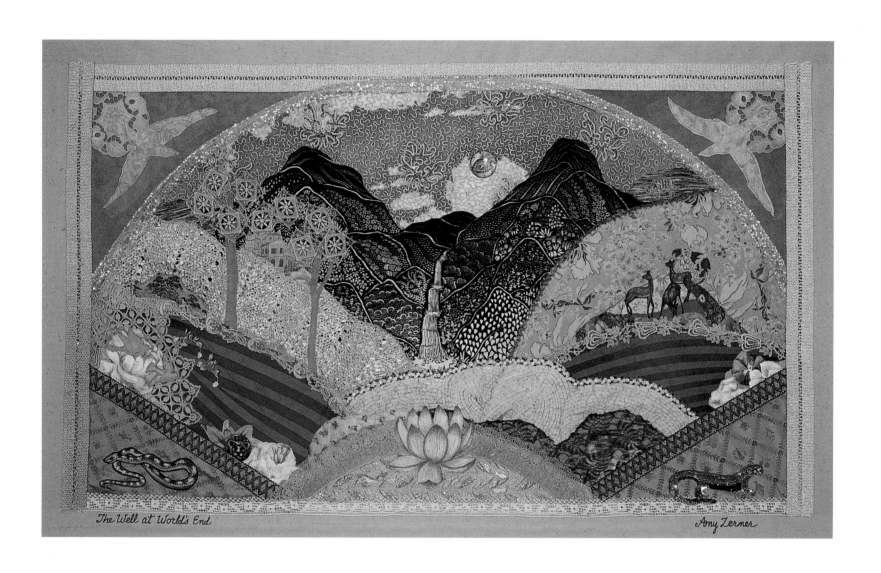

THE WELL AT WORLD'S END

63 x 38 1/2 inches, 1979

THE LOVERS

Here is a moment of breathless romance, a veritable archetype of that emotionally charged point of transformation where the heady freedom of a love affair may become a committed partnership. A man is on bended knee, seeming, beyond doubt, to indicate to us that matters are reaching a critical juncture and wedding plans are definitely in the air. The image is surrounded by floral sprays that make up a bridal wreath and the veiled woman is dressed in white.

A rose tenderly opens its petals beside the blushing maiden. The swallow, flying so close to the viewer, may be trying to tell us something. Entering on the left is an elegant rider. Will his arrival be a fortunate one or is a drama about to begin and spoil this enchanted scene? Perhaps this rider in military regalia represents the approaching time when these two lovers will have to walk together on the most perilous and unexplored of fairy tale quests: living happily ever after.

Fairy tales and other sacred myths help us understand our world and our place in it. The absence of a myth illustrating how to live happily ever after has undoubtedly contributed to centuries of cultures beset by wildly romantic courtships, story-book weddings, and marriages from hell. The ramifications of such tragedies are global as well as personal.

The sooner we start thinking of ourselves as artists and our lives and partnerships as works of art, the sooner we can enjoy an enchanted marriage. Every artist knows their creation is of the moment, so fragile and delicate it can be ruined as easily as it can be made personally satisfying. A valuable lesson for every artist is learning how to integrate the inevitable mistakes that are a part of their developing work-in-progress. Eventually, we learn to recognize, forgive, and even embrace these mistakes as opportunities to grow and create something original and wonderful.

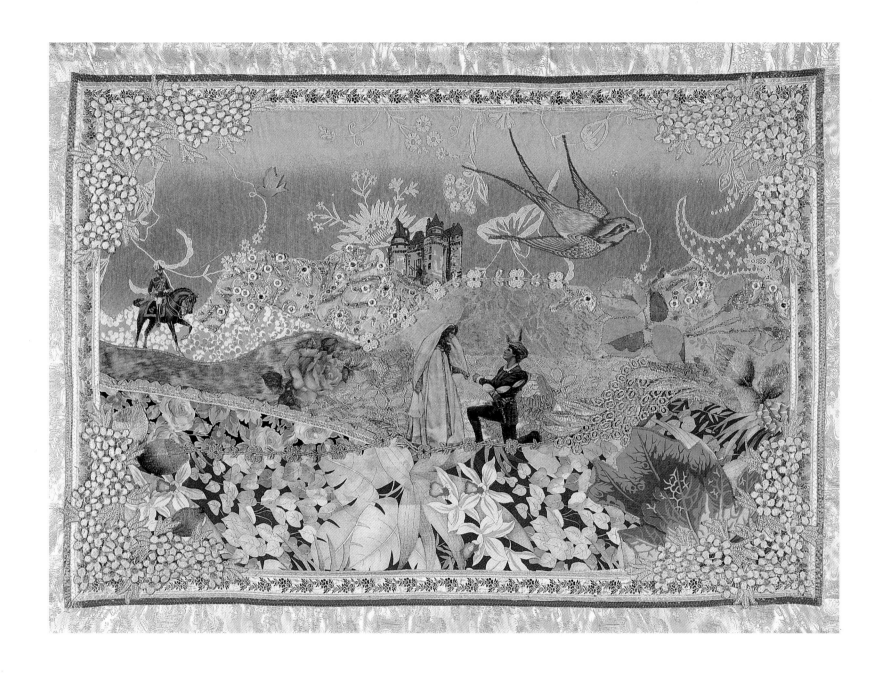

THE LOVERS
42 x 29 INCHES, 1993

POSEIDIA

Poseidia was the largest of the three islands making up the legendary realm of Atlantis; the last one to sink beneath the waves of the Atlantic Ocean some thirteen thousand years ago. It was a world of clarity and order where—for most of its long and noble history—people's minds were uncluttered and free to create their world.

Looking out on the ocean produces a calming of mood in nearly everyone. The colors of this piece are cool and suggest order and tranquillity. The feeling here is of a superior intelligence guided by spirituality.

Legend also has it that the city was energized by a great magic crystal that distributed its power without wires and without limits to all who had need of it. There were great Temples of Healing, Learning, and Wisdom. The people had not forgotten their divine origin and took the stewardship of the Earth as a sacred trust.

If all these great deeds were done thousands of years ago, it is not so unthinkable that they will be within our grasp in the not-too-distant future. Poseidia proposes what is to all too many people a hard concept to believe in: science can be guided by creativity and spirituality to produce inventions and conditions that benefit everyone. It can be done.

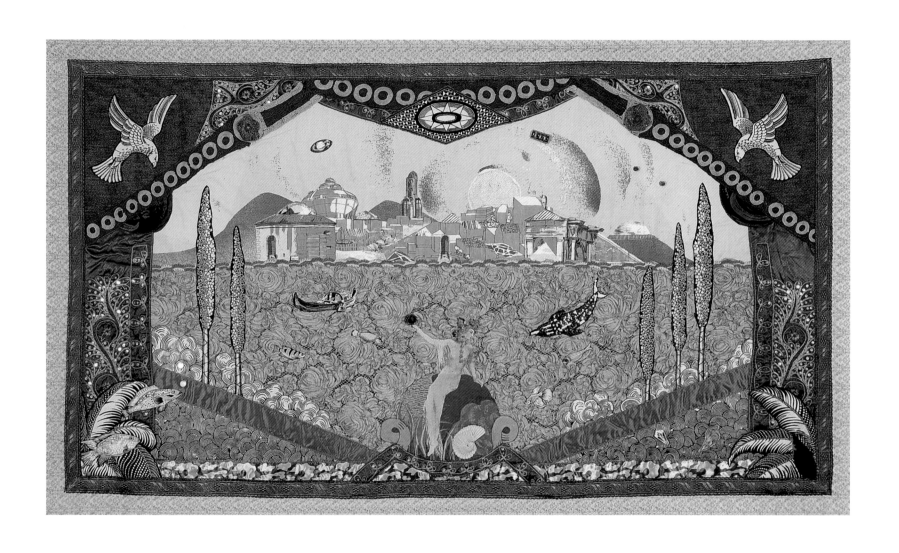

POSEIDIA

74 x 42¹/2 INCHES, 1980

WHAT I DREAMT LAST SUMMER

The title for this piece is a variation on "What I Did on My Summer Vacation," the title of the traditional first essay required of children returning to school in the fall. For Amy, this subject has evoked powerful emotions of freedom from regimentation and parental guidance and a return to days and days of playtime.

Here is an idealized vacation journey. With a towering lighthouse and a guardian angel blessing the trip with a favorable star, the ship is about to dock in a safe harbor. Though the deer in the foreground on the left seem to be moving away from contact with the coming strangers, in a cave in the upper right of the piece an oarsman is rowing out to greet them. There is a promise of good times enjoying the lush, wild beauty on the coast, and then a further journey from the seaside tower to a grand and formal castle on a distant mountain.

The feeling of this piece is one of a world made for our enjoyment. There are no straight lines, the telling symbol of the perceived necessity for perfection. All those issues that seem so important to us can be safely left behind for a time. The rainbow behind the angel is the traditional symbol of the covenant that we will not be destroyed for any transgressions committed on our dream vacations.

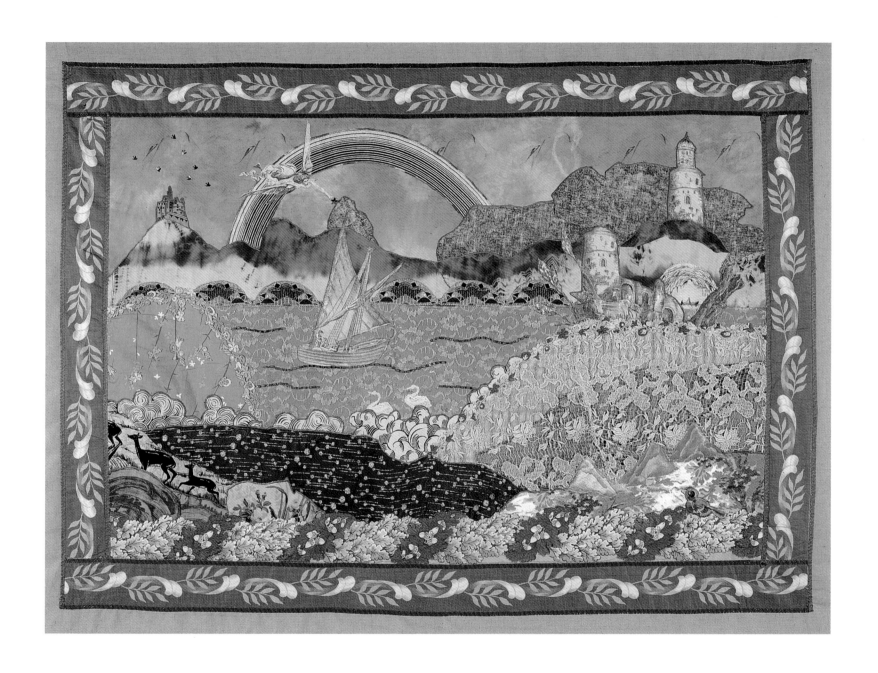

WHAT I DREAMT LAST SUMMER
63 x 46 INCHES, 1981

MIDSUMMER NIGHT'S DREAM

The stage is set. Throughout the darkness of the forest night, a most remarkable moonlight radiates from on high, casting a pale, magical glow. There are faint glimpses of little winged people and butterflies seemingly lost from the warmth of daylight. The heavy odor of strange blossoms seems to fill the air and there is a hush of expectation. A fine festival is about to begin, a celebration of the goddess of love and the casting of spells under the moon. The mood evoked is that intake of breath, that moment when the heart leaps before the show begins.

At first glance, *Midsummer Night's Dream* seems to be similar to the other pieces of the "Dreamscapes" series. However, it differs in several key ways. Amy's ability to accurately portray the haunting quality of moonlight reveals a new and even higher level of sophistication in her use of color. By choosing a nighttime scene, she has begun the process of examining the darkened, mysterious side of life that is more fully explored in the next series, "Vision Quest." Like the pieces of that series, *Midsummer Night's Dream* is more abstract in its use of embellishments to suggest elements of the natural landscape. The creation of *Midsummer Night's Dream* marks an important transition in Amy's work.

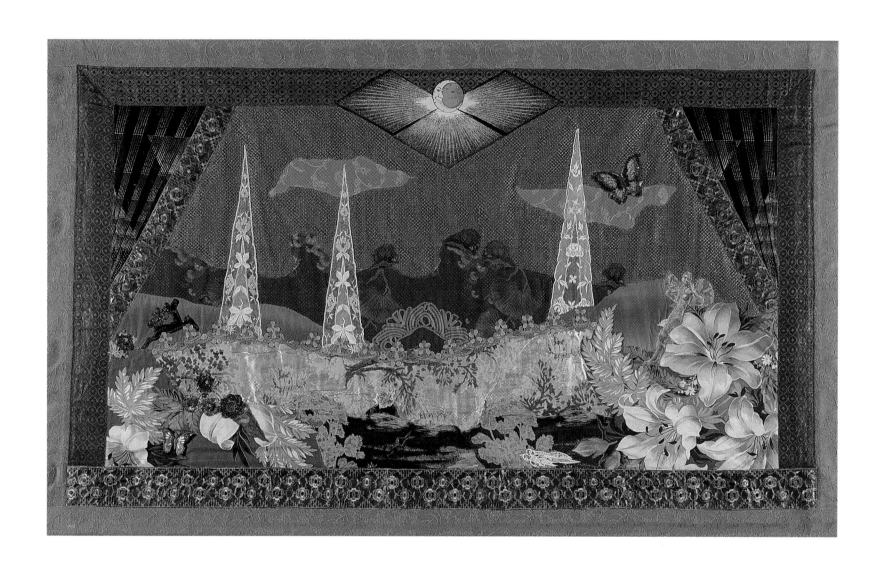

MIDSUMMER NIGHT'S DREAM
67 x 40¹/2 INCHES 1982

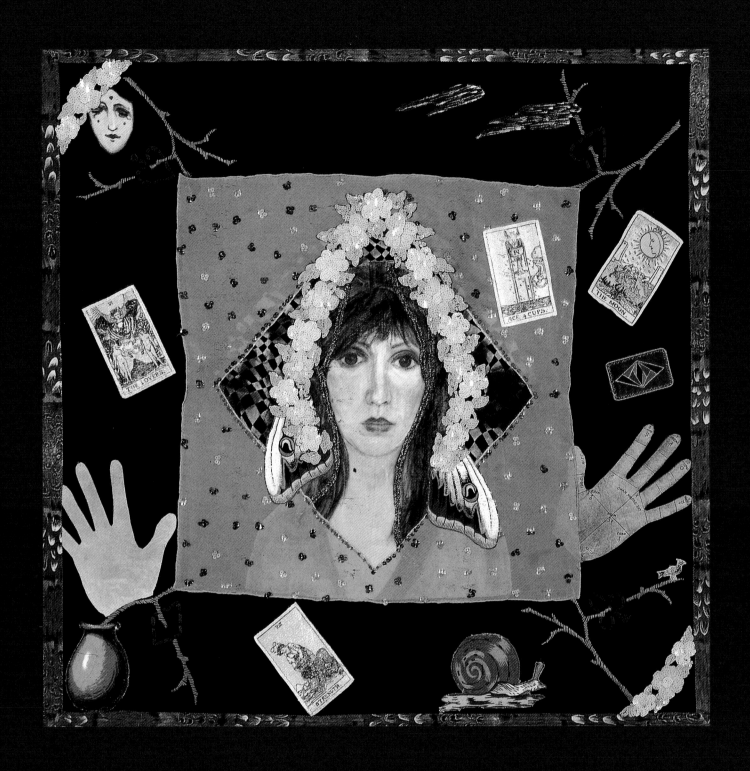

ACE OF CUPS (SELF-PORTRAIT)

37 x 37 INCHES, 1980

VISION QUEST

Life, as the Great Mystery, does not speak to us—at least directly. In every culture, great artists—though they may profess to be as mystified as the rest of us—seem to directly connect with life's creative thrust and reveal its message for all to see and marvel at. As the late Joseph Campbell said, "Who interprets the divinity inherent in nature for us today? Who are our shamans? Who interprets unseen things for us? It is the function of the artist to do this."

Amy Zerner is an artist whose art embodies humanity's great quest for the unknown. By blending together both her artistic and spiritual development, she has created collages that are unquestionably beautiful and rendered with an expert painter's eye for form, color, and composition. However, her works are also a visual representation of the unseen forces that completely surround, connect, and sustain us in our daily lives. When we look at her art, we are looking at her vision of what usually cannot be seen—the divine energies Campbell and the shamans of the societies he studied knew to be the very essence underlying human existence.

Shamans of indigenous cultures around the world all share the continuous process of the search for the "medicine," or that which will heal the wounds we carry and help us to live our lives to the fullest. A shaman must embark upon a vision quest, a sometimes perilous journey, to risk all in the hope of clearly seeing the link between the separate person and the ultimate source of existence. The quester must go through the ordeal alone, passing through the fires of self-examination and self-transformation, and into the darkness of the shadow side to face her own sickness, negativity, and fears. A shaman on a vision quest must make the journey in order to heal herself, if she and her art—her "medicine"—are to be useful to others in their own journeys from suffering to healing.

Amy Zerner's vision quest has taken her to see the invisible world and returned her safely intact. From her search for the understanding of life's mysteries have come deep spiritual insights that find form in her work as archetypal symbolism—images of life, death, and transformation. Each of her collages is a protective doorway, an entryway into the mysterious, higher realms. The power of Amy's art to inspire us, to

literally breathe into us the invisible spirit of hope, allows us to have a new, more positive, vision of our own world.

Although Amy's collages range in size from nine inches to nine feet, size is not at all relevant to the power possessed by them. Viewing her sublime work brings into our lives a quiet passion that seems to renew our hearts, minds, and bodies. Once the sheer and nearly overwhelming beauty of her imagery is penetrated, we realize that what we are seeing are uniquely innovative representations of the unbreakable gossamer links connecting us to the highest imaginable source of guidance, love, and being. Lace collars become thoughts, layers of fabric symbolize the infinite layers of the human spirit, an intricately woven doily becomes a spirit guide, and a dazzling array of shapes, colors, and embellishments become explosions of psychic phenomena.

The pieces in this chapter show the human image harmoniously integrated with imaginative representations of the unseen energies that surround and nurture us. Whether Amy portrays these energies as amorphous, undulating colors, ladders to the divine realms, or vibrant, geometric waves, they add a transcendent dimension to her pieces.

These collages seem to be alive. Some of the figures seem to be receiving and welcoming the vision that surrounds them. Amy, a collector of images of hands (she has a hand-in-a-heart tattoo dating from 1970 on her left forearm), uses them often and to great effect. The strangely tattooed hand reaching up in *Piercing the Veil* seems more powerful than an army of men as it tears its way through all illusion.

Amy's genius for using found objects and recycled materials of all kinds make these collages a most hopeful metaphor. They are symbolic of her belief that we can all successfully meet life's challenges and the grave technological and environmental challenges that face us.

Throughout this book, you will see how Amy's vision quest has led her to find a continually expanding meaning for finding paradise within her and without her. She has produced a body of work that is the map of her very personal journey to the worlds of wonder that are not only images of the possible, but are here right now.

ACE OF CUPS (Self-portrait)
on page 54

The hands in Amy's only fabric self-portrait to date are extended in a way suggesting both greeting and self-protection. A gesture seen in oriental art, it was thought to dispel fear. Her left hand is marked with the delineations of palmistry. The left hand symbolizes that which you have inherited from your parents; here the markings on this hand represent the ancient occult traditions Amy had inherited in her studies. Her right hand is blank, signifying the clean fabric upon which she would reinterpret such occult wisdom and thereby clean off the dirt of centuries of ignorance and confusion, both deliberate and accidental.

Inside the feathered border, the whole image grows plant-like from out of a small jar, impaling the symbols for the four suits of playing cards—diamond, club, heart, and spade—as it penetrates the darkness. Playing cards are descended from the tarot deck, and some of those cards, including the Ace of Cups, float around Amy here. When she made this piece, Amy had nothing but the desire to create her own version of the traditional tarot deck; the opportunity to do so came later, as you will see. Here the Ace of Cups, which is closest to her head, is symbolic of the new level of emotional richness and fulfillment she has attained on her personal vision quest. It is this strength of emotion that prompted her to create a self-portrait.

The snail at the bottom and the two bursts of fire streaking across the upper right of the piece are two extremes—slow and fast—that figure prominently in Amy's life. At the time of her birth, the Sun was in the astrological sign of Aries while the Moon was full in the opposite sign of Libra. Protectively garlanded in the flowers that usually run in profusion through her work, she peers out at us from in front of a chessboard. In her life, striking the balance between quick action and slow deliberation has required the awareness and help of her higher self, which looks upon her from on high.

VISION QUEST

The seeker steps through the gateway between the worlds and embarks on a journey to find the source of her power. Surrounding this gateway is a diamond-shaped border of glowing colors and undulating shapes. A heightened sense of anticipation is in the moving energy about her, but her eyes are shut to this landscape, signifying that her journey is one that leads within.

The borders of this piece are either parallel or at right angles to each other. This alludes to the sacred geometry of the power places found on Earth. For millennia, these places have been known to allow for communication between the different dimensions, shown here as the different patterns existing within their own bordered areas. These space-defining borders are only useful to us in our world of three dimensions; for a seeker on a Vision Quest, the place she must enter is a place of no limits or boundaries.

The guardian angels swirling around the seeker announce her arrival on the other side. They summon all entities there who have something to share with her. Most will protect and guide her on the path she chooses. Others will test her skills, commitment, and courage. Everything is hushed and exalted in this timeless moment as the great pilgrimage that can change destinies begins.

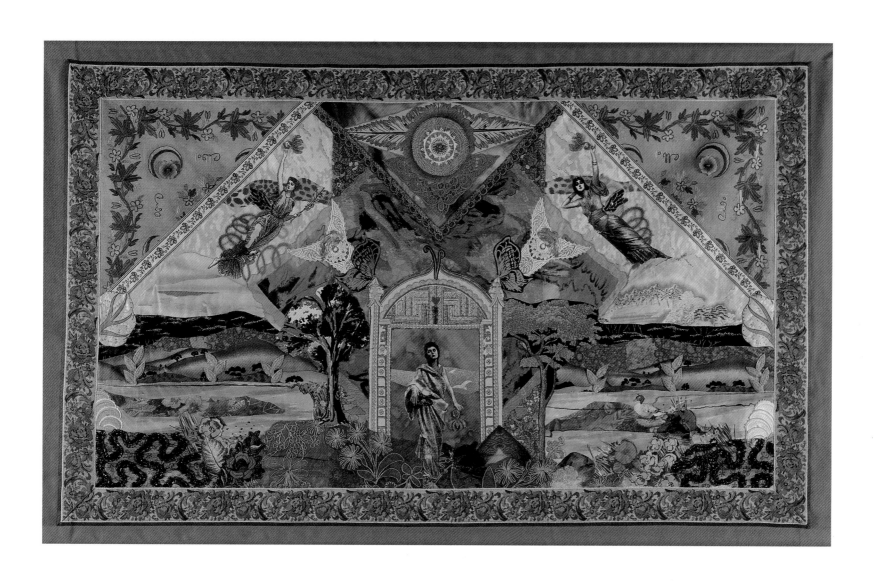

VISION QUEST
74 x 45 inches, 1990

MAYA

The word "Maya" has two very different meanings. It is most common-
ly known as the name of a race of Native Americans who lived in
southern Mexico and Central America. The Mayan civilization is thought
to have reached its height in A.D. 1000. Descendants of these people
remain, as do incredible cities that were abandoned intact and are now
completely overgrown by the jungle.

No one knows for sure why the Mayans left their land of
high step pyramids made of stone. They had built them up over centuries,
one upon the other, until they reached great heights. The pyramids were
constructed with great skill, as were their temples built on platforms, their
palaces, and engraved stone pillars, yet there was no metal found in their
country for the cutting of stone.

Their history recorded that all of their knowledge, which
included a calendar of incredible mathematical sophistication, had been
given to them by their god, who the Maya of the Yucatan peninsula called
Kukulcan, the Plumed Serpent. By other names, such as Quetzalcoatl, this
was the same supreme god of all the peoples of Mesoamerica. One day,
their god had left, promising to return at the end of their calendar's reck-
oning, a date which some believe is within the next twenty-five years.

On the other side of the globe, in India, the Hindus use
"Maya" as the word for "illusion." By this, they mean the illusion of the
separateness of things, when we are all in fact joined at the level of ener-
gy—or, if you prefer, at the level of God. Illusion is most often associated
with our gift of vision, but the two enameled, unblinking eyes staring out
at us from atop the two pillars of this piece surely can see through any
falseness. Perhaps they can even see the return of the Plumed Serpent god
of the Maya.

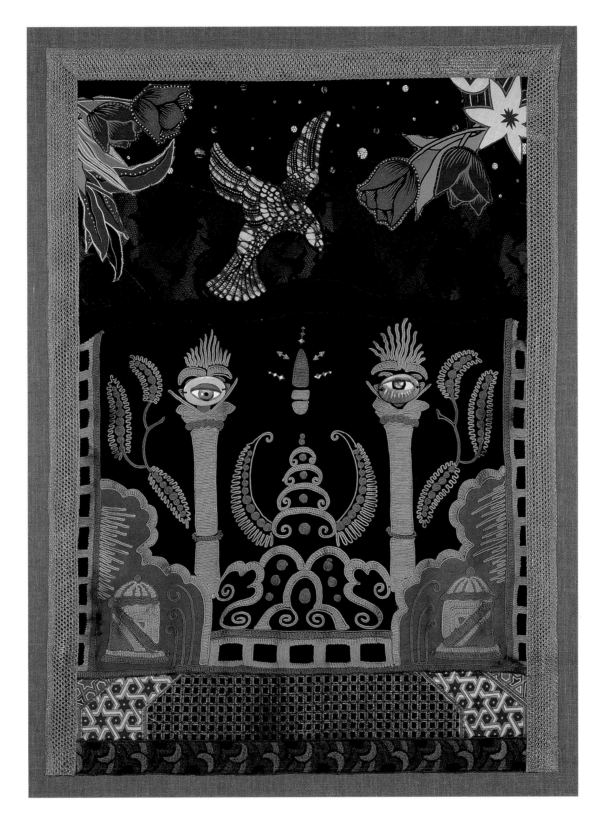

MAYA

29 x 37¹/2 inches, 1982

DANCING WITH THE MOON

This piece evokes the 1920s, the end of the Victorian era, and the beginning of freedom and equality for women after the first World War. A unique blending of a woodland glade with the elegant sophistication of a big city, this surreal rendering of a magic rite performed in Central Park has transformed the whole city into radiant energy. The central figure dances, and a skyscraper is transformed into a pulsing ladder to the Moon, which is dressed in a veil of beaded spider webs. The oriental scene depicted on the Moon's surface is a reminder of a feeling known well to anyone who has dwelled for a time in a large city; anywhere else seems as foreign as the Moon.

A snow white Borzoi is leaping in synchrony with his eccentric ballerina mistress. She holds up her private moon, a reflection of the larger one, to be consecrated in the moonlight. As an artist, she seeks to absorb that liberating feeling of other places, times, and worlds, and to interpret it to her audience as she dances. It is how she celebrates life.

The moon, ancient symbol of Woman, is completely full. An intense awareness prevails and also a feeling of power and completion. But there is more than fantasy here. Ancient as well as modern, the dancer is Diana, the most independent goddess, discovered in private ceremony, rejoicing in her own power.

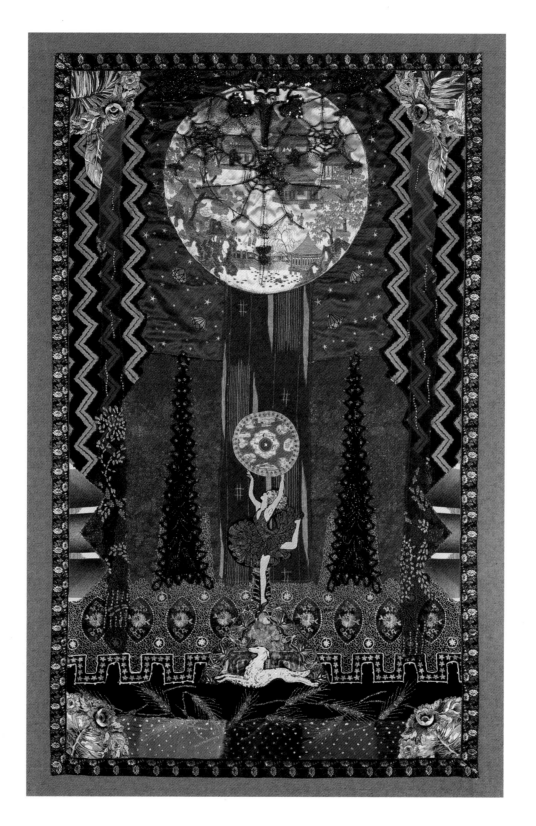

DANCING WITH THE MOON
35 1/2 x 55 inches, 1988

AS IT WAS

This piece is one of three works in a series consisting of the past, the present, and the future. The figure in her ancient headdress represents the distant past. The young woman's arms are open to fully embrace nature and its unending cycles and rhythms that are such an integral part of her existence. High above floats the moon, with which women have always had a special affinity. Upon its surface is a symbolic message of the sort priestesses have always evoked. There is no fear on this woman's face but only acceptance as she listens to the spirit birds that hover above her. The leopard skin, birds' feathers, storm, and lightning show an Earth as yet untamed, but her receptiveness has cleared a pathway of tranquillity. With the aid of her primal instincts she has reached a new level. Crystal drops of rain fall into the purifying water in which she stands, cleansing and renewing her spirit. This daughter of the moon is working with the spirits of nature and seeking affirmations for her steps into an as yet unknown future.

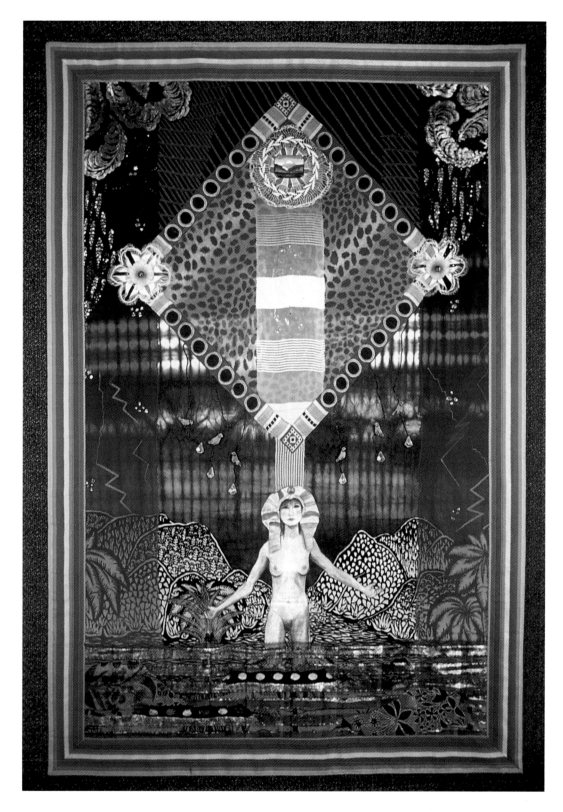

AS IT WAS

3 x 5 FEET, 1985

GUIDE DANCE

There are protective forces around each of us. Most people can recall one seemingly miraculous event where things could have gone horribly wrong, but for some inexplicable reason, did not. Some choose to personify these forces as Spirit Guides and think of them as either departed loved ones from this or other lifetimes, benevolent beings from other dimensions, or angels.

In this piece, we have a veiled scene of mother and child, as seen from the perspective of their Spirit Guides, surrounded with shapes and colors of transcendent beauty and power. While the Guides of the Past and Future look on like two candle flames, the Guide of the Present is making her presence known to her mortal charges, perhaps in the form of a flash of intuition, clarity of thought, emotional comfort, or maybe even as an apparition materializing in their room.

Our view of this scene is through a crystal-ball-like circle, symbol of three dimensional, cyclical life, which is itself surrounded by a series of arching energy fields, the coil that powers the matrix of our reality. The strong right angle that holds them up is divided into units to represent Time, while the intricately worked arch above is curved to symbolize Space.

This is an image that invites you to cast off fear of the unknown and surrender to your subconscious so as to be led into deeper awareness. Here the answers to pressing questions may be discovered unexpectedly, as if given by trusted friends; the Spirit Guides who flicker and dance like candle flames.

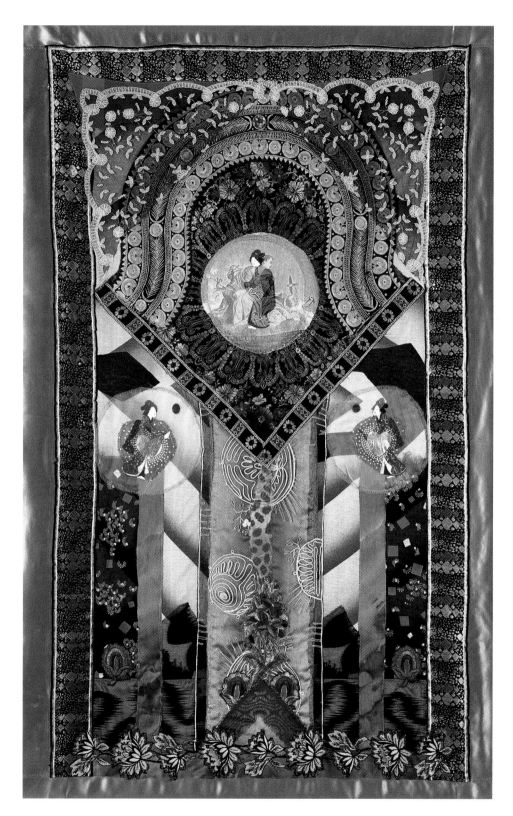

GUIDE DANCE

29 x 44 INCHES, 1987

PIERCING THE VEIL

The immense power possessed by this almost abstract collage bears witness to an image of that which cannot usually be seen. This is that sublime moment when we have penetrated the seeming "otherness" of things. Such mystical occurrences happen beyond time and space and sacred art can reveal them to us.

On an altar deep within the pyramid-roofed sanctuary in another dimension, the hand of a dedicated and accomplished shaman has exploded into view. Covered with markings that illuminate the extent of her knowledge, she receives a transmission of indescribable power from the ever-turning sacred circle. The circle itself is the interface that unites the chamber, the power of the pyramid, and the dimensions that lie beyond the notion of geometry and mathematics in divine union. It can "step down" such power so that it will not harm a mere mortal—even one so well schooled in wisdom. This is the kind of power that can create a solar system . . . or destroy one.

Here is a reminder that on our Vision Quest we may need more than our own efforts to effect this potent access. If power is sought, a higher power must be invoked or our efforts are doomed to failure. Without protection, that intricate lace—a spider web—blurs our focus. All time, the imagery of a lifetime, seems swirled together. In such a moment we are sure to feel the lonely isolation of the self as we find ourself in the midst of the unknown. But we are always connected, even to that which can never be clearly seen, especially in that timeless moment when we feel the meaning of life and our place in the scheme of things.

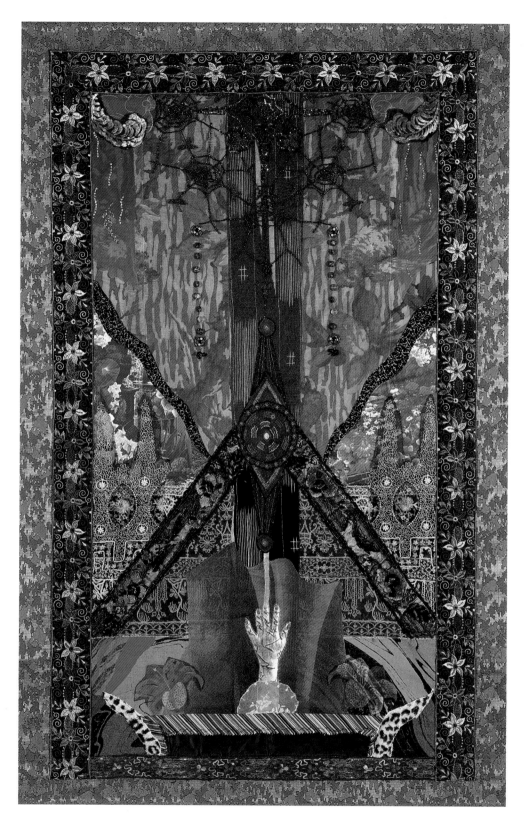

PIERCING THE VEIL

35¹/₂ x 55 inches, 1988

TRANSCEND DANCE

Released from the fuchsia flames of the burning desires that kept it attached to the material world, the giant butterfly, ancient symbol of our psyche and our soul, rises on a vapor of stars and comes to rest securely in a protected place, drinking the nectar of the gods from flowers woven of pure light. At the bottom of the piece, two butterflies who have yet to pass through the flames look on, drawing inspiration from the triumphant scene they have just witnessed. They must feast for a while on the butterfly bush that borders this piece before they are physically strong enough for their coming ordeal of liberation.

Since the most enchanting of butterflies starts out as a lowly caterpillar, they have always been used as an allegory for development towards an ideal. In this piece, we are reminded that our development as human beings is never-ending. These two lesser butterflies have already undergone a long and complicated metamorphosis, much as a skilled and knowledgeable person has already attained much as measured by material standards. All too often, the most successful among us feel a certain emptiness when we have neglected to include the spiritual dimension in our everyday experience. This feeling of lack often leads even the most conventionally trained people on what can easily be seen to be their own Vision Quest.

Everything in this piece seems to be moving upward. Powerful forces and explosions abound, announcing to the universe that one soul's longing for union with the absolute has been fulfilled. Transcendence of all separation and limitation has occurred. A developed being has attained the realization of its inseparable connection to the power of love, truth, and beauty, and come home.

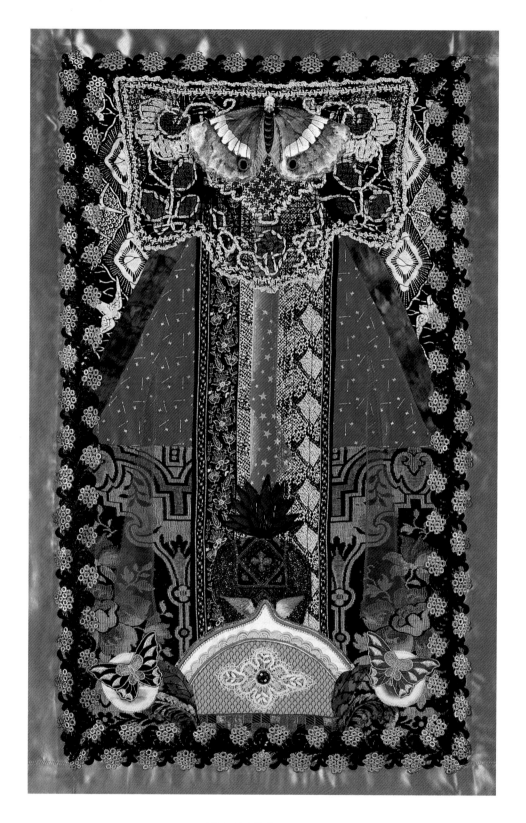

TRANSCEND DANCE
29 x 44 INCHES, 1987

WESTERN MEDICINE

Though seemingly small and insignificant compared to the powerful expanse that lies around them, a faceless man and woman, wearing the robes of shamans, are connected by a medicine wheel, which shows their unity. Bounded by the Earth and Nature, the furs and feathers of past hunts and the struggle to exist, they have climbed together to their power place atop a mountain to commune with the Great Spirit, symbolized by the life-giving presence of the buffalo. The sky stretches over them like a shield. Lightning darts like an arrow on fire, starting flames as it strikes. The Earth shakes. Strange symbols are seen but through the smoke of a ritual fire two phoenix-birds rise, rocketing up from the smoke, transformed.

Behind them an even higher mountain peak is touched with gold and covered with strange lights and mysterious activity. The voices of the ancient ones, the ancestors, are heard. The winds and the elements have been summoned from the Four Directions. Centered and healed, the shamans are one with All-There-Is and are worthy to direct Its power for the good of all.

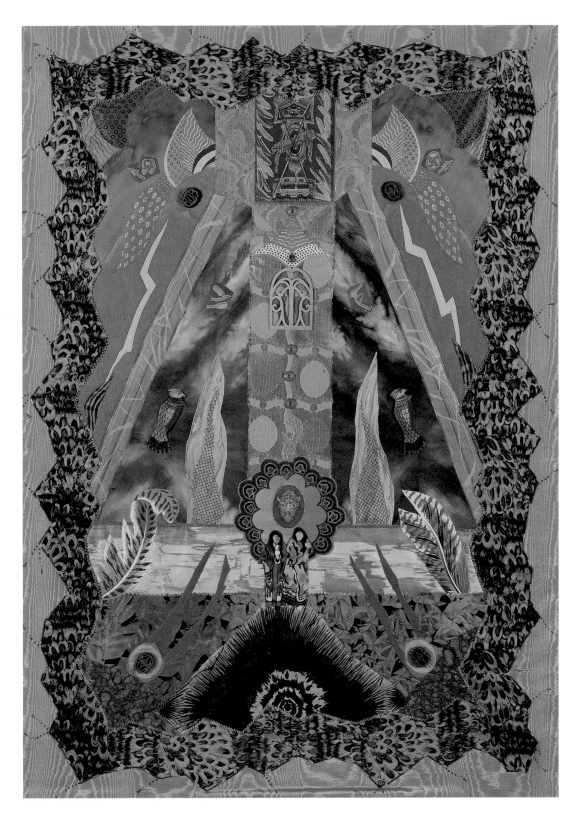

WESTERN MEDICINE

39 x 54 INCHES, 1990

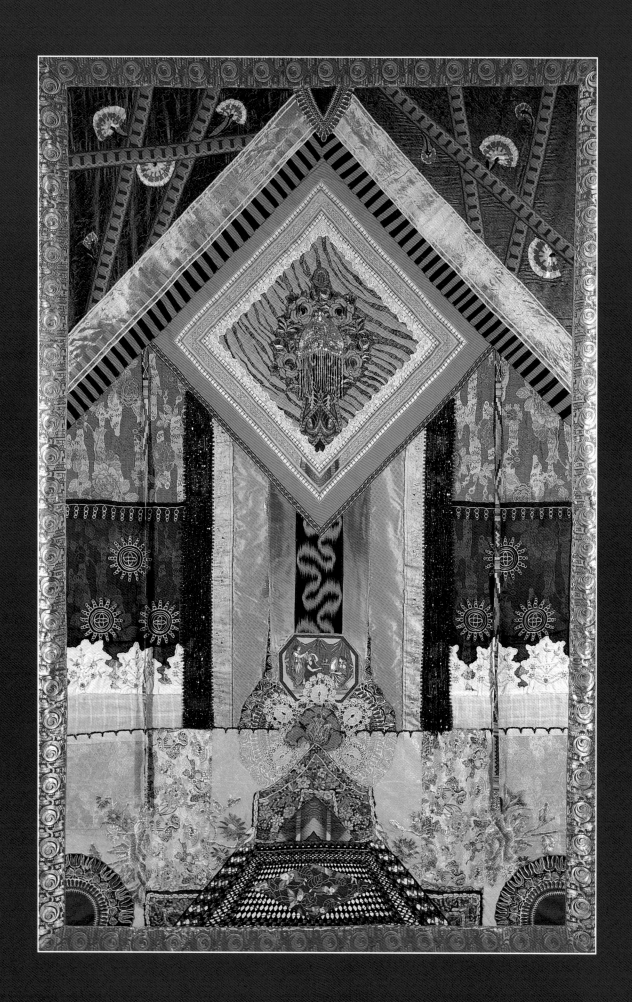

SACRED SPACES

The creation of sacred spaces can easily be seen as an organizing principle underlying Amy Zerner's entire artistic output. Each of her pieces is a transcendentally beautiful temple of wisdom that invites us to come into its space and renew our connection to the sacred.

The word "sacred" is derived from the Latin *sacer,* meaning "untouchable." A sacred space is one where we can feel safe and secure, beyond the reach of any disturbing or distracting outside forces. In a sacred space we can contact the immensely powerful forces—or muses—for the inspiration, motivation, healing, and illumination that are always within us, yet are often buried by the whirlwind of daily life.

It is this reunion with our own powers that gives Amy's work a religious feeling, for the word "religion" is itself derived from the Latin *religare,* meaning "to bind together again." The borders of her collages are like the walls of a temple; they serve as a structure that marks off and announces to all that within lies a sacred space.

Each of the collages in this chapter is nine feet by six feet, mostly horizontal. Five of the pieces were created in 1986, during a kind of sacred space in Amy's career. She was awarded a National Endowment for the Arts Fellowship in the category of painting, the first artist working primarily in fabric to be so honored, and it was an important recognition of the fact that she used her exotic fabrics like paint on a palette. It afforded her the opportunity to create the largest pieces she had ever made. Each is a sacred temple dedicated to the celebration and evocation of the healing powers of one of the five elements of traditional western metaphysical thought: Fire (action), Air (ideas), Water (emotion), Earth (matter), and Ether (spirit).

Individual pieces have their own color palette, for each of the five elements has particular colors associated with its esoteric meaning. Fire is associated with reds, burnt orange, golds, and magenta. Air is associated with the pale blues, white, and cream. Water is turquoise, sea-green, and deep blues. Earth is browns, blacks, olive, and mauves. Ether is associated with white, silver, and all pastel colors. Amy combines these colors with forms and images that are also designed to

make each Sacred Space come alive with the qualities of its element.

Running through the whole series is the temple form, characterized by the vertical columns which serve to divide each piece into three sections. These pillars can be seen to form a threshold between the everyday world outside and the spiritual realm of the sacred space.

The two outer sections create a bridge between our world and the central section. In each of the two outer sections are forms that are still recognizable to us as either representative of each element as it exists in the natural world or as ceremonial objects used to contain and venerate the very essence of the element that is displayed for us in the central section.

As in the architecture of almost all places of spiritual significance, when we arrive at the center of Amy's Sacred Spaces, we find ourselves in the inner sanctum and in the presence of the holy of holies. In *Temple of the Sacred Fire* we can almost feel the heat radiating from the altar where the Eternal Flame of Life itself burns without ceasing. In the airy and expansive central panel of the *Temple of Dreams* flies an archangel, symbolizing our divine capacity to have ideas that take us beyond what we can see and feel. Emanating from the watery heart-of-the-sea altar of *Temple of the Deep* are the ever-evolving life forms of the sea. At the center of *Temple of the Earthborn* is a woman who is a reminder to all that the human body, especially a woman's, is indeed a holy temple and should be treated as such.

Finally, the cats guarding the Tree of Life found at the center of *Temple of Incarnation* look knowingly at the violet vaginal doorway at the tree's base from where all spirits pass on their way to being born.

In the ancient world, it was an accepted custom that, when a person reached a certain level of development, either intellectual, spiritual or financial, that individual would build a temple to proclaim and share his or her good fortune with contemporaries and with the divine forces from whom all blessings flow. In 1987, Amy supervised both my design of and the construction of her large, two-story studio—the "sacred space" in which she works. It has served as the sacred birthing place for her work and the center for all of our activities.

By far, the most important function served by a sacred space is the feeling of being connected to and supported by the overwhelming forces, both physical and metaphysical, that otherwise would seem only capricious and threatening. Take pleasure in viewing all the individual symbols as you experience the many layers of Amy's Sacred Spaces and you will be communicating with these transcendent realms. This is an immensely powerful and important thing to do. To commune with the wisdom of the sacred realms is as essential to us as eating, drinking, breathing, and dreaming—if we are to function fully in the world. Amy's art is a most tangible example of the powerful beauty that is made manifest by that wisdom. Ancient, yet ever-new, it beckons us to the sacred sanctuary found in every loving heart.

TABERNACLE

(on page 74)

A tabernacle is a portable shrine, a place of worship distinguished from a church or temple. While the other pieces of the "Sacred Spaces" series represent fixed sites, this work represents the holiness in every one of the myriad disparate elements of the universe. At any given moment we can feel the inspiration and reverence associated with consecrated houses of worship, often built upon ancient holy sites and, with their carefully thought-out architecture, constructed to inspire.

In this image, in a small window, a woman is seen at her toilette, attended by two other women. Surrounding this prosaic scene is an imposing mixture of chaos and structure on a scale that dwarfs the three human beings. This is the human predicament: we must go about our daily affairs while overwhelmingly powerful forces swirl around us, and somehow bring ourselves into harmony with them. The Sacred Space is here to remind us of the grandeur of the universe in every place and time.

The hard right angles on the diamond shape above the women—a shape reminiscent of a South American "God's Eye"—contain undulating energy fields that seem to give rise to a veiled and helmetted being. This being is in the "holy of holies," the most sacred area of any ancient temple where only the most learned and trusted member of the tribe could enter to hear the oracle of the Great Spirit. Between the two columns flanking the entrance here, a burst of energy seems to rain down on the unsuspecting women. What we are seeing is the inseparable connection between the everyday and the supreme.

The *Tabernacle* is a constant reminder that wherever we are, we are in the presence of the sacred.

TEMPLE OF THE SACRED FIRE

Upon the altar at the heart of this temple burns the Flame of Becoming. Becoming is another way of saying "coming into being," the essence of Fire. It is the explosive spark that signals the arrival of energy from its unmanifest form, potential energy, into manifestation. The purple spark we see at the center of the roaring Flame of Becoming represents the heat and light that accompanies all of creation as it passes from an unmanifest idea into being.

Fire is the essence of creativity, the production of something that has never been before in your experience. In fact, another esoteric meaning of Fire is the desire that burns within us all. Before anything can be created, first must come the desire to see it materialized. The ability to visualize our desires and make them real is one of the basic meanings of spirituality. We become more spiritual the more we realize that the source of all experience is beyond the physical plane. Fire represents the interface between the spiritual and the physical plane.

The ascending, jagged sine waves of brilliant color symbolize the invisible, yet boundless energy that permeates Heaven and Earth, connecting them with a common destiny. In the outer chambers of the temple are burning braziers. On the right, a newly reborn phoenix rises out of the ashes of the flame that has consumed its old body. This symbolizes Fire's ability to transform. The smoke from the brazier that smolders to the left of the altar seems to obscure a ghost-like figure that flies through it. Though we usually think of Fire as producing heat and light, it also produces smoke that can conceal by blocking the light. The ancient sages knew all too well that all the magnificence of creation was Maya, their word for illusion. Did they possess the knowledge of Einstein's theory of relativity and know that on the sub-atomic level everything is all made of the same pure energy?

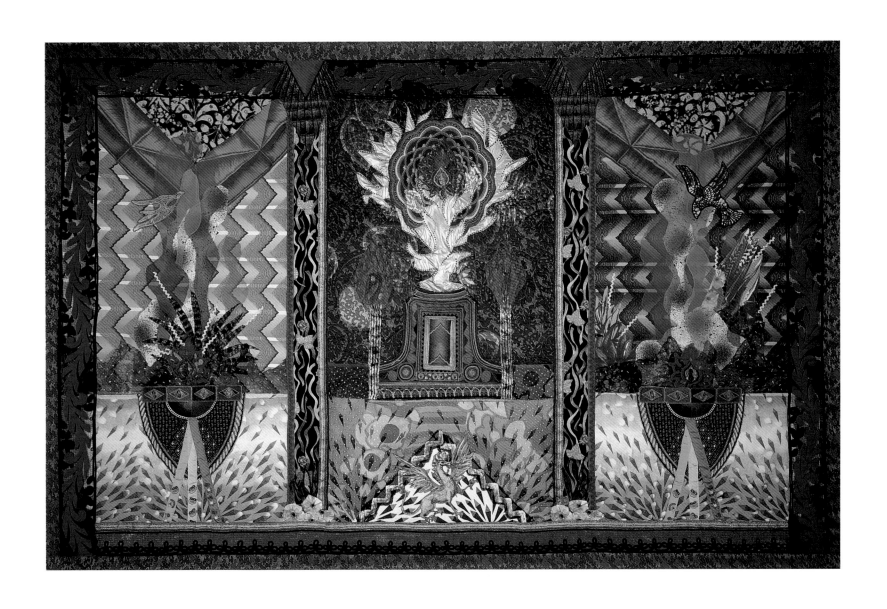

TEMPLE OF THE SACRED FIRE

98 x 65 INCHES, 1986

TEMPLE OF THE DEEP

The ocean of the *Temple of the Deep* is the realm of our emotions. Water is a very suitable symbol for our emotions. If we are unable to keep our heads above water or to be comfortable floating with the current we find ourselves in, we feel out of control. Like an island, we can be cut off from others and all sources of solace if we allow our emotions to isolate us. However, water can connect us with others through empathy, compassion, and psychic phenomena. Love, the great attractive force in the universe, is also a dweller in this temple. At the top of the piece, Neptune looks on his immense watery kingdom and all lovers who are drawn to bodies of water as surely as the oceans are drawn to the Moon.

Tears are also mingled with the waters in the *Temple of the Deep.* They are a sign of deep emotional involvement; they are also cleansing and a sign of release, not weakness. In the martial arts, the highest goal is to emulate water. Water is so strong it cannot be compressed. Through perseverance it can, in time, wear down the mightiest mountains. It moves around what it cannot push aside, while at the same time wearing it away slowly but relentlessly.

The ocean is so deep that light does not penetrate its furthest depths. It is a place inhabited by some of the strangest creatures on our planet, including the seahorse, a species whose male gives birth to the young. Though the waters of a swamp are shallow, they, too, are darkened and bring forth strange forms of life. We cannot deny the existence of either these strange creatures or of our deepest, darkest emotions. All the strange creatures of the planet have their part to play in its evolution. Likewise, our dark emotions can propel us to new understanding and empathy with the plight of others if we remember that the best way to change the world is to change the way we look at it.

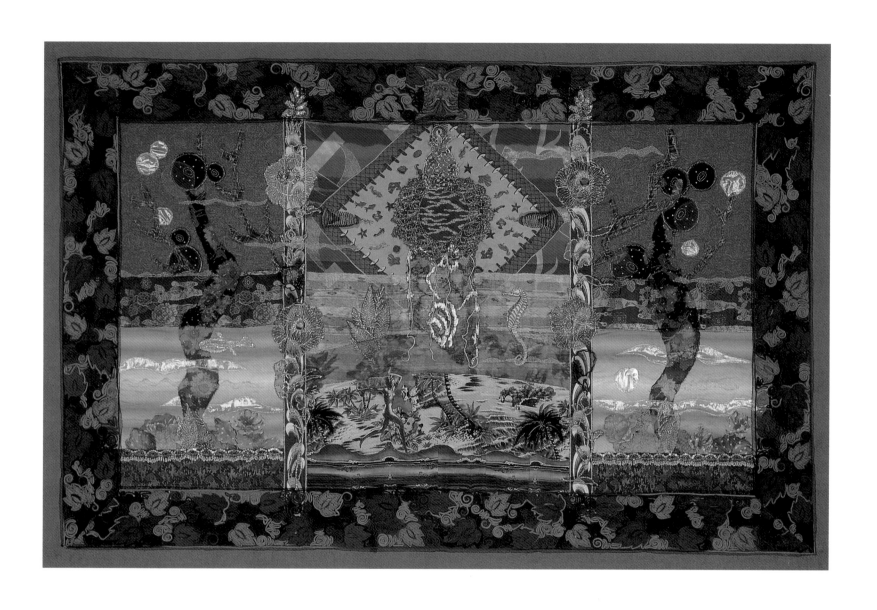

TEMPLE OF THE DEEP

103 X 65 INCHES, 1986

TEMPLE OF THE EARTHBORN

This is the underground grotto where Mother Earth resides, eternally watchful and nurturing to all she has given birth to. She knows there is life even in the rocks and she does her best to help all who are born of the Earth to live their life to the fullest. She knows, too, that we are sisters and brothers to each other, to the animals and plants, and to everything else on Earth and beyond. She wants us to know that we are made from the bounty of elements present in the stars since the creation of our universe. If we forget that we are stewards of her bounty, she will remind us.

The temple is a cave deep inside the planet where the mass of the Earth can absorb any vibrations, negative or positive. Not only does it cancel out the vibrations of the outside world, it generates its own. Here lives the very pulse of life, symbolized in our bodies by the beating of our hearts and in this tapestry by the vertically striped pattern surrounding the central altar, reminicent of the patterns made by genetic testing. Earth is the element of patterns, structure, grids, and matrixes. The shape at the base of the altar is like a protractor, the ruler we use to calculate the angular relationship of lines in space. Since Earth rules structure it also rules mathematics and angles. It even rules the kind of "angles" we all play when we are involved in material concerns, another subject falling under the domain of the *Temple of the Earthborn.*

Scientists have proven that matter is really mostly empty space. Apparently, Mother Nature produces the incredible diversity of the material world through the most skillful use of light and shadow, symbolized by the light-on-dark pattern of leaves to the left of the central room of the temple and the exact same pattern reversed dark-on-light on the right. The breast seen against this pattern emerging from the hill of jewels along with the leaves and flowers symbolizes that we are all fed by the Earth, our Mother in the most literal of terms, a treasure beyond value.

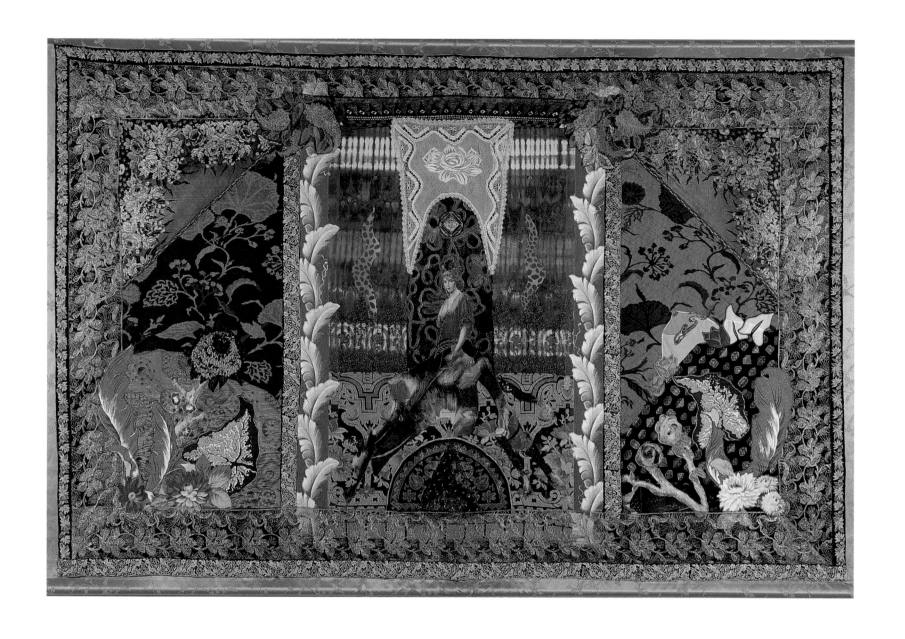

TEMPLE OF THE EARTHBORN
103 X 65 INCHES, 1986

TEMPLE OF DREAMS

Here stands the *Temple of Dreams*, the temple associated with the element of Air. Traditionally, Air has been thought of as representing the realm of ideas—or thoughts, if you prefer. However, as she often does in her art, by attaching the concept of dreams to that of ideas, Amy reveals a timeless truth that has lain buried for centuries: dreams and ideas are two sides of the same coin. They are different expressions of our desire to better understand our life situations.

Though they are usually in response to situations—either actual or potential—are ideas really that dissimilar from dreams? Are ideas not a very useful form of our waking dreams? In dreams, our subconscious mind makes the fullest use of a rich symbolism that we are then challenged to penetrate upon awakening. If we are fortunate, we can associate the symbolism of a dream with a situation in our life and gain remarkable insights; sometimes, even a glimpse of our future. Many of our world's most important art and inventions have come to us this way. Dreams provide us a way of understanding and solving many of life's problems.

At the center of this fabric collage floats an angel, a word derived from the Greek word for messenger. Flying high above a situation gives one the perspective of an angel, which usually involves forgiveness once we are able to fly high enough to see all the factors involved. The airy, dreamlike feeling of this temple symbolizes the fact that ideas can come from any direction. It also suggests that direction itself is merely an idea.

The misty, lofty turrets of the buildings below the angel were once merely ideas in the mind of their architects. They reach to the sky, symbolic of the fact that human achievements are always trying to take us up to the realm of angels. The delicate lace that unites the elements of this piece is like our personality—our idea of ourself that holds our ideas and dreams together.

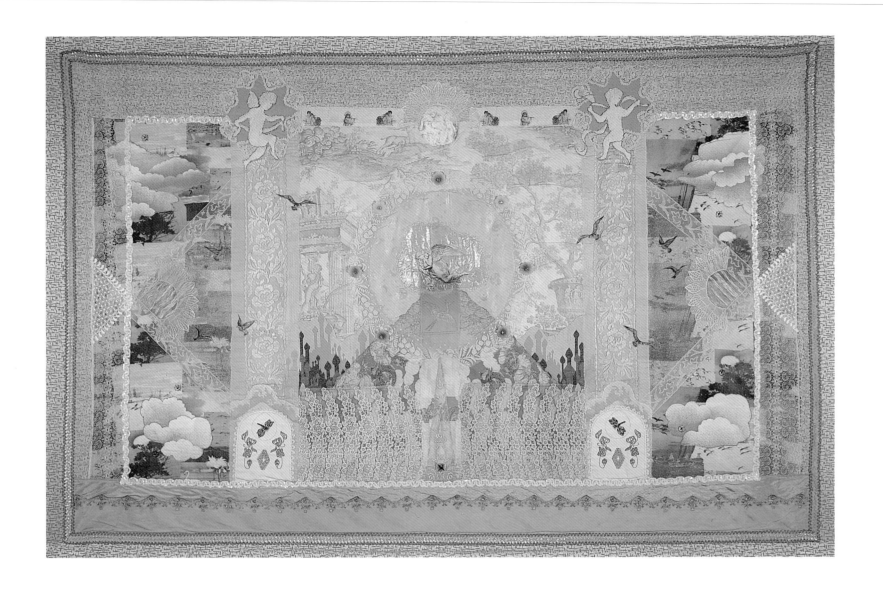

TEMPLE OF DREAMS
98 x 65 INCHES, 1986

TEMPLE OF INCARNATION

The *Temple of Incarnation* is where the Higher Self resides. In all theories of reincarnation, it is here that we are said to choose our parents and make arrangements with other beings to meet "down there" on Earth. Of course, "up there," we know everything is designed to increase our awareness about how infinitely capable we are, but once we are born it is easy to forget and get scared. However, in this temple, far beyond the concerns of day-to-day living, our Higher Self learns more about itself through its inseparable connection to us here on Earth. There are many philosophers who have postulated that our Higher Self, existing beyond Self, may also be in contact with our many incarnations throughout history, past, present, and future.

Here, at the base of the eternally budding Tree of Life, we find a purple cave guarded by two giant cats. The flowers on this tree are in the shape of hands, symbolic of the unseen hands that guide and protect our lives. The cave itself is symbolic of the birth canal that brings us into our incarnation on Earth.

Cats spend nearly all their time sleeping, and these two are symbolic of the dream-time we all come from to be born and go back to after our time is up. In the reality of the *Temple of Incarnation,* our thoughts, desires, and emotions can be seen and sensed. They can even be materialized instantly, if we so desire. Why leave such a pleasant place? I am not sure, but I think it might get a little boring. It's like wanting to increase the skill level of a game you are playing. Incarnated on Earth, the rules are different and much harder. It may be the ultimate game of life and death, for even silly things certainly seem that important to us here on Earth sometimes, until we remind ourselves that few things are—except life and death.

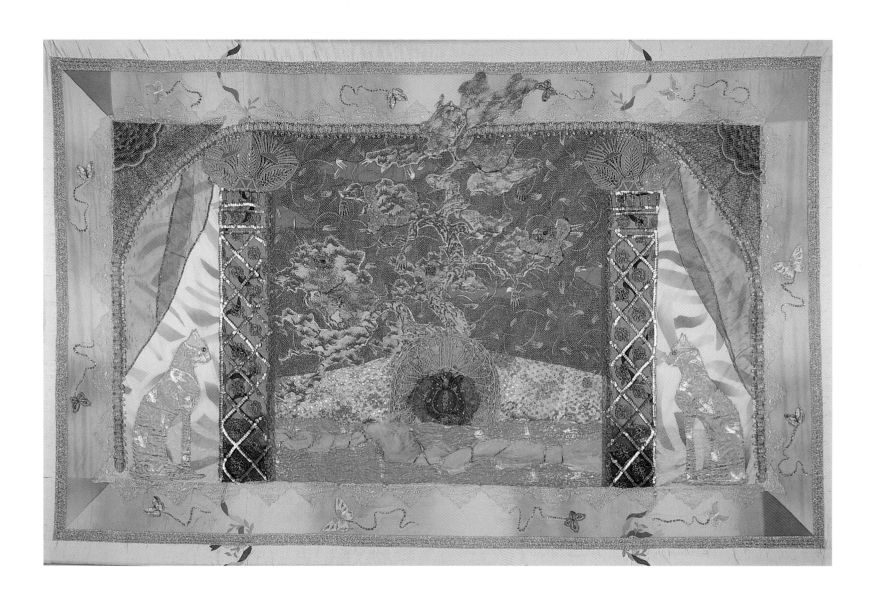

TEMPLE OF INCARNATION
98 X 65 INCHES, 1984

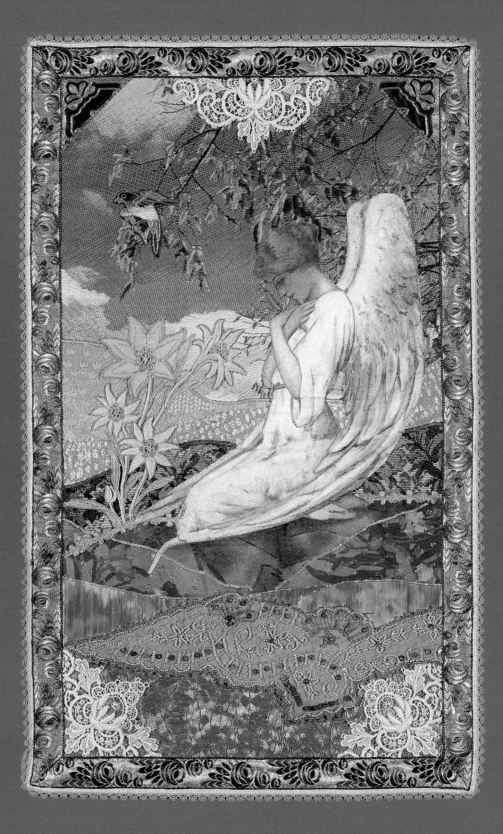

EARTH ANGEL

19 x 28¹/₂ INCHES, 1993

MEDITATION

In "Dreamscapes," we saw how Amy Zerner explores the energies and the significance of the universally shared experience of dreaming. In "Vision Quest," she expands this exploration to the rare waking dream-state of the shaman's quest for self-realization, healing, and personal power. Amy's "Sacred Spaces" provide a consecrated safe haven in the outside world for us to ground both of these sublime states of being in our own daily life. The ideal aesthetic environment of our sacred space is not really an end in itself but rather a necessary prerequisite to a new beginning. It is within our safe haven that we can feel completely secure from outside interference and turn our attention to our inner voice. By sitting still, calming our breath, and watching our thoughts, we soon see the clarity of our real nature emerge. It shines through the haze of distraction and illuminates deeper levels of meaning in our lives. This is meditation.

Every spiritual seeker comes to know that the secret of contentment cannot be gained from achievements in the world but only from finding inner peace. Security, fame, wealth, and even happiness are all transitory at best.

Meditation helps us to stand back and observe, rather than be caught up in, the drama of our lives. Like the creation of art, stilling the mind requires discipline and effort. The ultimate goal of meditation is to establish conscious union with what we consider divine. However, to accomplish this requires relinquishing all goals and thoughts of accomplishment. Meditation challenges us to see through this duality of all opposites and view them as different ways of looking at the same unifying truth. We come to realize that peace begins where our expectations end. This acceptance of things the way they are is not a surrender to overwhelming forces, but is the best way to understand and cope with what we are dealing with at any given moment. The union of opposites occurs in what the ancients knew to be the most sacred, powerful, and most enduring of all the secrets of the great Mystery Schools—symbolism. Every visible object, every thought, and every emotion is symbolic of the invisible, eternal principle that has given rise to it.

Most people think of meditation as a motionless exercise done with eyes closed, to better "see" the symbolism of the higher realms. However,

throughout history, one sacred aspect of artwork was that it could be used as a source of sacred symbolism to hasten our attainment of a contemplative state. Since Amy's art is the flowering of her own meditation-in-action, her art is ideal for viewing while trying to achieve a meditative state.

The unpredictable originality and liveliness of spirit found in Amy's work is the result of her determined, single-minded quest for enlightenment. Her richly intricate, yet balanced collages are possible because she has mastered both her technique and the meditative ability to focus her mind in stillness and relaxed contemplation, and yet to work in the world at the same time. Amy's art possesses its unique vitality because in it she has attained the spontaneity of discipline and the discipline of spontaneity, one of the principle tenets of Zen Buddhism.

Zen is a sound that describes a state wherein being completely immersed in what you are doing at every moment—with no extraneous thoughts of what brought you to be doing it or what will be the result of your efforts—is enough. The goal is to not allow the rational mind—with its insatiable desire to separate, name, count, and manipulate—to get in the way of the direct experience of being. The way of Zen is a powerful counterbalance to the pressures of living in civilization. Once you can get beyond the paradox of having as your goal the absence of having any goals, you are following the way of Zen.

For many centuries, one school of Zen—called *Lin-chi* by the Chinese and *Rinzai* by the Japanese—has been using koans, or paradoxical riddles, as a way of helping a student meditate. By concentrating on the koan, the rational mind twists in the grip of the paradox until it finally quiets itself and a direct experience of awareness is possible. There are many koans, but perhaps the one best known among them is, "What is the sound of one hand clapping?"

All the pieces in this chapter are like visual Zen koans. There is the human being, more rock-like than the rock, while the inanimate objects seem alive with movement. Each figure seems possessed of an intense spiritual activity more active than physical motion. This is symbolic of the unwavering strength and determination we need to reach enlightenment. There is a joy in all the strangely interrelated pieces that make a visceral impact on the sincere observer. The mixture of the quaint with the exotic produces a direct experience of the art that is a challenge to our habitual desire to dissect and classify.

Zen is one of many meditative practices that help us to live each moment fully. All methods of meditation show us that we are not separate from everything else. Zen wants us to *do,* not talk about it, think about it, or read about it. You can read every book written about Zen and never understand it. But if you watched Amy at work, you would come much closer to knowing what Zen is.

Working with no preconceived ideas beyond the most general of themes, she assembles her palette of fabrics, laces, trimmings, ribbons, beads, embroideries, enamels, transfers, and a host of other found objects, and turns them into visions of Paradise. She begins with a collection of fabrics and elements and plays with them until the dream begins to form before her. The image is built up as the different media are

brought together. Different areas are embraced in different ways. Some are painted, while others are alternately lavishly embellished or used to produce a simple contrasting area to that elaboration. Her artistic mastery is that of pure intuition at work, unfettered by awareness of her ego or of any limits. In fact, the pieces you see in this chapter marked a radical departure for her. Her superb eclecticism is revealed by these images which are made of paper. Here her palette includes color laser transfers of fabrics and her normal array of materials, only this time they are often manipulated as to size and color, and even painted again.

Her work expresses the spontaneous and natural movement of a bird or frog, or in the appearance of a rainbow or star. Her collages seem to be always in a perfect state of becoming, which is, by analogy, the condition of the enlightened human being in this world. We can then view the world with new eyes. The world has not changed, but through enlightenment the change is within ourselves. We can, through meditation, acquire an intuitive awareness of the transcendental principle that unites man and woman, woman and flower, man and animal, animal and plant. It is a frame of mind that implies an extraordinary blending of non-attachment on one hand and a feeling of total participation and understanding on the other. That is what the figures in these works are experiencing—the realization of truth though introspection.

UNIVERSE
11 x 10 INCHES, 1992

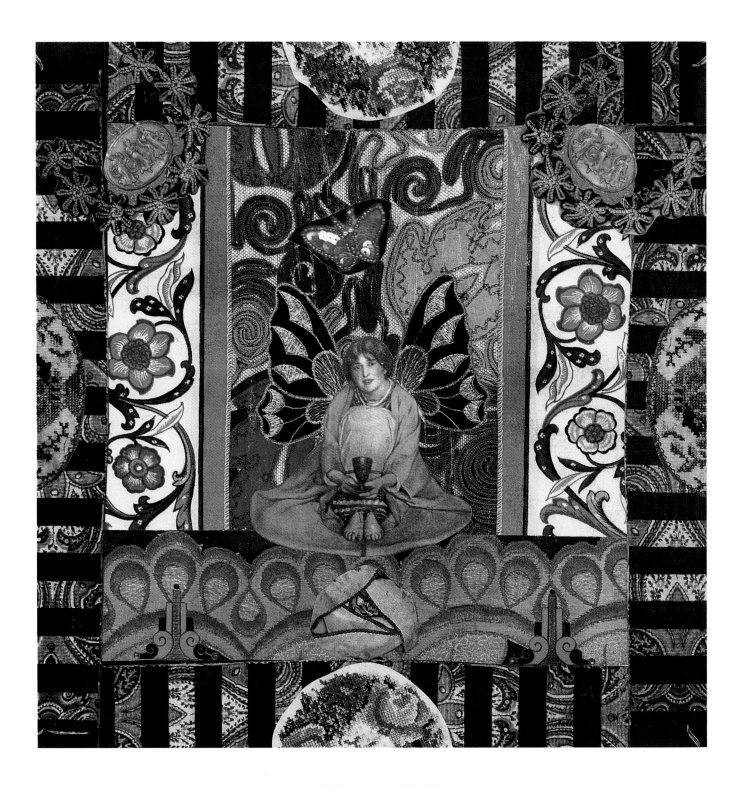

TRANSFERENCE OF HOPE
14¹/₄ x 14¹/₄ INCHES, 1989

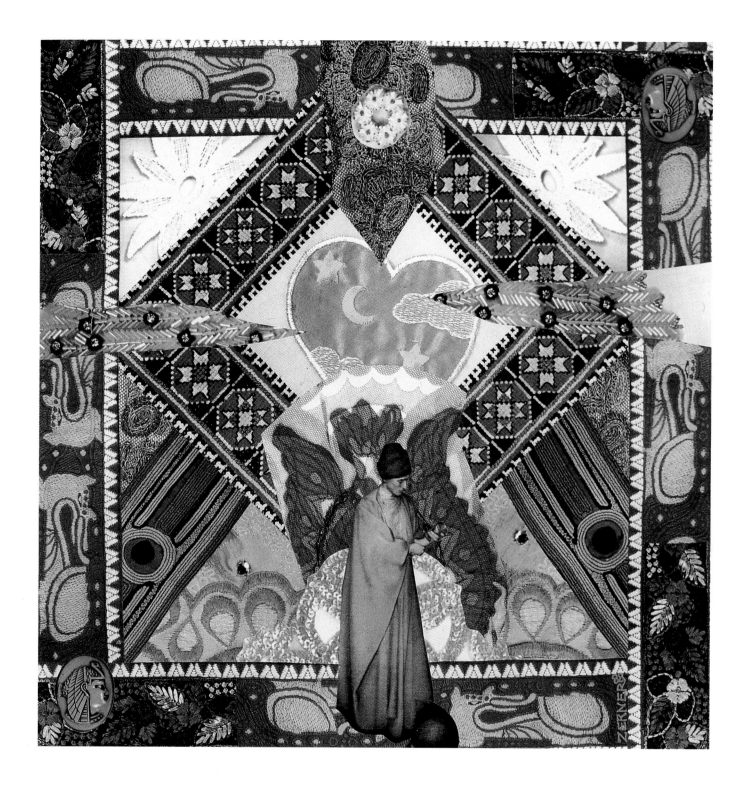

TRANSFERENCE OF LOVE
14¹/4 x 14¹/4 INCHES, 1989

TRANSFERENCE OF WISDOM
14¹/₄ x 14¹/₄ inches, 1989

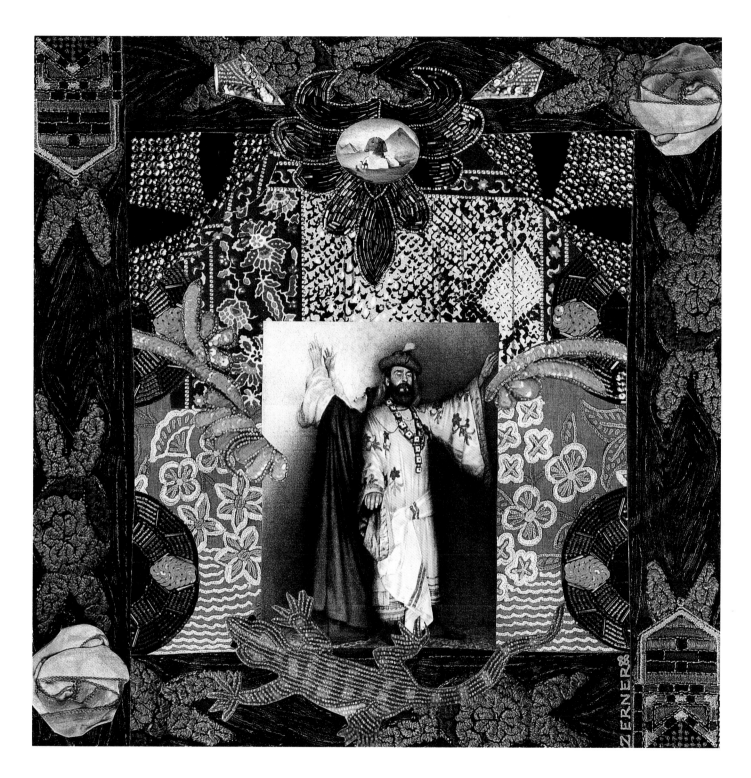

TRANSFERENCE OF POWER
14^1/4 x 14^1/4 INCHES, 1989

BUDDHA

11 x 10 INCHES, 1992

REFLECTION

11 x 10 INCHES, 1992

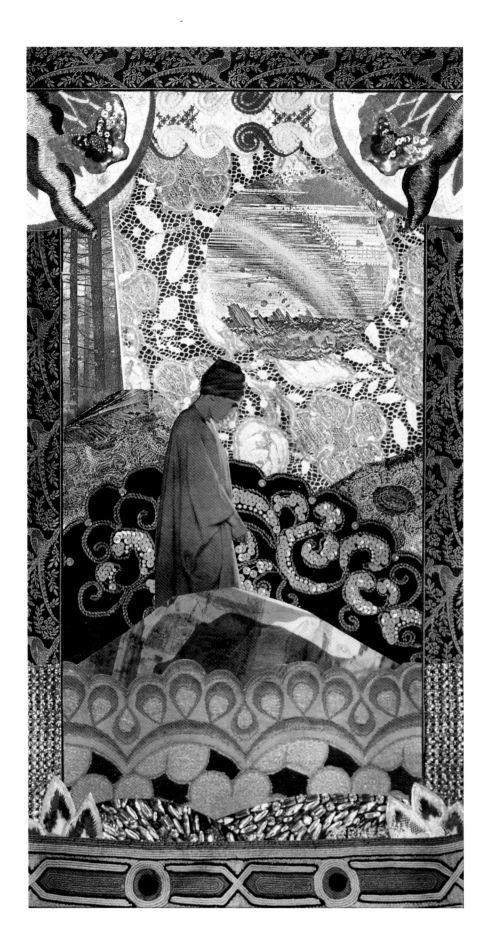

WISHFUL THINKING (HAPPINESS)

11 1/2 x 21 1/2 INCHES, 1989

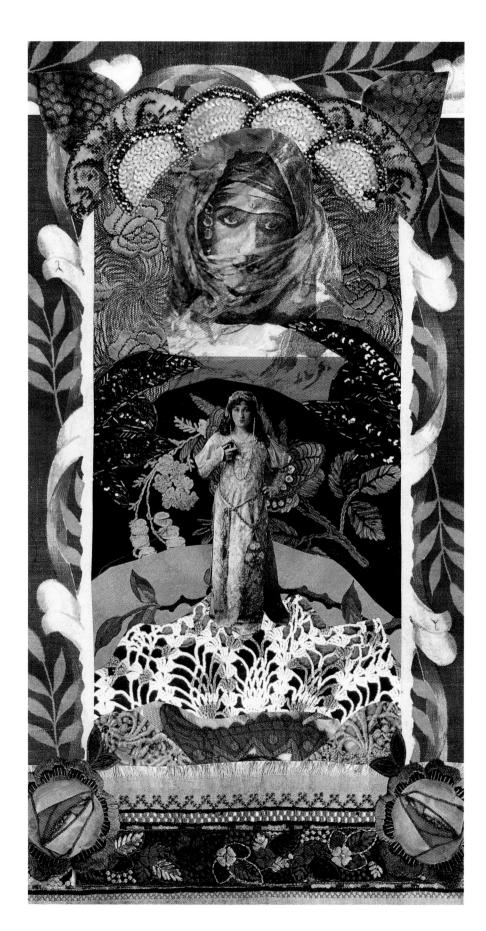

WISHFUL THINKING (BEAUTY)
11¹/2 x 21¹/2 INCHES, 1989

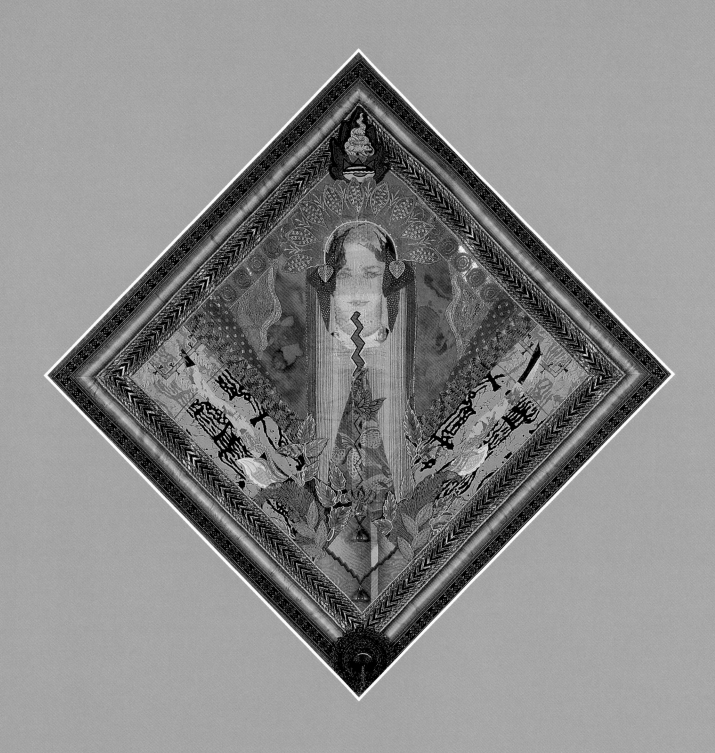

SPELLBOUND

28 x 28 inches, 1989

CHAKRAS

The "Chakra Shields" series marks a continuation along the upward spiral of Amy's artistic and spiritual development. In it, she returns to the personal experience of meditation, but finds within it the most transpersonal of forces—the actual mechanics of the transmission of the life-force itself. When you come to know the meaning of this series you will see how the subject of the chakras is a metaphor for that upward spiral and, in fact, for the evolution of all consciousness.

The word "chakra" is Hindu for "wheel," though the pieces of Amy's "Chakra Shields" series are obviously square. To understand why that is, we must first learn a little bit about the chakras, which for many has been a life's work of patient study and practice.

The chakras are a series of seven centers of psychic energy in our body said to be located along the spinal column from the base of the tailbone to the crown of the head. The chakras are not visible on the physical plane; however, for almost ten thousand years, practitioners of the ancient science of yoga have seen them in their mind's eye during meditation. Chakras are usually visualized as seven spinning, wheel-like vortexes of colored light. Each chakra is associated with increasing levels of consciousness or self-awareness, and has, when opened, the power to heal.

Each of the chakras represents an area of human experience and is associated with a color. The first chakra is at the base of the spine, and is depicted as a fiery red. That is where our powerful animal instinct for self-preservation, our primal life energy—known as kundalini—lies like a coiled serpent waiting to be awakened. Next, the orange second chakra is located at the height of our reproductive organs and is associated with the giving up of our ego through reproduction and creativity. The yellow third chakra is opposite our navel and is connected to our self-assertion as we shape and expand our being in the world. The green fourth chakra is at the level of the heart and is connected to our ability to love and feel the love of others. The fifth chakra is at the throat level and is blue. It is associated with communication, knowledge, and self-expression. The pink sixth chakra is located between the brows at the point where many spiritual teachers say our "third eye" is

located. It serves to connect us to all other beings through holistic thought and psychic communication. Finally, our purple seventh chakra is located at the top of the skull. It links us to the energy of the universe and is connected with our devotion and identification with causes and forces beyond our individual selves.

The progression of the chakras mirrors both our personal evolution and the evolutionary pattern of humanity itself as we try to elevate our thoughts and deeds beyond our primitive instincts and toward greater love, cooperation, and understanding. The chakras are at the heart of the ancient eastern thought that has, in turn, had such a tremendous influence on western thought. The importance of the chakras may even have been known by Jesus. In the Book of Revelation, the disciple John makes reference to the "mystery of the seven stars" and the "seven churches" (Rev. 1:20).

The chakra wheels are usually shown in the traditional art of India as swirling streams of energy flowing outward, like the petals of a lotus. Chakras are considered to be the actual points of interchange for the transfer of the divine to our physical bodies. The seated cross-legged yoga posture most of us are familiar with is called the lotus position because in that traditional pose of meditation, one is said to be able to see in their mind's eye the variously colored "lotus flowers" i.e. the chakras.

During meditation, the energy of the universe is visualized as flowing into the seventh or Crown chakra, located in the cerebrum or brain. This energy is then visualized as flowing down freely to each of the other chakra positions in turn. When all of the chakras are open and flowing freely, the body is healthy and the mind and spirit are in harmony with the universal plan.

Amy's own meditative work with the healing power of the chakras inspired her to interpret them in a new way. These seven non-traditional interpretations came to her in the form of a waking dream meditation on the color and healing properties traditionally associated with each chakra. She intuitively chose to represent them as a series of diamond-shaped shields.

Amy has created these shields and written the accompanying poetry so that the viewer can actually use them meditatively, in order to balance and harmonize their chakras. The symmetry of each of these pieces presents a balanced state that leaves little room for negativity and disease. The transcendent beauty of each piece offers us the invisible yet invulnerable protection of our true oneness with our loving universe.

Each of Amy's "Chakra Shields" is a prayer that we will remember our connection to the unlimited energies that surround us. They inspire us to do the work necessary to keep that connection clear and unbroken as they nurture and beckon us to reach our full potential.

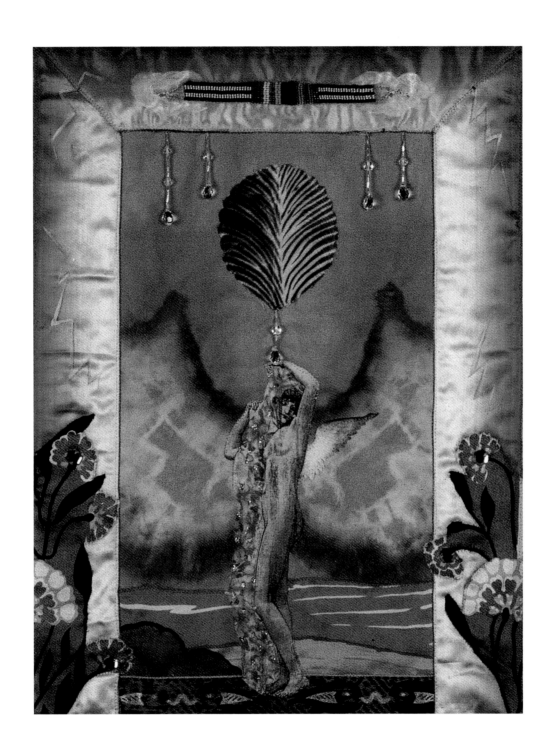

PRAYER FOR CLEANSING
20 x 25 INCHES, 1984

RED

I am vibrant and vital,

aroused with Life Force.

I am passionately physical

and potently animal.

My strength grounds me.

I will survive.

A. Z.

RED CHAKRA SHIELD
23 X 23 INCHES, 1988

ORANGE

I am protected from

anxiety, immune to negativity.

My sense of well-being

radiates Life Energy.

I give and I receive.

I am a transformer.

A. Z.

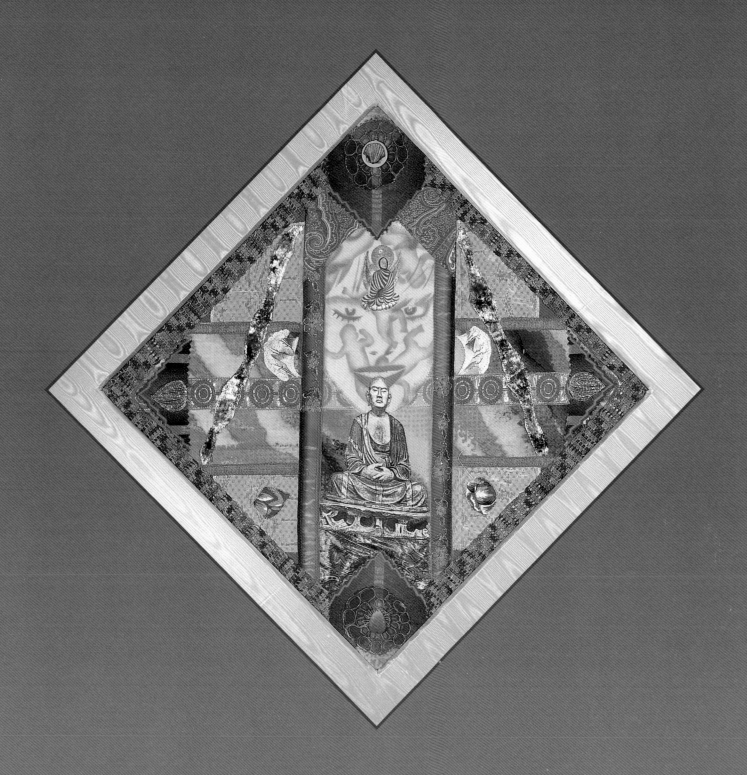

ORANGE CHAKRA SHIELD

23 x 23 INCHES, 1988

YELLOW

I am fulfilled emotionally,

for spiritual wisdom is my gift.

My place in the Universe

is clear and focused.

I accept my power.

<div align="right">A. Z.</div>

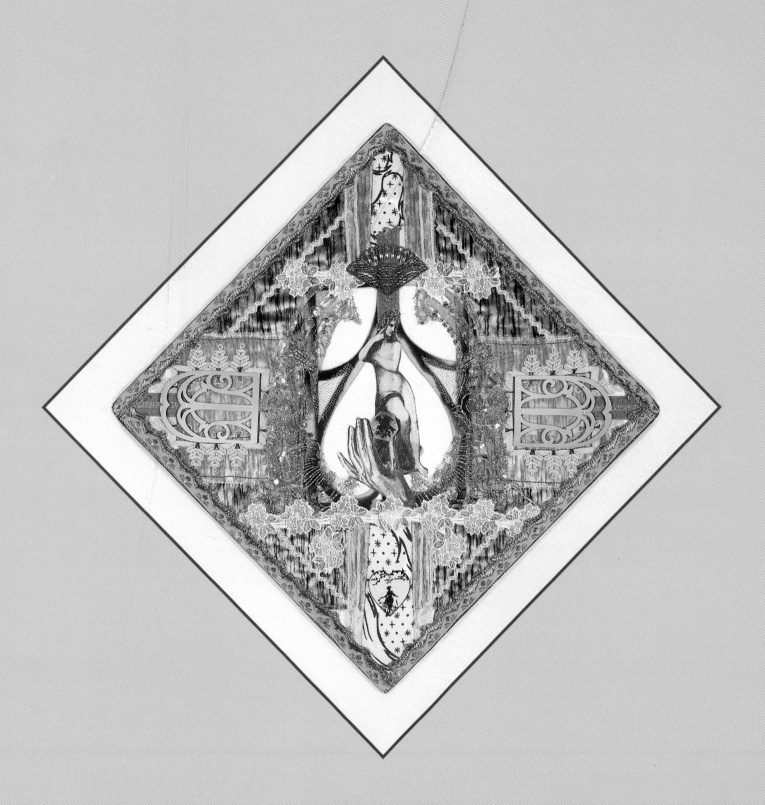

YELLOW CHAKRA SHIELD
23 x 23 INCHES, 1988

GREEN

I soothe and comfort you

because I am the Healer.

Relax now into the balance.

We are all connected

naturally with Grace.

I grow through compassion.

A. Z.

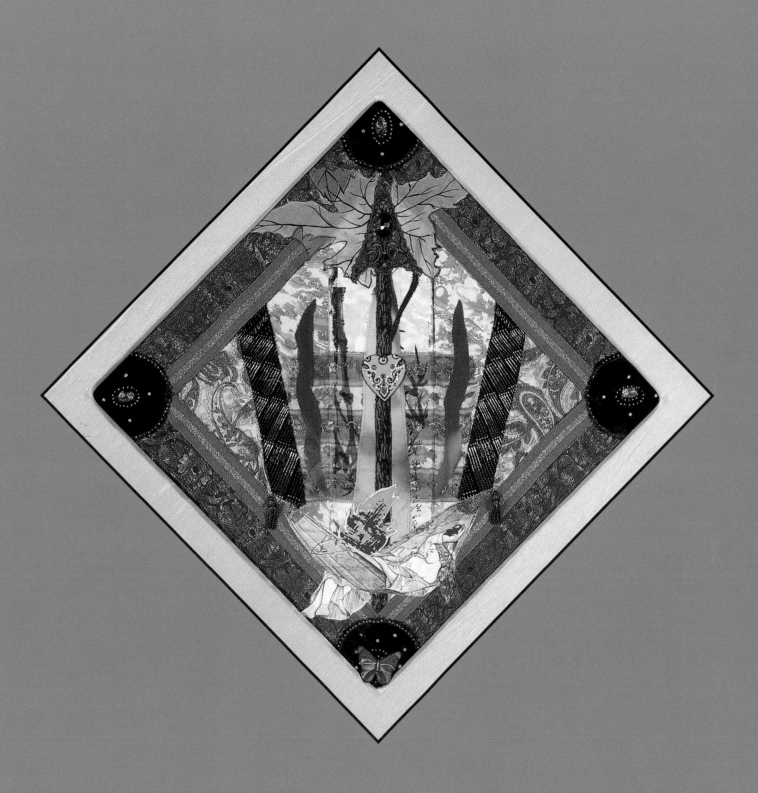

GREEN CHAKRA SHIELD
23 x 23 INCHES, 1988

BLUE

I assimilate, I communicate.

My ideas flow peacefully.

Expressing the Self,

listening, speaking,

the information is inspired.

I reveal my true feelings.

A. Z.

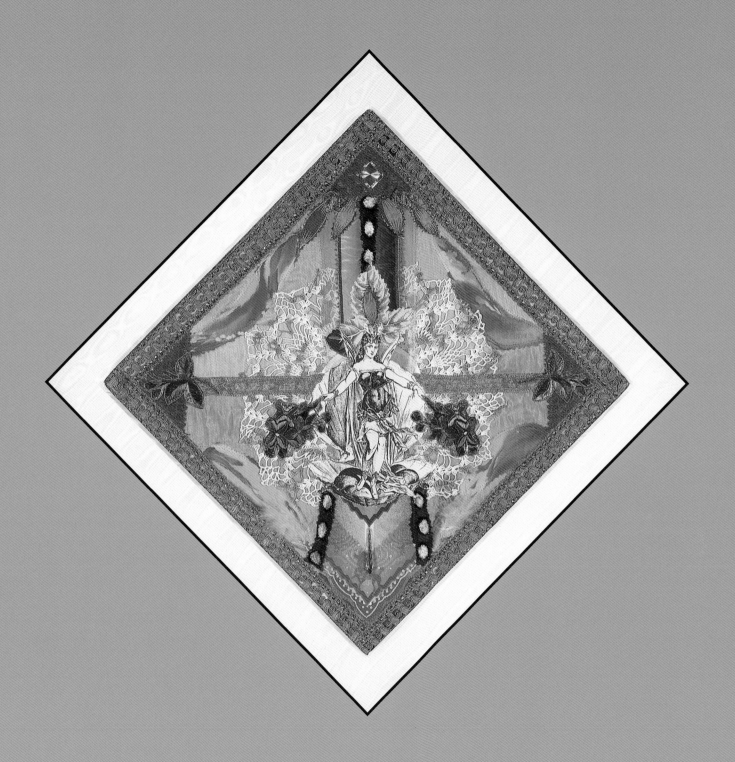

BLUE CHAKRA SHIELD

23 x 23 inches, 1988

PINK

I see your beauty

and your light.

My feelings of love

fill me with great joy

and heal my pain.

I am open to life, love, and union.

A. Z.

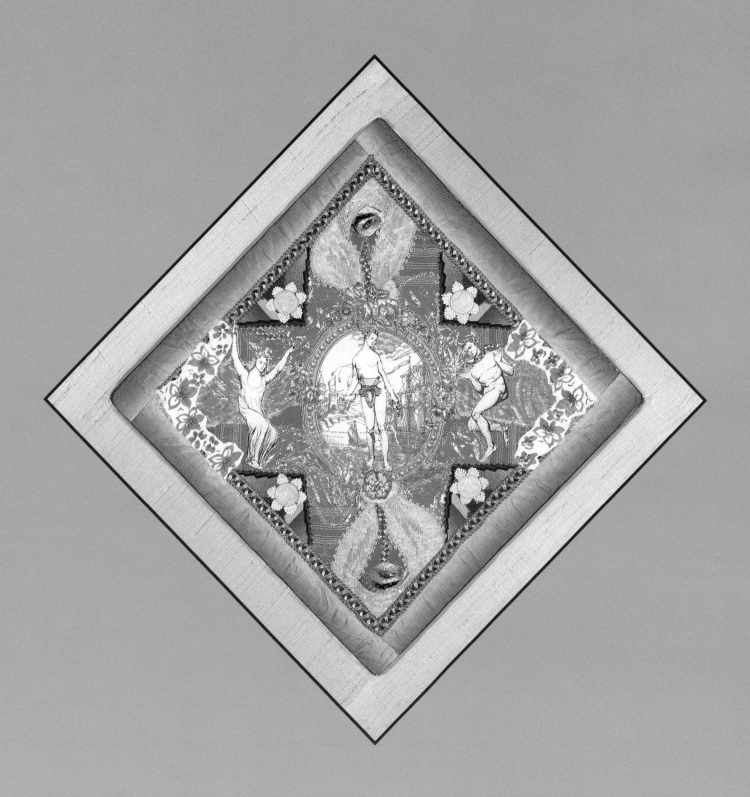

PINK CHAKRA SHIELD

23 x 23 inches, 1988

PURPLE

Faith and Knowingness

unite me with the

Eternal Universe.

With dignity I am crowned.

The Divine is within.

I am connected to Spirit.

A. Z.

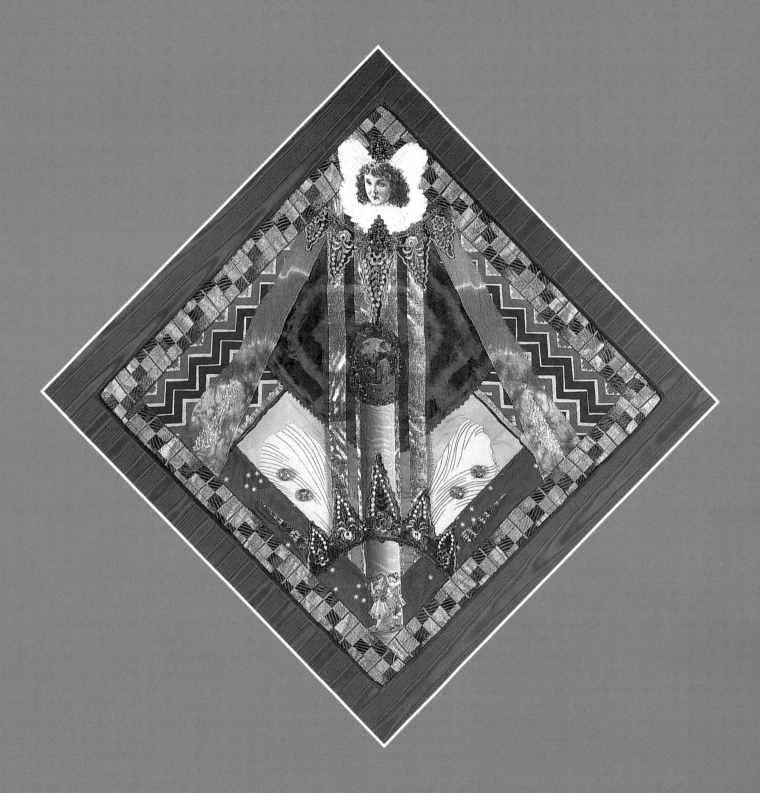

PURPLE CHAKRA SHIELD
23 x 23 inches, 1988

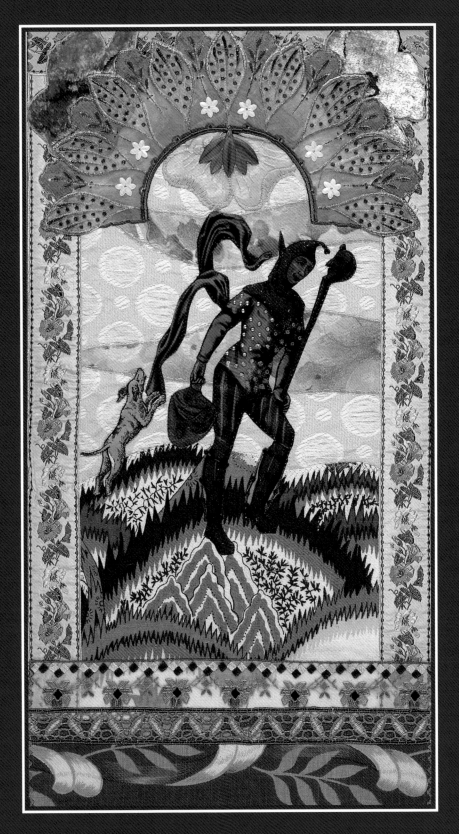

THE FOOL

12 x 24 inches, 1989

THE ENCHANTED TAROT

Since antiquity, artists of great vision—as well as inventors, mystics, seers, and psychics—have devised their own special methods to bridge their wakeful, reasoning consciousness to the intuitive power of their creative subconscious. They have used fervent prayer, chanting, deep breathing, meditation, fasting, introspective isolation, stared into crystal balls and candle flames, danced themselves into trances, or, since at least the twelfth century, used the symbolic art appearing on tarot cards to contact the intuitive world of their inner sight.

Like our dreams, the tarot and all visual arts use symbols to guide us in a way that routinely transcends differences of language and culture. This is why art is the primary way through which we are able to "communicate" with peoples and cultures from the near and distant past. This commonality is reflected in the tarot. The tarot cards—pieces of beauty in and of themselves—are universal archetypes and symbols that have transcended time and distance. Since its introduction into western civilization, the tarot has allowed not just the spiritual adept but any seeker of guidance direct access to the wisdom and power of their Higher Self.

The fabric collages of Amy's "Enchanted Tarot" are a new use of the ancient art of storytelling to tap into this unlimited power source. The tarot is descended from a time when only the privileged few could read. Like the cave paintings made by neolithic tribes to teach their young the physical and spiritual attributes of local animals, the tarot has evolved from the ancient unbound, pasteboard "books" of hand-painted cards used to teach the illiterate populations of India, China, and, later, Europe, the life lessons learned by the wisest of their race. Wisdom was felt to be essential to a successful and harmonious life. Cards were a convenient method for transporting and preserving ancient traditions when religious pilgrimages, economic necessity, wars, and natural disasters made distant and arduous travel essential.

The exact date of the first use of tarot cards for divination is not known. Since the beginning of recorded history, it has been common to consult the oracles of various deities who were legendary for dispensing advice and predictions about the conditions of one's life. Traditionally, oracles have always been used as bridges to help people speak to the magic world they

knew to be beyond the "real" one. Each time we consult an oracle, we go on a Vision Quest; we are finding our vision of the future. We can turn to oracles for wisdom, inspiration, and solace when life becomes too rapid and chaotic. Oracles help us to make poetry out of chaos and to bring light to the self with conscious knowing and participation. The tarot is a kind of oracle.

The images of the tarot do not tell us our "fortune," but are tools for creative decision making. By observing our reactions to the messages and feelings offered to us by oracles we come to better understand our desires, goals, and motivations. We come to see what blocks us and what, in turn, releases us.

Amy Zerner's own study of the tarot inspired her to design her own deck of tarot cards to help us all enter the magical realm of self-awareness. In so doing, she was following in the footsteps of many great artists, most notably Salvador Dali. Amy felt that it was imperative to create a deck whose images radiate life and love, and which manages to evoke the traditional meanings of the cards without the garish, violent pictures that frighten many away from the tarot. In 1988, she began work on what can easily be called a masterpiece, "The Enchanted Tarot." It is an epic series of seventy-eight fabric collages.

A tarot deck is composed of the twenty-two cards of the Major Arcana, or "Greater Secrets," and the fifty-six cards of the Minor Arcana, the "Lesser Secrets." The cards of the Minor Arcana are divided into four suits called Wands, Swords, Hearts and Pentacles. These are associated with the four elements of the ancient esoteric traditions, Fire, Air, Water, and Earth respectively.

The deck is a symbolic representation of the forces that shape our life. The suit of Wands corresponds to the element of Fire, which is associated with action, passion, creativity, enterprise, faith, the season spring and the direction south. The suit of Swords corresponds to the element of Air, which is associated with ideas, communication, truth, justice, struggles, the season fall and the direction east. The suit of Hearts corresponds to the element of Water, which is associated with emotions, moods, dreams, fantasy, romance, the season summer and the direction west. The suit of Pentacles corresponds to the element of Earth, which is associated with material possessions, labor, values, security, the season winter and the direction north. There are four "Royalty" or court cards in each suit, a Princess, Prince, Queen and King, who are symbolic of personality types suitable to the element described by each particular suit.

The cards of the Major Arcana can be viewed as an allegory for the great spiritual quest for self-knowledge and growth taken by each soul as it plays its part in the drama that is life on Earth. The cards of the Minor Arcana represent our everyday affairs. By meditating on the timeless truths embodied in the cards, we can gain insight into the workings of the world and how to best harmonize our activities with it.

Rather than work on one fabric collage at a time, Amy chose to work on the twenty-two images of the Major Arcana first, and then on one complete suit at a time. Her work area lies beneath a cathedral ceiling twenty feet high with a skylight, giving the large, mauve-colored studio the appearance of a temple right out of one of her "Sacred Spaces" series. It was here

that she laid out all of the individual background fabrics for each suit. The creation of one piece brought inspiration for another, and so she would move from one to the other like a bee in a flower garden. In this way she was able to give each suit a look of continuity, and to make sure that all symbolic elements—the human figures, the images, shapes, and colors surrounding them, or the borders—were harmoniously represented.

I had never seen her work so intensely on a project. Nearly every day and night was completely devoted to making sure each piece was true to itself and, at the same time, fit in with the rest of its suit. It was only after she had completed each suit that I would write down the meanings I saw in each piece to "illustrate" her art with my words in the deck's full-color companion book.

The story played out on the miniature stage-sets that are the cards of *The Enchanted Tarot* is one of hope and faith born of the fact that the human spirit is eternally seeking to know itself and its power. When you experience the pieces displayed in this chapter, don't be surprised if fragments of long forgotten dreams come washing over you, bringing you visions of how things were, how they are now, and how they could be in the future. Such wonderful visions are just souvenirs from past trips to the place we never leave, the place where our future is unfolding and our past is, too—the land of our dreams.

THE MOON (Detail)

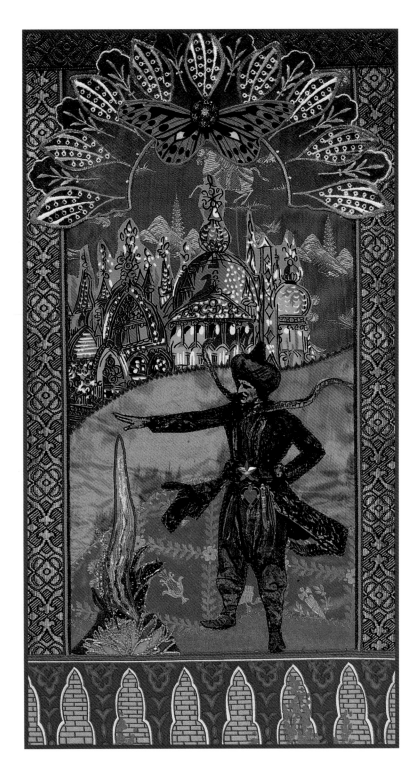

THE MAGICIAN
12 x 24 inches, 1989

THE MAGICIAN 1

A skilled and clever magician performs an occult ritual as energy pours from his extended right hand to erupt into a pillar of living Fire. As Fire can transform what is added to it, this shaman can transform one thing into another: Water into steam, clay into brick, and Fire into ashes. While The Fool symbolizes unconscious knowledge, The Magician is the embodiment of the conscious mind, with its ability to know and manipulate the physical world. Like The Fool, The Magician also wears a pointed hat, the apex of which alludes to the human ability to draw down cosmic forces. But The Magician's hat is swathed in layers of rich fabric, just as the pure energy of a human being is wrapped in layers of flesh and blood, as well as thought and emotion. On his belt The Magician wears a Pentacle, a Heart, a Sword and a Wand as tokens of his mastery over the four elements, Earth, Water, Air, and Fire. Behind him is his heavenly city, symbol of the divine origin of desires made manifest on Earth through the power of thought. The Magician is the mediator between these two worlds. With initiative and cunning, he decides which ideas will be made real.

THE HIGH PRIESTESS 2

Under a star-spangled sky, The High Priestess of the Moon stands at the entrance of her sacred temple grotto. Passive and quiet, she represents a vessel of memory and holy female wisdom. Her powers are so great that they are almost beyond actions, and the griffin at her feet senses her desires and goes to obey her. Her timeless secrets are communicated to us through an inner voice, or intuition, and only those wise enough to retreat into silence will know them. Above her, perched on a crescent moon, sits an owl sacred to Athena, goddess of wisdom. The crown of The High Priestess evokes the waxing and waning moon and the natural rhythms of the female cycle. Her filmy veils and the water at her feet are symbols of the mysterious female energy that many men profess not to understand. The High Priestess effortlessly directs her psychic ability in harmony with the desires of the universe that is her child. Her hands are hidden behind the energy centers at the base of her spine and atop her head, to signify that true power comes from the use of individual spiritual energies and is available to all.

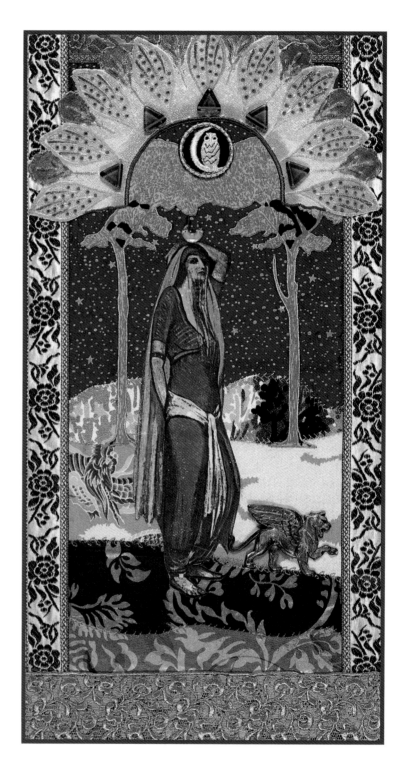

THE HIGH PRIESTESS
12 x 24 INCHES, 1989

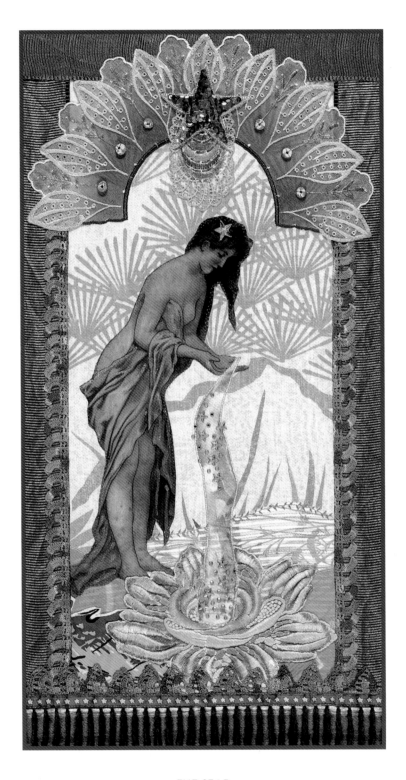

THE STAR
12 x 24 INCHES, 1989

THE STAR 17

There is peace after a storm. A star of hope and wonder shines in the heavens, promising spiritual illumination and inspiration. Below, with one foot on the land and the other poised magically on the surface of the stream of the unconscious, a nearly-naked maiden stands entranced. She is joyously receiving the waters of the pond, which rise up to her from an enchanted water lily while she pours an endless shower of stars from her two cupped hands, back into the flower. She shows that as heaven nourishes the earthly universe, the beauty of the physical world nourishes heaven. The star in her hair is truly a star upon which to wish for little miracles, with the guilelessness of a child. The response will be love, beauty, peace, and help of all kinds. In the realm of The Star all is fresh and new, all is innocence. The maiden's language is poetry and art as she is in perfect accord with her spiritual gift. The Star is a reminder that after the storm of life's upheavals, there is a cleansing and purifying time when a sense of wonder heralds the new belief that dreams can come true.

THE MOON 18

Under a waning Moon, in a dark and eerie land-scape, a lost child stands with her faithful dog. She gazes up at the Moon in fear, remembering terrifying stories of a Moon Witch who can play cruel tricks on those lost in the night. She raises her hands as if in prayer and hopes that she will be saved and guided through this nightmare. Across a moat of turgid water, inhabited perhaps by fearsome things, she suddenly sees the turrets of her castle home. But the drawbridge is up, the gates are locked and no one seems to hear her cries. Has the Moon Witch's magic barred her way home? Just as the child is about to succumb to overwhelming feelings of despair, danger, and the sadness born of longing for home and family, the Moon beams out more strongly from behind the clouds and suddenly appears warm and pensive. She is crying because she has been so wrongly thought a malicious Moon Witch. Tears from this pale-faced goddess fall into the water and suddenly the land swells up higher than the moat and the gate surrounding the castle. The child clearly sees the way home as she gives thanks to the Moon.

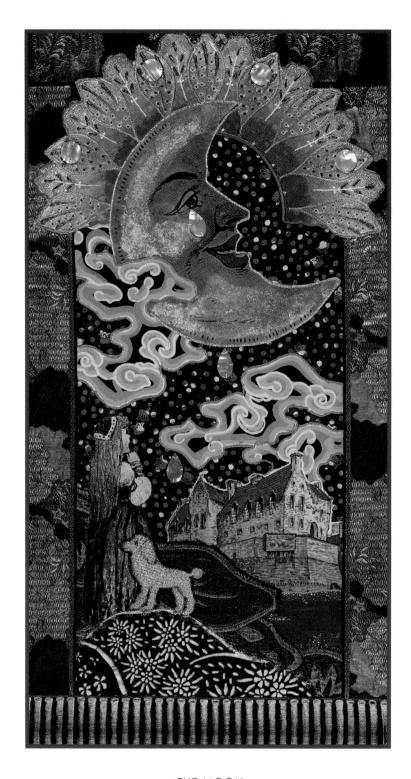

THE MOON
12 x 24 INCHES, 1989

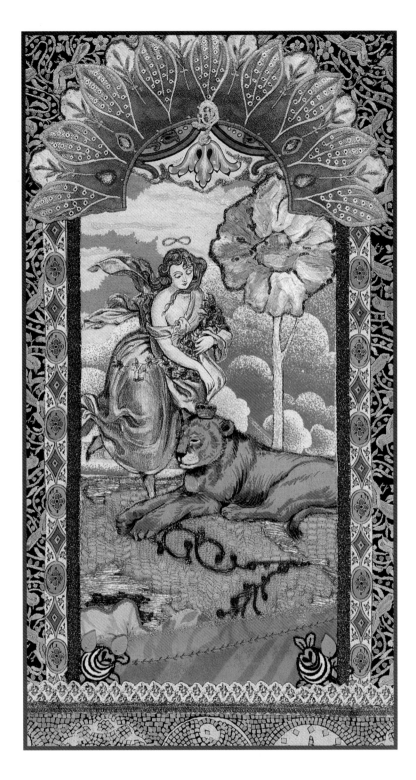

STRENGTH

12 x 24 INCHES, 1989

STRENGTH 8

A beautiful young princess has entered through a leafy portal into the garden in which she played as a child. Nature has held sway and now the untended garden has become overgrown. Its weeds and flowers are still beautiful, however, and she gathers both to make a harmonious bouquet. She suddenly encounters a great lioness whose paw has been caught by the tangled thorns of a rose bush that was once the pride of the garden. The fearsome animal roars loudly but the courageous young woman is not afraid. She frees the lioness and guides her with gentle control until the beast lies prostrate at her feet. The princess knows that "The beast knows your heart's thought." She has tamed the animal's wild nature with her spiritual touch. She had no need of physical strength; by love she has conquered. The crown on the lioness signifies that she is the Queen of Beasts, and this brave, young princess is now Queen of Strength, with the sign for "infinity" crowning her highest energy center. By conquering the natural fears of her own bestial nature she has harnessed the infinite power of her spirit.

THE CHARIOT 7

Carrying the spoils of war, a warrior maiden, Brunhilde, triumphantly wins the race. The horns of her reindeer steed and the shield behind her symbolize the aggressive qualities that have brought her this victory. With her robust physique and stern resolve, she has harnessed not only her own considerable energies but also those of Nature. Self-assurance and bravado have helped her in her headlong race against formidable opposition. By suppressing all feeling and emotion, she has held onto the reins and gone forward from barren fields into green and flowering ones. The qualities that have enabled her to succeed will not always be of value in all circumstances. She must enjoy this moment of glory with the knowledge that it, like other such moments and heroines, will pass. Beneath her is a chariot symbolically rendered very small by her total conquest.

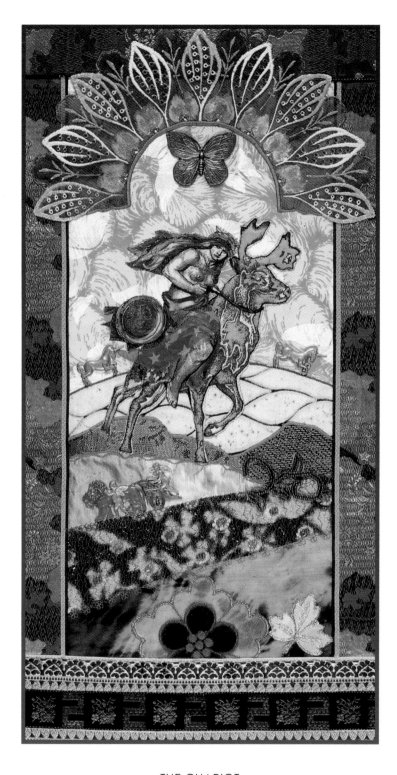

THE CHARIOT
12 x 24 INCHES, 1989

THE HANGED MAN
12 x 24 INCHES, 1989

THE HANGED MAN 12

Under a calm, blue sky and above the radiant, flowering Earth, a man hangs upside down, suspended by one foot from the tail of a dragonfly. The dragonfly emphasizes that this scene is not one of torture, but a part of a natural process. The young man's life is in limbo but his face shows only acceptance and absolute faith at this moment of total surrender to a higher power. He seems to be listening to an inner voice. He may be looking for an answer that is completely opposite to all he previously believed. Perhaps he has deliberately sacrificed himself to attain some desired goal. He could be in a trance, or in a state of illumination as a result of the increased blood flowing to his head. It does appear, however, that the pattern of his everyday life has been reversed to provide a new outlook. The water flowing beneath him symbolizes that the young man has risen above emotional turmoil to accept this suspension of his usual way of life. The enforced period of waiting may be viewed as a way of gaining a new perspective.

JUSTICE 11

With a face possessing the innocence of youth, and the wisdom of years, a winged messenger bears the ultimate truth. Her heart-tipped, star-encrusted spear—a mixture of the Heart, Pentacle, Wand, and Sword of the Minor Arcana—will cut through the outer layer of obscuring veils to reveal the simple truth, hidden at the core. This bright blade will mete out a deserved punishment, or protect and defend valid beliefs. The scales held in the angel's right hand are used to weigh all factors to find the balance between truth and justice. The angel of Justice is *not* blind but does sees all the sides of any given question. Beyond this impartial angel, a pink sky indicates the dawn of a new day that will reveal even higher moral values. Justice is implacable; in the search for truth, Justice will always prevail. The angel stands on a huge leaf, symbolizing the natural, ordered calm that Justice brings to a world of apparent chaos. Without her, no kingdom can long endure.

JUSTICE
12 x 24 INCHES, 1989

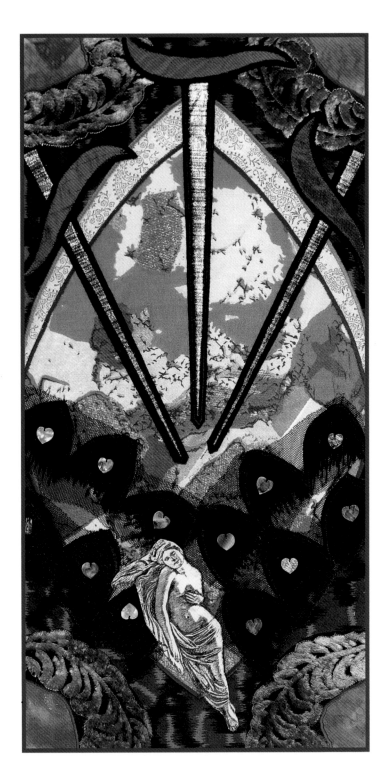

THREE OF SWORDS: "SORROW"

Outside this cave of sorrow and loneliness, darkening clouds scud across the sky of a cold fall day. Under an inverted triangle of swords, a half-naked figure slides into a deep crevasse. Wounded hearts are enveloped by tearful black shapes that threaten to unite and engulf the scene. This triangle of swords has brought grief to the dream. Has a lover taken flight, perhaps with another, leaving the pain of loss, absence and the inevitable mourning for what might have been? The swords are pointed at the figure's bared breast as the ground beneath her rocks unsteadily. Filled with self-pity and jealousy, where can she turn? She has been idealizing a person or a situation and now the reality has led to this current disappointment. Life seems to be meaningless. Life can and must go on, however, and this inner pain must be endured as one lesson in a life of learning.

THREE OF SWORDS "SORROW"
12 x 24 INCHES, 1989

NINE OF SWORDS:
"NIGHTMARE"

In the night, a sleeping figure lies trapped in a dark, nightmare world existing on the edge of sleep. Strange demons, repressed hurts and childhood fears range freely. Worse than the sight of this chaos is the feeling of being in its grasp. Unclear forms alter shape, and circle in ever-stranger and more fearsome forms. This is a lonesome place, far from help and comfort. Shadows of pain, suffering, and depression overwhelm the sleeper until she becomes a victim of her own thoughts and, like a martyr, repeatedly impales herself on their hurtful points. Her eyes are closed because she cannot bear to look at these fears when she is awake. The only way she can escape from these nightmares, however, is to open her eyes and awaken to what is really bothering her. She must confront it in broad daylight, no matter that there may be reputations lost, false friends discovered, or the most unpleasant of feelings set loose. The alternative is torment.

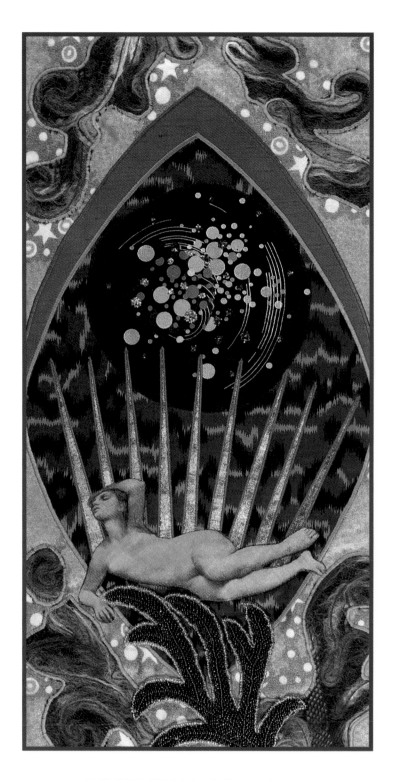

NINE OF SWORDS "NIGHTMARE"
12 x 24 INCHES, 1989

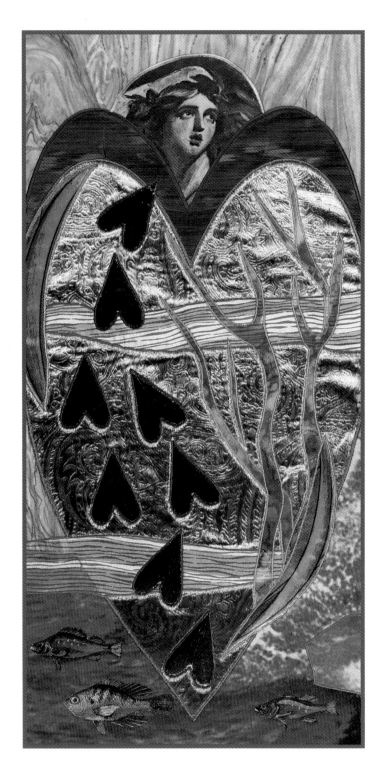

EIGHT OF HEARTS: "SACRIFICE"

A melancholy woman cries eight heart-shaped, ice-rimmed tears which fall, like dried leaves, into the frigid stream below. Her sacrifice has been in vain, and she is drained of all energy. This is a tale of love and devotion that has been denied and now serves no purpose. The fish swimming in the freezing water below symbolize deep emotion, but emotion that threatens to overwhelm, and possibly even immobilize. To have given so much, uselessly, has rendered the woman as bereft of hope as the barren branches growing through the central heart. Like the illusion produced by winter snows, here it seems that life has been smothered forever and she cannot possibly endure in such a wasteland. Gone is the inspiration that moved her to the supreme proof of loyalty; to put another's benefit before her own. As the extent and implications of her folly are revealed, she stands momentarily frozen in her tracks, but as spring flowers are watered by winter snows, so will her tears nourish a wiser use of her devotional energies in the future.

EIGHT OF HEARTS "SACRIFICE"
12 x 24 INCHES, 1989

EIGHT OF PENTACLES: "CRAFTSMANSHIP"

A strong, young figure stands by a well-constructed wall of her own making. The wall has been built brick-by-brick, with great attention to detail and a persistent productivity. She proudly views the results of her work with an expression of serenity, knowing that she has done her very best. She is obviously a disciplined worker, well-prepared and efficient. Her feet are planted firmly upon the ground. There is a feeling of centeredness and order about her. The flowers in full bloom above her head are both the blossoming of her productivity and its reward. This harvest follows order, not chaos, trust, not control. The skilled young woman is careful and methodical in performance and naturally intuitive in everything she does. She is the embodiment of craftsmanship.

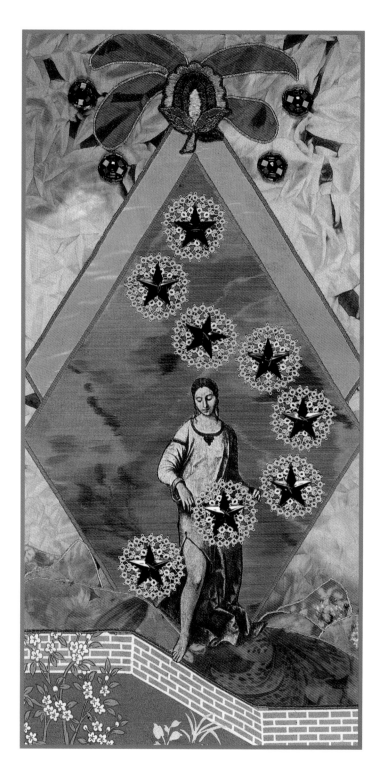

EIGHT OF PENTACLES "CRAFTSMANSHIP"
12 x 24 INCHES, 1989

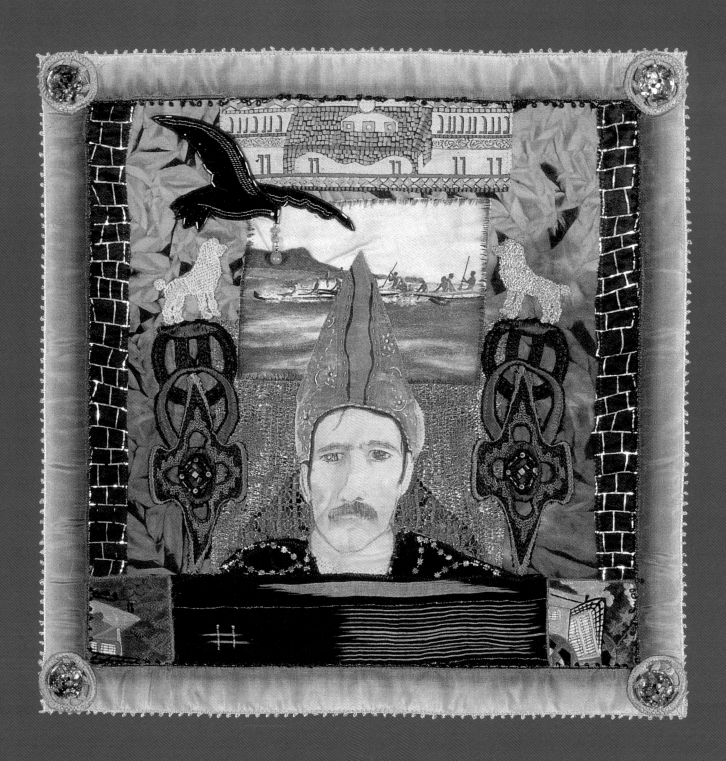

TRANCE POSE

22 x 22 inches, 1988

ALCHEMY

The subject of alchemy naturally lends itself to a thorough exploration in a book about Amy Zerner's art. Alchemy is about transformation of all kinds, not just the transformation of lead into gold, though Amy's collages are a perfect metaphor for even this popular misconception of alchemy. She makes art of great beauty and lasting value using many found objects no longer considered desirable by their former owners— a symbolic transformation of lead into gold.

I have seen Amy sew a dishcloth from a rummage sale right next to a piece of a countess's extravagantly beaded ball gown, just to get the right effect. I have seen her attach a precious jewel right next to a fascinating charm made of base metal. By juxtaposing the ordinary with the extraordinary, Amy expands on the worth and meaning of both. We realize their value to us is not only relative, but exists only in our mind. The final determination of their value is judged by how they complement each other and add to, or detract from, the overall good of the piece. In the same way, we are all equally valuable in the sight of the universe's grand alchemical plan of transformation and evolution.

In truth, the "lead" that real alchemists must first transform is their own imperfect natures, and the most essential "gold" they are trying to produce is the rare and valuable wisdom derived from the search. Amy's sacred collages are a striking visual reminder that something of supreme value is produced when these and other basic principles of alchemy are applied in our everyday lives.

Once our understanding deepens and we pass beyond the level of looking at the superficial meanings of forms, words, and relative values, we begin to see that, at the very heart of alchemy, it is the process of creation that embodies the transformational essence. In fact, this is alchemy's greatest teaching: the process is as important and valuable to the alchemist as the result of that process. If we can learn to experience fully where we are right now in our own process, without dwelling on the past or on a particular future, then and only then can we be said to be truly alive. This is a prize worth more than gold. This is the meaning of one of alchemy's most enigmatic teachings: no alchemist can create gold unless it is already in their possession. In other words,

you will never be able to unlock the riddle of the trans-mutation of lead into gold unless you have rid yourself of limiting beliefs and gained the true golden wisdom that comes from the development and skilled blending of both intellect and intuition.

Amy's special creativity springs from her intuitive understanding and practical application of alchemy's process-oriented approach. Like any true artist, her main interest is in the creation of her pieces. Her studio is filled, not with strangely labeled jars of chemicals and laboratory equipment, but with fabric bolts and boxes containing thousands of pieces of loose fabrics, and drawers full of special papers. She has these as well as all of her found objects, laces, ribbons, beads, ornaments, paints, enamels, and countless other embel-lishments carefully organized and their position memo-rized. All these things are her unique version of the tra-ditional alchemist's *materia prima*, the primal matter necessary to begin what alchemists called The Great Work.

Amy crawls around her evolving works, cutting and piecing together not only fabrics with what-ever her discerning eye calls for, but, symbolically, piec-ing the things she understands with the things she does not understand. The events of the day are blended with the dreams of a lifetime.

Her artistic process is a form of waking meditation on the possibilities afforded her extraordi-nary creative expression. In this way, there is no differ-ence between her life and her art. She makes art as a bee makes honey or an alchemist makes gold. Each prepared background fabric or paper border becomes the tradi-tional alchemical alembic vessel where, heated by her

roaring imagination, she melts down the past into the present and prepares it to help her shape the future.

This is the most basic formula of alchemy: *Solve et coagula*, "dissolve and combine." Amy adds, takes away, and adjusts the position of everything until the right placement presents itself. She sees the basic essence of each object, not only its shape and color, but how each component in the entire work will interrelate.

Amy lays each element out on its own spe-cially prepared background piece of either fabric or paper. As she creates, she does not in any way affix the myriad components of her collages. Once she decides that the overall collage she has laid out is finished, she will photograph the work with a Polaroid camera and then take the entire piece completely apart! The allegory of the alchemical process continues, for only those col-lages that have been distilled into this complete and per-fect image will be disassembled, and each of their pieces, either fabric or paper, will be specially prepared to insure their durability. Then the work is reassembled—paper with archival glue and fabric sewn with super-strong high-tech threads.

It requires a supreme confidence to attempt such a thing even one time. Amy's artistic skill and self-confidence have been tempered in the fire of this process more than five hundred times to date.

In 1990, Amy and I produced *The Alchemist: The Formula for Turning Your Life to Gold*, from which the images contained in this chapter have been chosen. It is a divination system specifically designed to mirror alchemy's mixing of the four tradi-tional elements—Fire, Ar, Water, and Earth—to produce formulas for the transformation of the "leaden" weight

of situations and negative patterns that hold us all back, into the "golden" wealth that comes from having our lives run smoothly, joyfully, and productively. For *The Alchemist*, Amy created forty-eight collages.

For many centuries, alchemists hid their formulas from eyes not ready to understand by using strange words, symbols, and images. The advice given by *The Alchemist* is clear and direct. In it, we tried to distill the essence of the process-oriented approach of alchemy and make it accessible to all in a simple, enjoyable, quick, and accurate way. As usual, Amy made an incredibly difficult technique seem easy—cutting, placing, and gluing thousands of separate pieces of paper, some incredibly small and delicate. These images and the wisdom they contain evoked my text.

"As above, so below," is an ancient alchemical principal proclaiming the interrelatedness of all things. In the same way that alchemy preserved chemistry during the Dark Ages of superstition and ignorance, this simple phrase has preserved a powerful scientific truth that is proving to be almost as significant as Einstein's $E=mc^2$. Carl Jung, a psychologist as well as a student of alchemy, was the first to intuit and postulate his law of synchronicity, a word he coined to describe the holographic relatedness of all things happening at the same time.

However, it took Benoit Mandelbrot and his chaos theory to describe with mathematical accuracy the actual formula Mother Nature uses to create the tapestry of life. His work on the concept of self-sameness proved that every detail reflects the whole. Each part is essential for the whole to be what it is. Everything is related to and has a measurable effect upon everything else. A butterfly flapping its wings in Japan affects the weather outside your window.

Synchronicity is as common as gravity. When you start looking, you find it everywhere. We are all interrelated forces for change. Only as we transform ourselves can we transform our world. Perhaps our efforts at personal alchemy will yield another legendary golden age of art, truth, and beauty. The great social anthropologist, Margaret Mead, revealed that special kind of relationship between the individual and humanity when she said, "Never doubt that a small group of thoughtful, committed citizens can change the world. Indeed, it is the only thing that ever has."

LIGHTNING

Act as a bolt of Lightning whose brilliant spark releases the atmosphere's charged tension in a concentrated burst. Quickly shake things up and try something bold, new, and out of the blue. Let neither conventionality nor the fear of reversing yourself restrain you. Watch through your mind's eye for signs of the creative accidents of thought we call "inspiration." Let imagination take you across the universe or across the room, for the gold you seek is where you find it.

LIGHTNING
6 x 9 INCHES

SMOKE

Act as all-concealing Smoke whose veils hide that which must be kept from eyes not ready to see. Slow down your fire's rage and wait to see what will happen. Keep its glowing embers smoldering so that you may rekindle the flames later when the time is right. Till then, withdraw your energies, and if others think they see unnecessary delay, weakness, or even retreat, remember that sometimes things are not what they seem. Keep your appearance and true intentions secret, for now is a time of silence and illusion.

SMOKE

6 x 9 INCHES

THORNS
6 x 9 INCHES

THORNS

You will find yourself trapped in the painful grip of Thorns, forced to learn the lesson of enduring hard times. If you try to free yourself by struggling blindly against your fate, you will only impale yourself more. You will be unable to go backwards or forwards until you concentrate on the small but powerful points you failed to comprehend before. Freeing yourself will be hard work, but seeing how strong and tough you can be in the face of hardship can free you from the fear of its return.

GOLD

You will transform your situation into the true Gold that is sought by every Alchemist. Your life will take on a new value and meaning that will increase your wealth in many ways. Your prayers will be answered. You will be able to take control of your situation and do what is best for all involved. You will have so much that you may want to share it with those close to you. Make sure that they are ready to receive what you have worked so hard to attain. They may have to learn much before they are ready.

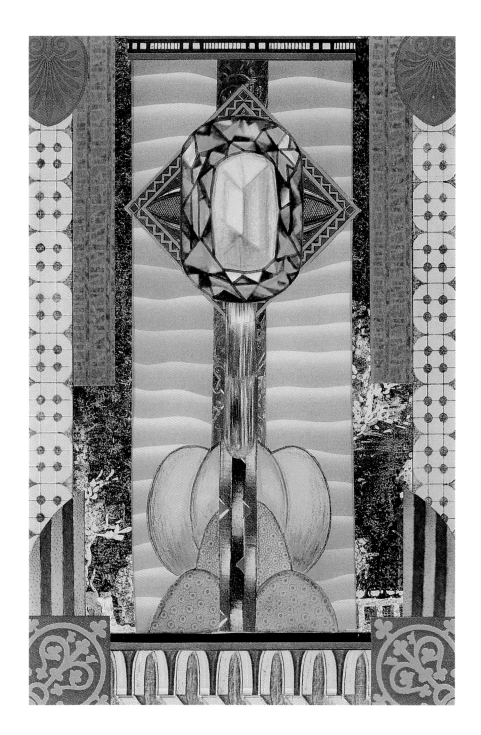

GOLD

6 x 9 INCHES

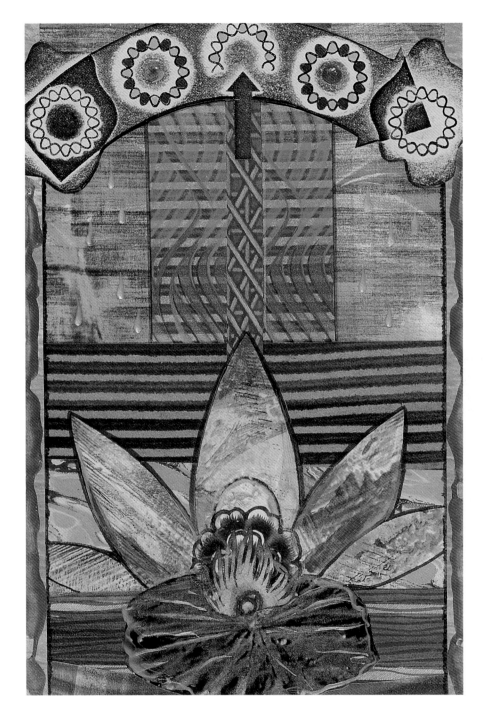

LOTUS

You will encounter the ever-unfolding beauty of the Lotus flower emerging from the mud the way love emerges from the murky depths of our emotions. How will you handle love? Feelings of love for another are like the clear and unbroken reflection of the Lotus in the water. The image lasts as long as care is taken to maintain the respectful tranquillity that allows us to enjoy life. With love all things are possible, for love replaces our confusing doubts and weakening fears with faith in ourselves and others.

LOTUS

6 x 9 INCHES

PEARL

Just as the lowly grain of sand enters the oyster and wraps itself in successive layers of material born of the irritation of its host until it becomes the beautiful, prized Pearl, so you will attain this symbol of emotional maturity when the many harsh irritations of your process cause you to seek a state beyond the ebb and flow of pleasure and pain. We can go beyond our emotions by first realizing that their origin is in our attachment to our desires. The most prized possession of a true Alchemist is contentment in all circumstances.

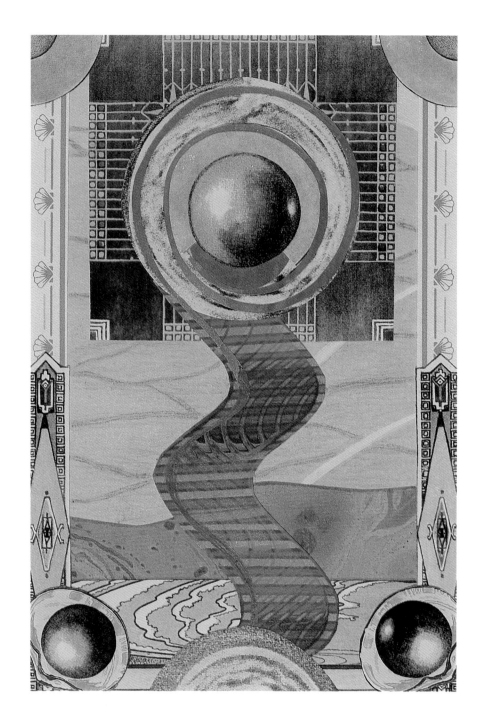

PEARL

6 x 9 INCHES

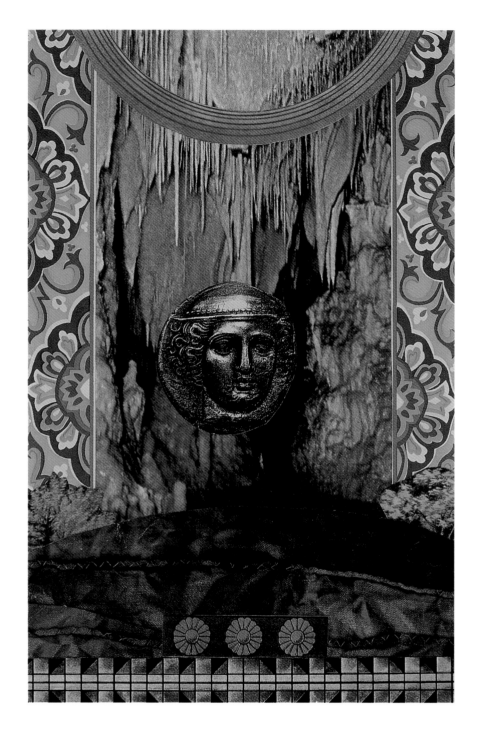

CAVE

At this point in your process you will become isolated inside the protective walls of the Cave. In this safe haven of peace and quiet you can rest from your labors and regain your strength for the challenges ahead. Without the distractions of the outside world to influence your thoughts, you can review what you have accomplished and learn from what has not worked for your greatest good. Allow the quiet voice of your inner wisdom to advise you about the next course of action you will be taking when you emerge.

CAVE

6 x 9 INCHES

BARREN TREE

The faithful execution of the most promising plan will still lead you to the Barren Tree, for the tree rightly obeys its own rhythms and the cycles of the seasons. Though you will be frustrated by your apparent failure to reach your goal, you will sense that natural laws are working in their own way and time. In time, you will see the wisdom of enduring without what you desire now. In time the seasons change and the tree will give forth leaves for shade from the summer sun and luscious fruit ripe for the picking.

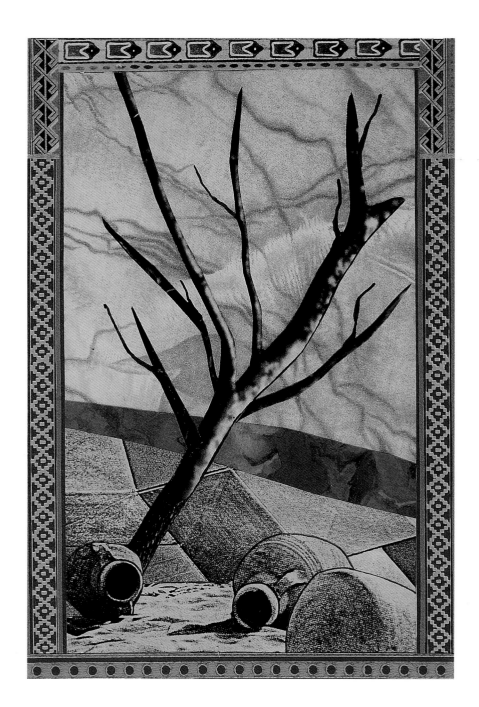

BARREN TREE

6 x 9 INCHES

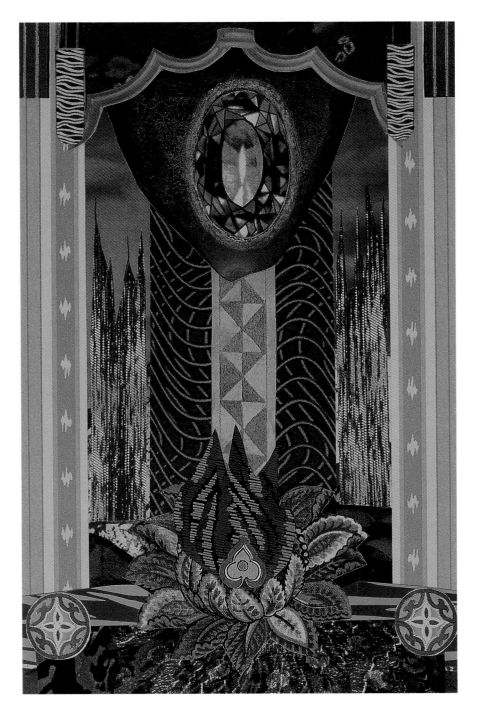

FIRE RUBY

Act as one who has attained the sacred Fire Ruby and know that you are in complete harmony with what you should be doing to realize your goal. Continue on your present course of action, for all is going exactly as it should be. Fire is Faith in Action and so let go of all limiting doubts by eliminating any distinction between you and what you are doing. You are a human being; you are the direct experience of your life, and only by so doing do you truly partake of its fullness.

FIRE RUBY

6 x 9 INCHES

FIREWORKS

Act as a long evening's display of Fireworks whose attractive power and ability to delight are a celebration of the skills of many brought together for a common goal. Enjoy the making of new connections and alliances, for together, as a team, the effectiveness of your joined resources is easily spread out over a much greater area. As you imitate the natural beauty and harmony of the heavens themselves you will come to know their power to inspire all to greater heights.

FIREWORKS

6 x 9 INCHES

DISTILLER

Act as an Alchemist's Distiller whose boiling chambers and cooling tubes break solutions down into their component parts as their various boiling points are slowly and deliberately reached. Analyze and evaluate your alchemy process, taking care to separate and retain only what is valuable. Attention to small but critical details will enable you to reduce the risk of error to an acceptable level. By classifying and purifying the elements of your process you will render it most useful to your purpose.

DISTILLER
6 x 9 INCHES

TORCH

Act as a single Torch whose fire has been brought to a head as a sign of individual strength. Show your fiery hand as you bravely stand your ground to both friend and foe. Your burning desires can only be satisfied by you alone, but you can strive for what you want only if and when you are sure in both head and heart of what you want. Do this and be confident that by living in the moment and being a pure expression of action you will conquer your self-doubt and fears and, by so doing, accomplish your goal.

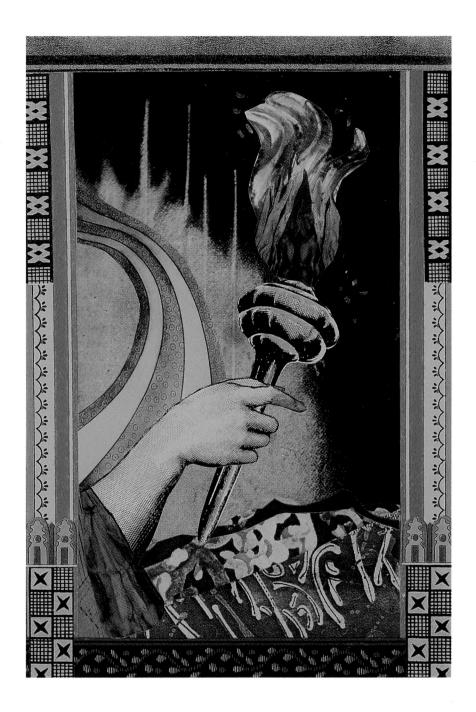

TORCH

6 X 9 INCHES

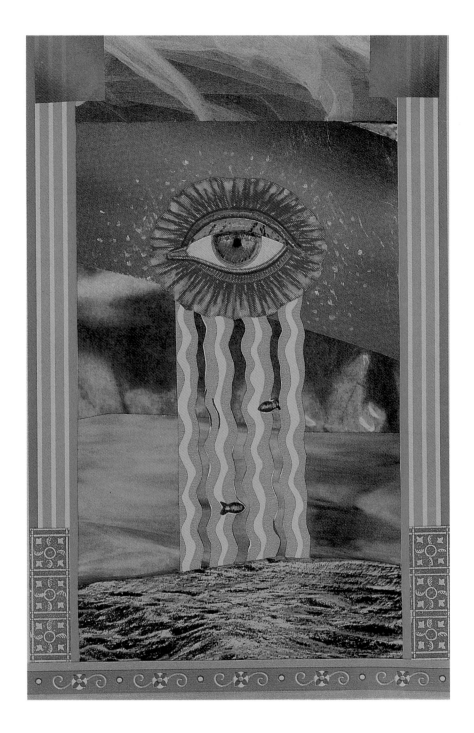

MIST
6 x 9 INCHES

MIST

A blanket of Mist will cover the land and all it touches will be united in the common experience of having to navigate a distorted world of unreliable vision and anonymous shapes and sounds. You will be forced to rely on your sixth sense—the intuition which the Sages called our "third eye"—for help. Like the Mist, our intuition envelops and unites us with All There Is, but in a shared experience of Being. Calm, patience, and practice are necessary if we would fully trust that our intuition is completely accurate.

ANGEL

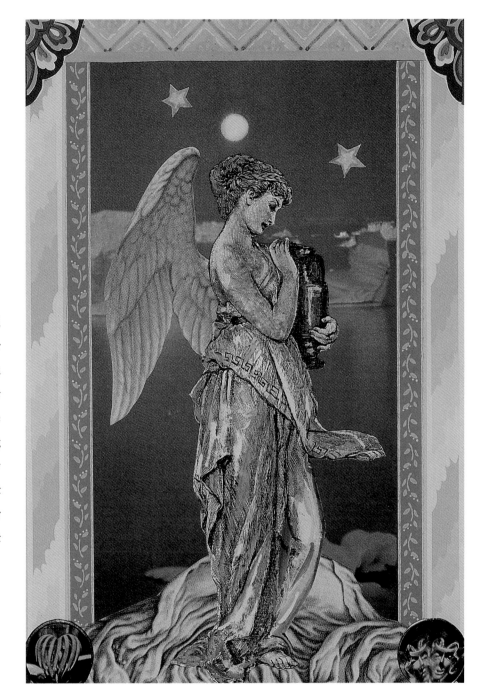

Be aware that behind you stands an Angel patiently waiting for you to surrender your prideful desire to resist contributions from sources outside of yourself. Your alchemy process can include the gift of Grace from the highest sources if you have faith that receiving aid that is beyond your control does not imply your failure. Faith requires great bravery for it requires you to let go of your beliefs, open your mind to the truth, whatever it may be, and not fear the unknown.

ANGEL

6 x 9 INCHES

EURZULIE, GODDESS OF SENSITIVITY (Detail)

THE GODDESS

Centuries ago the great sages of China taught that when the balance of female and male energies, what they called Yin and Yang, were out of balance on Earth or in Heaven, no people could prosper. This basic truth, together with what we have learned about the importance of myth in our lives, is what makes Amy Zerner's stylized portraits of The Goddess in her various guises so very important.

For most people, the word "God" invokes the image of an all-seeing, all-knowing, all-powerful Supreme Being, while the word "Goddess" implies a quaint myth of antiquity, of little importance to our everyday experience. It is this imbalance that makes it necessary to add the word "The" to "Goddess" to even attempt to equate Her significance with that of God, who needs no qualifying word to declare His power.

In the pieces displayed in this chapter, Amy has used the female form to personify various aspects of the ultimate source of the vibrant, nurturing energies of the life-force surrounding us. These women are not only idealized images of the feminine process, which gives birth to and nurtures us all; each is one of the infinite expressions of The Goddess, the One who gives birth to and nurtures the entire universe and everything in it.

Of course, both Goddess and God are sexualized personifications of what might more accurately be called All-There-Is, The Great Singularity, or, as the Native Americans refer to It, The Great Mystery. We are all children of these loving Parents. To impose either gender on the unnameable Force that created, and continues to create, everything is an ancient human convenience that should be used to make It more comprehensible and accessible, not be the cause of further strife.

However, the living conditions today for billions of women around the world are not much better than those suffered by women in the Dark Ages. Symbolically, the awareness of the equality of Goddess and God is imperative if we are to ever have a balanced relationship between women and men. Amy has addressed this imposing situation with her series of Goddess tapestries and with the ceremonial robes of the following chapter, "Materializations." Over the years, their creation and display have given light and life to

what are both ancient and new feminine archetypes of strength and brilliance.

Although she started out as a painter, in 1974 the theme of fundamental change was operating in all areas of Amy's life. I came into the picture around the same time she began to paint with fabrics, laces, found objects, and anything else that she intuitively knew belonged in her pieces—not just paint. Her use of these unusual materials and manipulated color transfers was a strong statement in itself. However, this radical shift in artistic mediums was occurring just when she began to let her studies of astrology, shamanism, philosophy, and the nature of personal reality inform her unique fabric collage paintings. Her work became truly synergistic, to the point where her technique, subject matter, and choice of medium were making many different artistic statements, even though Amy was and is content to let her work speak for itself. The power and meaning of each "painting" began to greatly exceed the sum of its parts, which were, themselves, already imbued with their own profoundly important meaning.

Many of the vintage elements of her work have been made by the loving hands of women possessed with incredible skills that are now almost forgotten. She gave new life to many taken-for-granted examples of "woman's work" and, by doing so, she honored and celebrated the women who had designed and made them. Also, many of the items she purchased in antique stores, thrift shops, and rummage sales were from a time when their use had been as common as a television is today. Now, they were rare and sometimes very costly antiques—remnants of a bygone era. Their original use is unfamiliar enough to allow Amy to use them to suggest

trees, bridges, mountains, and a host of other forms. In a very real way, this can be considered symbolic of the inevitability of change.

Amy's desire to better understand and correct the obvious inequities existing between the treatment of men and women—not just in the art world but in all facets of modern life—has led her to portray goddesses that differ significantly from those of the past and represent a mythology that is far more relevant for our time. During the more than twenty years we had studied the metaphysical teachings of various cultures separated by both space and time, we had been impressed by how each teaching stressed the absolute importance of balancing female and male attributes to achieve true harmony and personal power. Yet, we were struck by the lack of this harmony so evident in the outside world.

We were inspired by books like *God Herself* by Geraldine Thorsten and *The White Goddess* by Robert Graves to learn more about The Goddess. We came to know of Her power and its supremacy in the more peaceful, agrarian days before the rise of cities, wealth by conquest, and the recorded history of warlike peoples and the male gods they worshipped. We came to see The Goddess's fall from universal worship first as a metaphor for, and then as a historical explanation of, the inequalities existing between women and men today.

We learned how the religiously sanctified suppression of women and their sexual powers was imperative to the proponents of the emerging patriarchal religions. Every woman had been held sacred as a living symbol of The Goddess, Herself, in the time before recorded history when God was a woman. This, in turn, led us to see the urgency of the need for Her return to a

position of equal respect if there was to be any hope of achieving the peace between the sexes that we enjoy in our life together. Eventually, we became even more aware of our role in helping to make this happen in the form of our fourth inner guidance system, *Goddess Guide Me.*

For Goddess Guide Me, Amy created twelve tapestries containing the wisdom of the different Goddesses whose names and legends span the boundaries of time, nation, and race. Each represents a different aspect of The Goddess, which is further divided into three forms of advice: what to keep in mind; what emotions will be experienced; and what higher principle can help one align both head and heart. Each image fills the whole picture just as She fills our whole lives.

The towering forms of each Goddess seem to equally love Earth and Heaven. They give the viewer a sense of being firmly connected to the rock, soil, and water of the "body" of the form of The Goddess that has survived up till today: Mother Earth. The Goddesses of *Goddess Guide Me* have no feet, in the tradition of "The Venus of Willendorf," the earliest carved image ever found, which is thought to be a devotional statue of The Goddess. The missing feet are thought to be symbolic of her inseparable connection to the Earth from which all life derives.

The rebirthing of sources within us, which have been denied for thousands of years, is often a slow and painful process. However, the equality of the sexes is not only more important than most people suspect, it is closer at hand. The problems of our age compel us to root them out at their cause. Low self-esteem, especially among women, seems to be crippling so many who could otherwise be a part of their solution. If we are to undo the harm that has come before us we must make ourselves secure within as we act in the outer world. Only then will we be able to make ourselves useful to others. Only when we can love ourselves can we love others.

Amy's work and career have become a significant part of the loosely affiliated movement to restore The Goddess and all women to a position of equality with men. In fact, there are many important figures in the woman's equality movement—women and men—who own her collages and ceremonial robes.

It is all of us who will benefit when the archetypes of Fighter, Leader, Revolutionary, Healer, Executive, Inventor, and Supreme Being are applied equally to beings in womanly form. The return of The Goddess is symbolic of the developing commitment to not harm Mother Earth and her progeny. By creating images of The Goddess at home in Her paradisiacal landscapes, Amy's work is a reminder of our Arcadian past, a healing refuge for our psyches wounded by the violence of modern day living, and a reminder of what can be if we all work to restore balance to our lives and to our world.

DIVIANA
GODDESS OF PROTECTION

My head is crowned with the symbol of our Cosmic Mother, the Moon, who has circled the Earth watching over all since life began. I close my eyes to irritating behavior when I know such gentleness helps others endure the inevitable pains of growth.

My heart is pink with the milk of human kindness, but at its center is a core of precious gold, the most incorruptible and yet malleable of all metals. I feel the healing power of compassion and forgiveness towards all who are trying to grow.

My home is in the moonlight that enables all to find their way in a darkened, moody world, where unclear shapes and shadows suggest the presence of forces outside our control. The amount of light reflected by the Great Mother Goddess's symbol, the Moon, depends upon her position. I stand upon my sacred stone, Moonstone, which emphasizes love and protects my sensitive, maternal instincts. My dress is the color of moonlight upon a forest lake and its patterns display the strength concealed by my apparent dreamy softness. My cape is lined with images of the tiny sparks of life transmitted from mother to child. My sacred animal is the rabbit, whose life is devoted to the rearing of its young. Rabbits do not have the fiercer means possessed by the other animals, but survive and prosper because they quickly take defensive action.

I use my intuition to guide my defensive efforts to protect myself and those I care for from whatever threatens growth and learning.

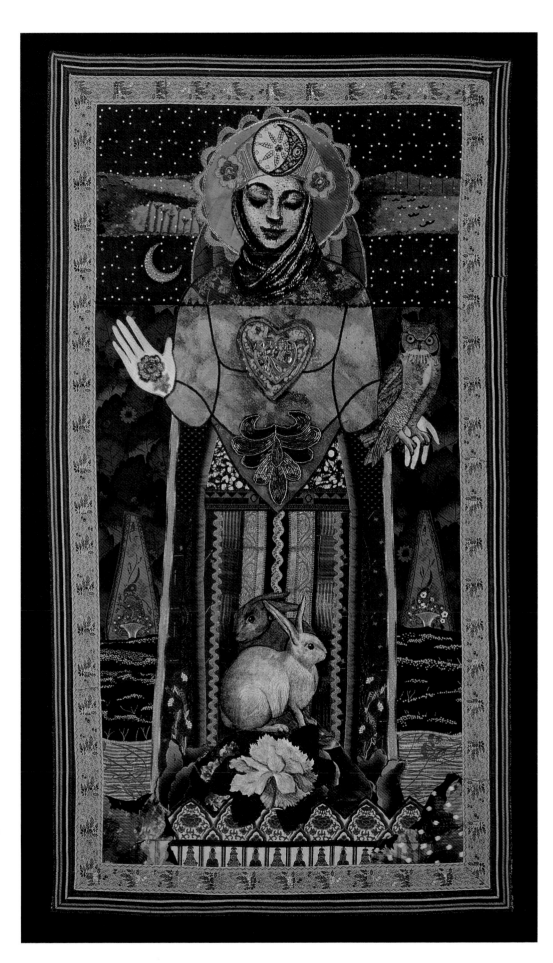

DIVIANA
GODDESS OF PROTECTION
27 x 45 INCHES, 1991

HEKAT
GODDESS OF MYSTERIES

My Head is crowned with veils of invisibility. I blend into a mystifying, magical sky where waxing and waning eclipses turn day into night. I conceal plans and actions from those not ready to accept me as I am. I do not deny the risks and hazards I see.

My Heart is completely filled by the sacred Scarab Beetle of Fertility. Life renewing energy radiates throughout my body. I feel so passionate about my desires that I resurrect my hopes and plans for their fulfillment, despite their apparent demise.

My Home is among the Great Pyramids of Egypt, monuments made to preserve the bodies of royalty. Their very form is the embodiment of the deathless precision of pure science and mathematics. Metaphysical wisdom was taught by Priestesses of the Great Goddess. Science was then our servant and not our master. I stand upon a base of my sacred stone, Obsidian, whose perfect blackness absorbs negativity and amplifies my power. My dress is adorned with forms describing a secret mathematical formula and a border symbolizing a nuclear chain reaction. My cape is the color of the Fire that both destroys and creates life. My sacred animal is the cobra, whose angry bite transforms life into death. The cobra's eternally shed skin symbolizes the promise of a new life emerging out of death.

I invoke the power of unseen, indescribable forces to aid me in transforming that which has outlived its usefulness into what I know should be.

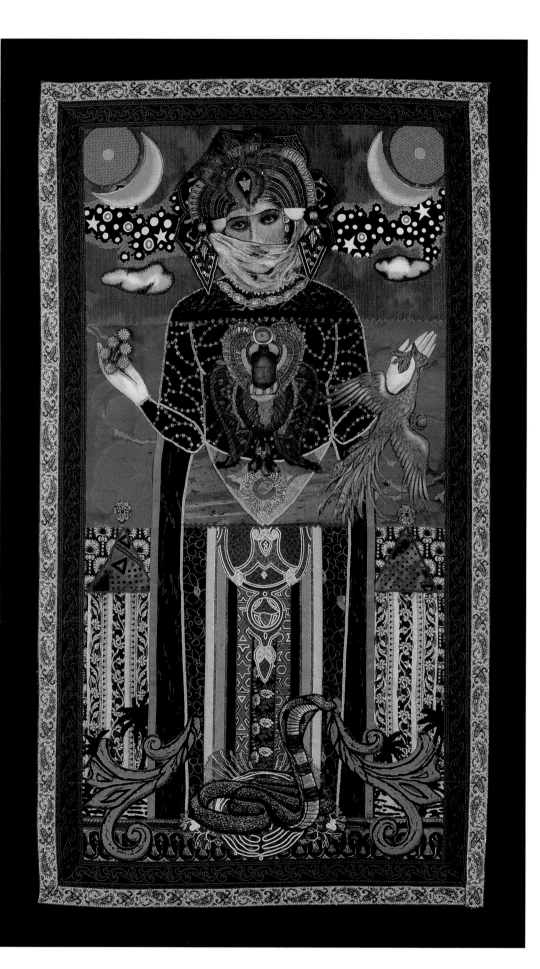

HEKAT
GODDESS OF MYSTERIES
27 x 45 INCHES, 1991

EURZULIE
GODDESS OF SENSITIVITY

My head is crowned with sea foam and shells from the living ocean. Two fish leap out to remind me that my home is beyond earthly shores. I believe strongly in the goodness of this and other worlds. I am willing to place my own needs second to help those in need.

My heart contains the seawater that touches and unites all the lands on Earth. A protective charm on a strand of pearls floats inside. I feel so connected to All-That-Is that I can intuitively sense what another is feeling. I protect myself from negativity.

My home is in the strong off-shore currents that flow among the coral reefs lying beneath the waves. These great walls are formed by the bodies of billions of tiny sea animals, like those pictured on the lining of my cape. Here, life floats suspended in the simple experience of living with no regrets or plans for the future. Creatures of all shapes, sizes, and colors continuously find new ways to adapt and survive in my chaotic environment. I stand upon a base of my sacred stone, Mother of Pearl, which gives up tiny pieces of itself to build up the prized Pearl. My sacred animal, the seahorse, has evolved a system whereby the male gives birth to the young. Growing up to two feet in height, they have given rise to tales of mer-children like the one who plays at my dress.

I adapt to conditions so I can spend my time creatively evolving ways to attain my goal at my own pace. I flow with the current in which I find myself.

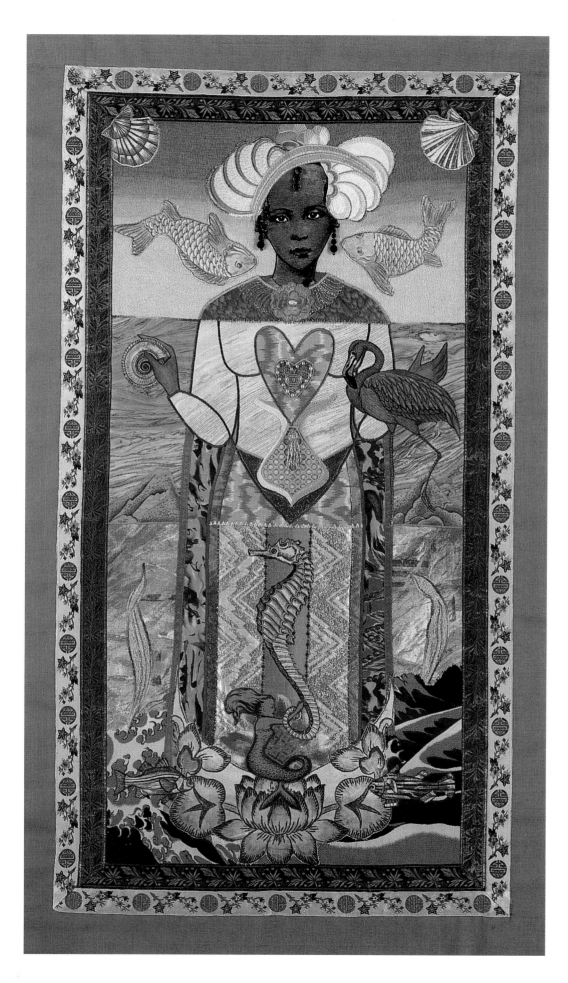

EURZULIE
GODDESS OF SENSITIVITY
27 x 45 INCHES, 1991

PASOWEE
GODDESS OF ENDURANCE

My Head is crowned by a leader's headdress and the badge of the Thunderbird who was so full of himself that the Great Spirit curbed his power. I have great powers and abilities; not all are easily visible. I see beyond appearances and cultural stereotypes.

My Heart is ringed by the spinning Wheel of Time held in the arms of the Great Spirit. At its center is the turtle upon whom the Earth rests. I feel centered and grounded by my eternal connection to our Mother, the Earth and Her ceaseless cycles, rhythms, and seasons.

My Home is the land now called America. Many centuries ago my ancestors also took part in a great migration from far away. I stand upon a base of my sacred stone, Turquoise. It strengthens me, improving circulation and memory. My dress is painted to symbolize the old way when we lived in harmony with our Mother, the Earth, and danced our thanks to the Great Spirit that dwells within all things. We saw destructive strangers harm our Mother and our sisters and brothers, the animals and plants. Soon our wait will be over and respect for the Earth will return. My sacred animal is the buffalo whose body we used in its entirety for food, clothing, and shelter. We took the lives of the buffaloes without anger and offered prayers of thanks to them for their sacrifice. They enabled us to live during the long winter when nothing grew.

I accept without resentment that I must wait and prepare for developments to reach the stage where my desires become attainable.

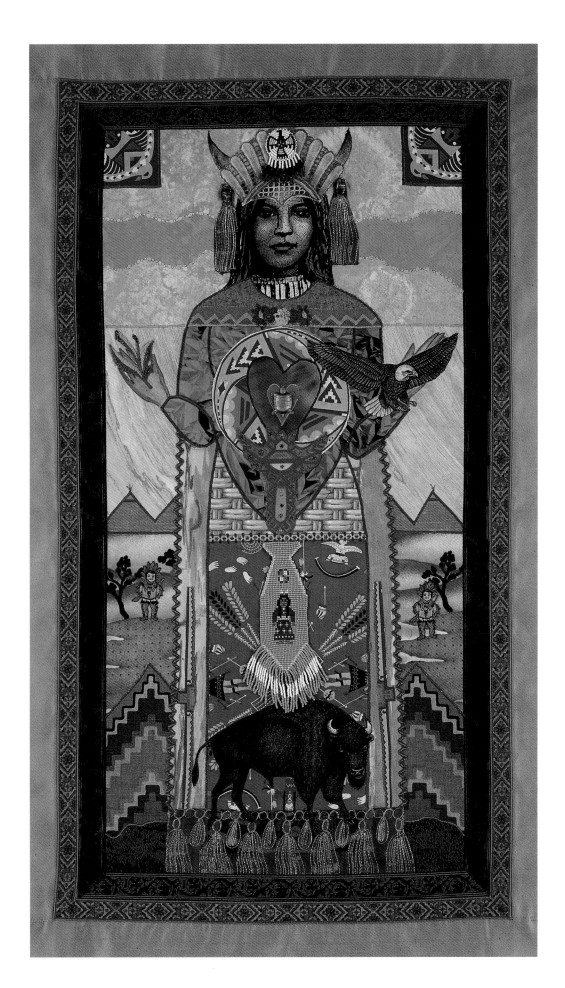

PASOWEE
GODDESS OF ENDURANCE
27 X 45 INCHES, 1991

ROMI KUMU
GODDESS OF WILLPOWER

My Head is crowned with the same living Fire that rages in my eyes and finds voice in my words. The force of my will is as intense as the tropical sky above me. I focus my willpower to realize my desires and bravely burn away thoughts of compromise and defeat.

My Heart glows like red-hot coals for at its center is my smoldering desire symbolized by the purposeful, single eye that only sees things one way. I feel certain that I am powerful enough to materialize my heart's desires.

My Home is in the wild rainforest whose trees supply oxygen for the world to breath and shelter most of the animals, plants and insects on Earth. Here all live by a single-minded dedication to survival, without compassion for weakness, threats, or competitors. I stand upon a base of my sacred stone, Bloodstone, symbol of the warrior. It gives courage and vitality without limit. My dress is the color of flame framing a hieroglyphic message known only to me. My cape is lined with images of the first single-celled animals whose ceaseless individual efforts produced all life-forms. My sacred animal is the tiger whose fearless beauty announces an unrefined physical presence whose power must be honored. Tigers live alone, except to mate, and my erotic needs are compelling enough to force me to temporarily abandon my habitual behavior.

I use my willpower decisively to satisfy my desires and attain my goals, overcoming fears that are a natural part of my decision to rely only upon myself.

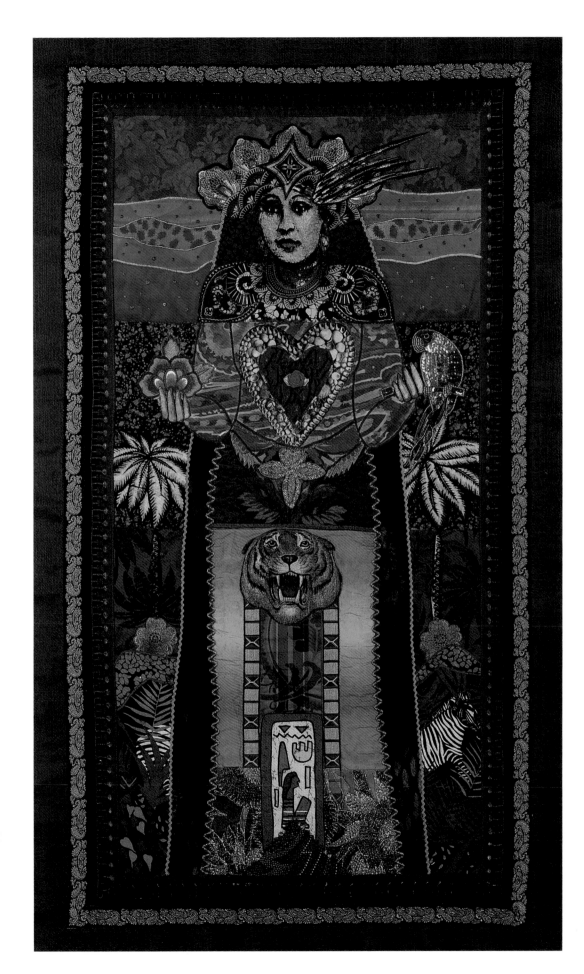

ROMI KUMU
GODDESS OF WILLPOWER
27 x 45 INCHES, 1991

T'AI YUAN
GODDESS OF DUALITY

My Head is crowned with the winged helmet of Celestial Balance, symbol of the striving for reconciliation that is the meaning of peace. I attain my goals in ways that benefit all involved to our mutual satisfaction.

My Heart has layers that are light and dark, hard and soft. At its center is the Yin-Yang symbol of female and male intertwined. I feel both the feminine and the masculine aspects of my personality are working together in harmony.

My Home is the Orient where all the seeming dualities of life are understood as being two sides of the same coin. Overcoming restraints, the feminine principle gives birth to the infinite expressions of life, while the masculine principle seeks to impose order and control upon chaos. Balancing the two is our life's work. I stand on a base of my sacred stone, Jade, which gives me timeless values and lasting friendships. Upon my dress is the image of bamboo whose chaotic and tenacious growth overwhelms all other plants. But from its leaves, shoots, and stems come the basic tools of culture and order: food, sewing needles, pens and brushes, cooking utensils, boxes, furniture, houses, and boats. My sacred animal is the Dragon, symbol of the highest authority, good fortune, and the balance of Yin and Yang. Dragons caution all against greed.

I attain balance, fairness, and judgement born of a desire for justice, by seeking out the council of those whose lives I admire.

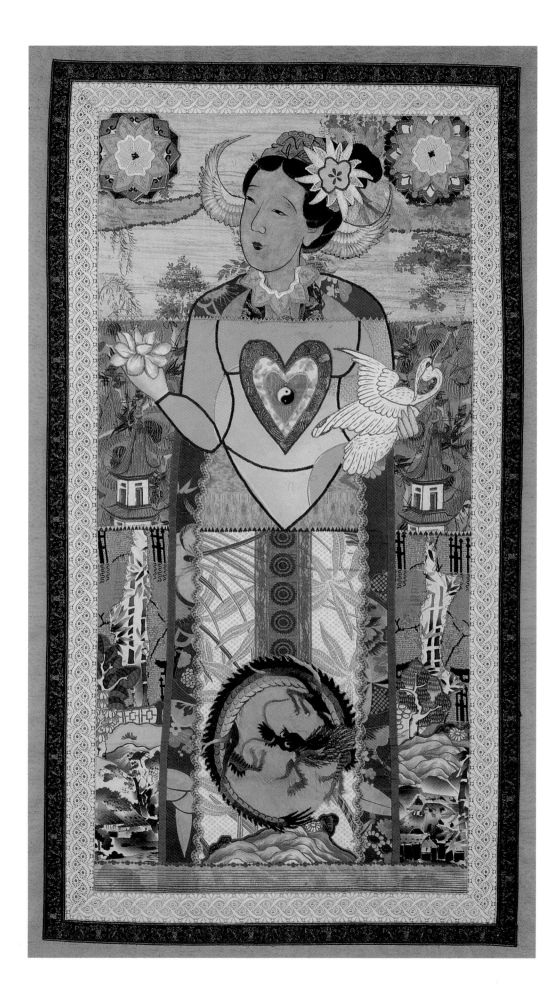

T'AI YUAN
GODDESS OF DUALITY
27 x 45 INCHES, 1991

ATLANTIA
GODDESS OF THE UNEXPECTED

My head is crowned with the brilliant energy of a new idea, a reward for my being open to the infinite possibilities of life. I look at my life's goals as if seeing them for the first time. I am too much a skeptic not to believe that anything is possible.

My heart contains the ice-cold emptiness of space above the Earth's atmosphere, from where I see the effects of humanity's efforts. I feel emotionally detached so I can best do my part to right the wrongs I see threatening the well-being of all involved.

My home is the ancient, lost continent of Atlantis, whose people enjoyed a technology more advanced than we have today. Pyramid-shaped fusion power reactors emulated the inner workings of the Sun, symbol of our Cosmic Father. My dress contains images of their crystal capstones, through which they distributed the unlimited energy that eliminated most problems that can threaten a civilization. I stand upon a base of my sacred stone, Lapis Lazuli, which enables the mind to go inward and seek its own source of power. It was a people out of touch with their spiritual and political power who brought destruction to Atlantis. My sacred animal is the griffin, one of the many mutations caused by the misuse of science and creative energy. Your future depends on learning history's lessons and applying these truths as you realize your vision of tomorrow.

I use unconventional ideas and methods to revolutionize my experience of life. I am an instrument for radical, sudden, and positive change.

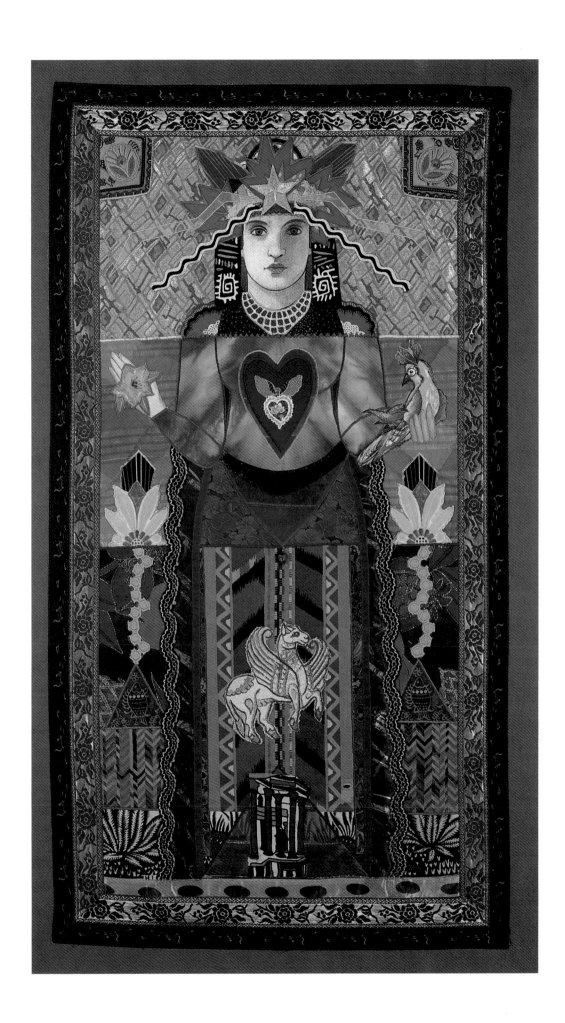

ATLANTIA
GODDESS OF
THE UNEXPECTED
27 x 45 INCHES, 1991

HYPATIA

Hypatia, a central and beloved figure of the famous Neo-Platonic School of Alexandria, Egypt, was one of the most outstanding women of the ancient world. Hypatia was revered as a secular oracle because her unsurpassed wisdom caused the most learned of her time to seek her guidance. She proved conclusively that the origin of all religions and even their "miracles" was in the personal application of teachings descended from the prehistoric Goddess religions—even then called "pagan." By so doing she became a threat to those whose wealth and power came from exploiting the faith of the masses. Hypatia's death—a martyr at the hands of mad monks in A.D. 415—brought an end to the Neo-Platonic School and their attempt to reveal the secrets of the ancient Mystery Schools to all women and men. May the eternal Torch of Truth, which burned so brightly in Hypatia, enlighten us all.

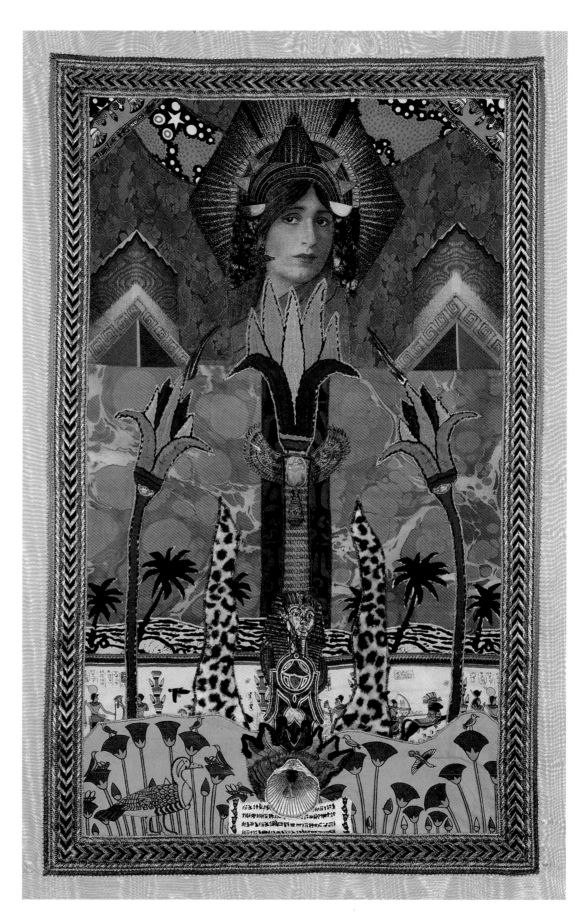

HYPATIA
27 x 40 inches, 1992

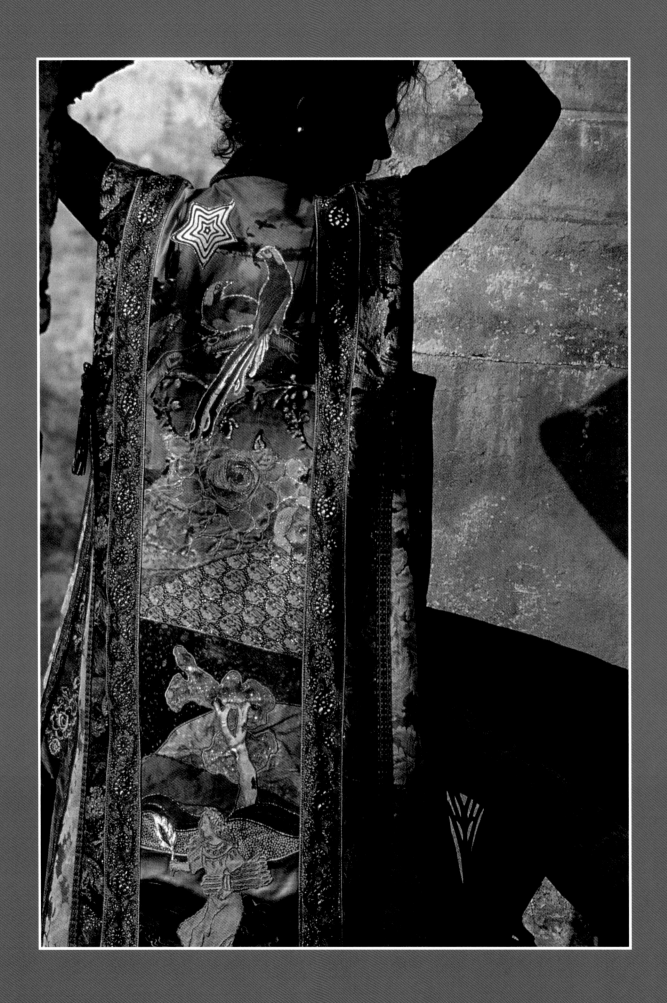

MATERIALIZATIONS

In 1990, Amy, aware that her fortieth birthday would occur on March 23 of the following year, decided to do something that she had never done before. She applied her collage technique to the execution of wearable art. She produced a series of ceremonial robes that she knew would ritually honor her mid-life passage. She knew that the act of ritual ceremony is an important way to participate in a myth, creating a union of the spiritual with the physical.

As we have seen in the interplay between the various chapters of this book, Amy's work is possessed of a rare sense of balance and harmony because of her ability to ground the most esoteric concepts within the context of everyday life. She wanted to make ritual vestments adorned with "living stories" of The Goddess. Each vestment would enable its wearer to honor Her. Amy's search for a suitable pattern for her new series, which she has decided to call "Materializations," lead her to the historic Tibetan Panel Coat.

For eight hundred years, the Tibetan Panel Coat (called *teng go*) was worn by actresses and actors portraying the Dakini or female Celestial Beings of Tibetan myth. At the present time, China's suppression of the Tibetan way of life threatens these traditions and lends an added dimension to Amy's use of this pattern as an act of solidarity, commemoration, and remembrance—some of the most important uses of ritual and ceremony.

Ceremony helps us make the cycles of life more meaningful. It helps us summon knowledge and enlist the help of the divine. The use of ceremony shifts the levels of our perception and allows us to work in harmony with the cosmic forces. It reminds us that our powers are far greater than we sometimes realize. Such powers can create transformations, symbolized by the donning of one of these magical vestments. If we make the time in our life to wrap ourselves in these purposeful landscapes, we can symbolically draw their power inside of us and help us realize the many ways we are like magicians.

Wearable art is used most often for the sake of beauty, but here it is used for the preservation of the sacred. Specific concepts are stored and communicated through Amy's elaborate iconography, emerging from

her repertoire of techniques and patterns, and guided by her intimate connection to higher forces of creativity and light. She gathers, arranges, links, and layers each piece as it comes to her. She guides the pieces and the panels as they alter and combine, evolving to become a synthesis of all the fragments that have gone before, only mixed with bits and pieces of the totality they will become in the future. The materials themselves hold mystery with their hidden messages.

It is her hope to awaken the wearer and the viewer, to facilitate the processing of dreams and intuitions. Behind each vestment exists another view, another world waiting to be born from layers of memories. Here, Amy's dynamic visual interpretations of the unseen world are given a new dimension, whether they hang on the wall or are actually worn and move through space. The act of seeing these embroidered mythological gardens come to life is itself a potent form of purification and veneration. It creates a condition that is regenerative of our sense of our own possibilities and divinity. That alone can destroy self-doubt, the most daunting of the obstacles that inhibit us on our quest for enlightenment.

In these "Materializations" we see that beauty is not only decorative, but creates an enhancement to the ritual of our daily life. The purpose of our Vision Quest is achieved not only in contemplation, but in direct spiritual function, assisted by surrounding ourselves in such sacred art. The central panel of each vestment is made of precious, carefully chosen silks and brocades, velvets and satins, and special ribbons and trims. Each is reinforced by the beauty, the rarity, and the

uniqueness of the combined variations to imbue each garment with vitality and ceremonial intent. When we wear these robes, we can become the essence of The Goddess. We can become the deep mystery of ultimate religious experience where concepts and explanations are transcended.

Ceremony renews our inner spirit, whose source is the sacred. It bonds order and chaos—by connecting such diverse patterns and materials that bridge space and time. Seemingly opposing concepts like Goddess and woman are brought into balance, in keeping with the first principle of alchemy: as above, so below. When we put on clothing, we are imitating our spirit, which cloaks itself in different bodies at different times. It is a ritual that can remind us we come into the world naked and wear clothes until we are ready to be naked again.

Participating in a ritual displays a reverence for the energy processes, rhythms, and cycles of the Earth and beyond. Amy's pieces are an overlapping of myths and dreams about creation, transformation, beauty, and power. They reflect her quest for the attunement of her mind, body, and spirit in order to see the whole and see the soul.

The primary function of ritual is to help build and reinforce a spiritual connection in our daily lives. Rituals acknowledge the existence of a Higher Power, in ourselves and in our world. They also reinforce our desires and strengthen our intent as we work to materialize those desires.

Adornment is the ancient functional element of ritual. It is the remembrance of the beauty of

our eternal divinity. These robes symbolize the development of the Self as the central essence of our birth and rebirth. The important principle in every mythical drama is that a transformation is taking place and that transformation can be made visible through great art. In this way, the significance of our life's lessons can be brought into our conscious minds. Each robe of the "Materializations" series is like a curtain that reveals more than it conceals. Putting on one of Amy's sacred garments transports us to a state somewhere between prayer and prophecy.

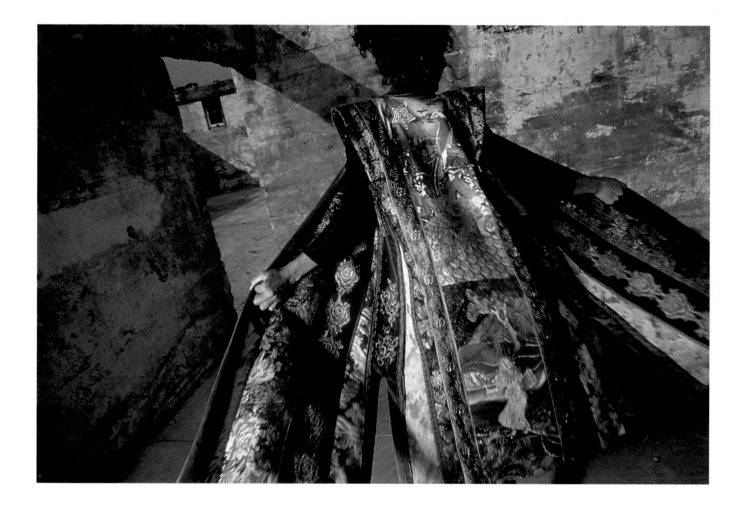

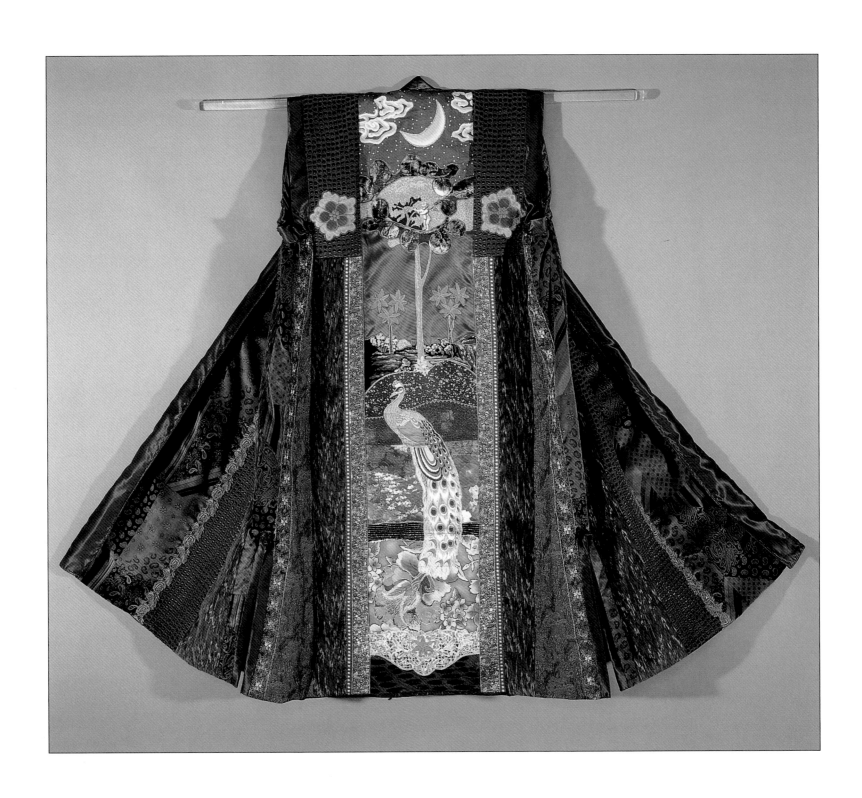

PEACOCK ROBE
1991

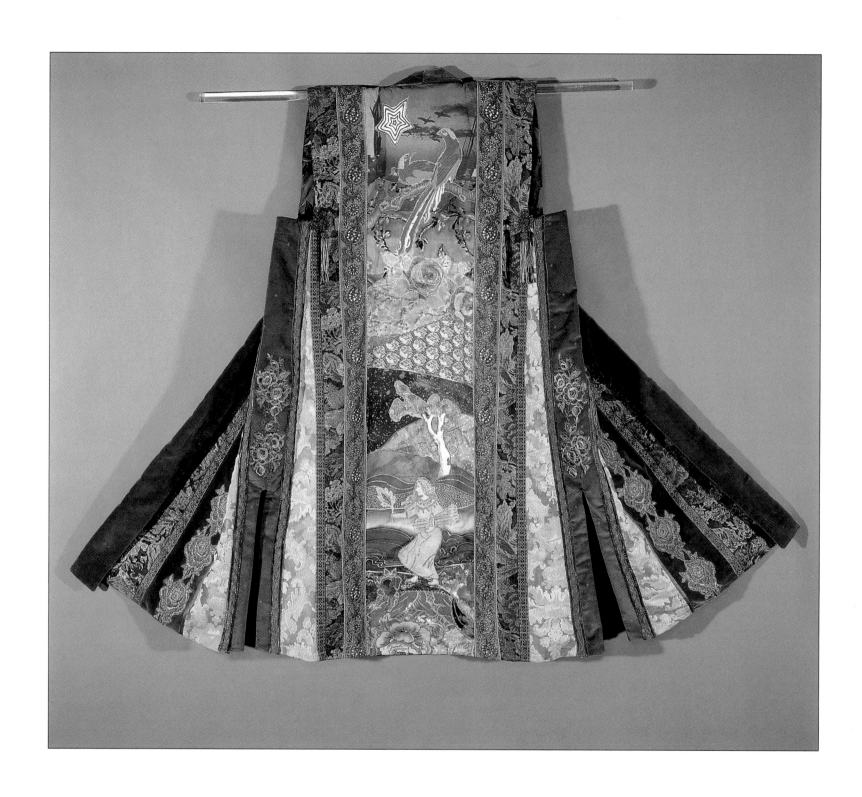

DEMETER'S ROBE
1992

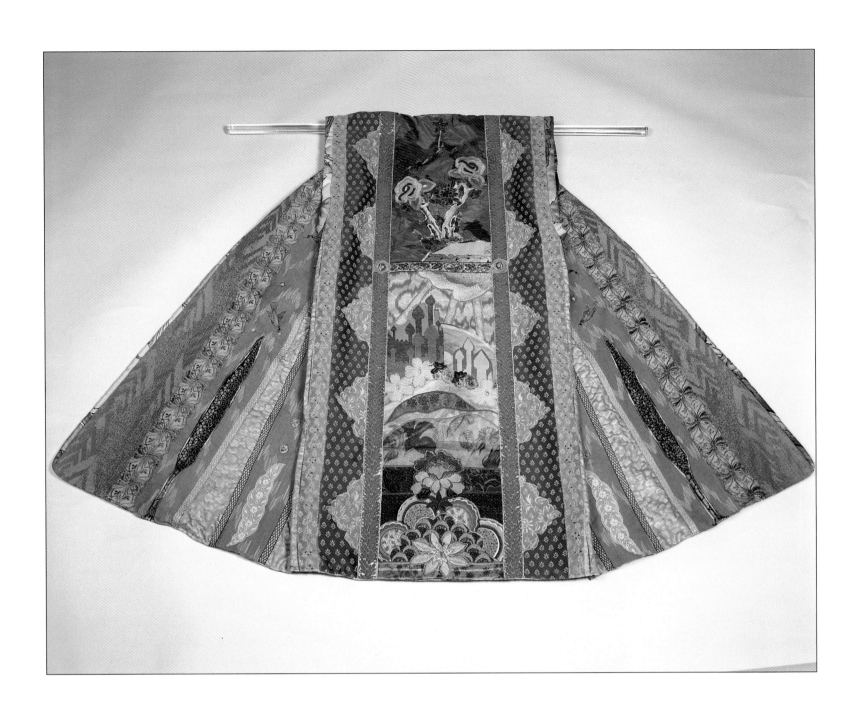

CASTLEKEEP ROBE
1993

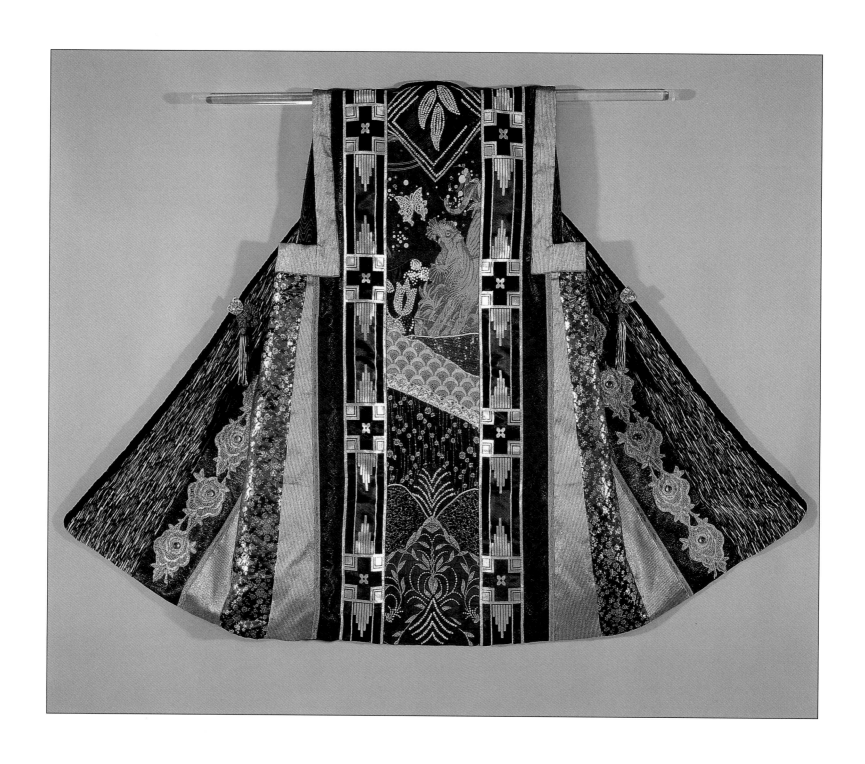

TIGER'S EYE ROBE
1992

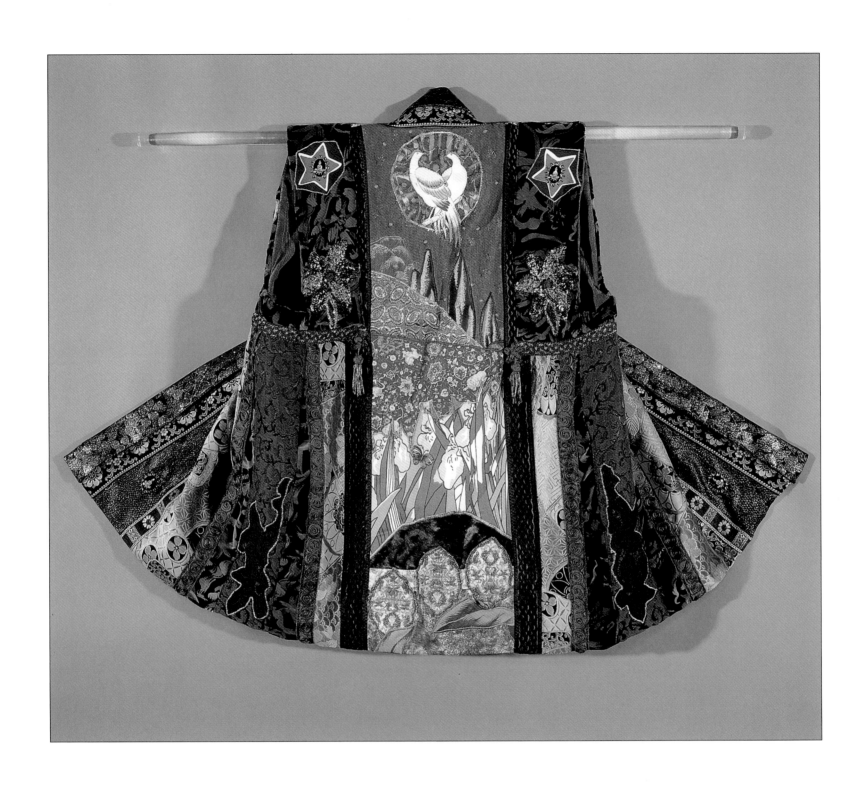

SELENE'S ROBE
1992

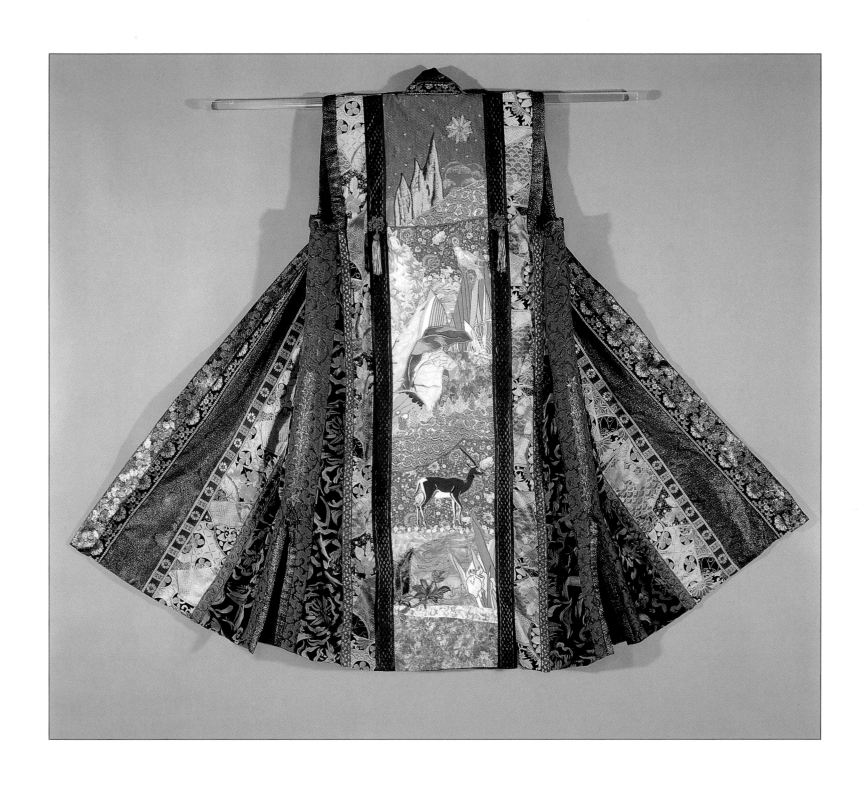

GAIA'S ROBE
1992

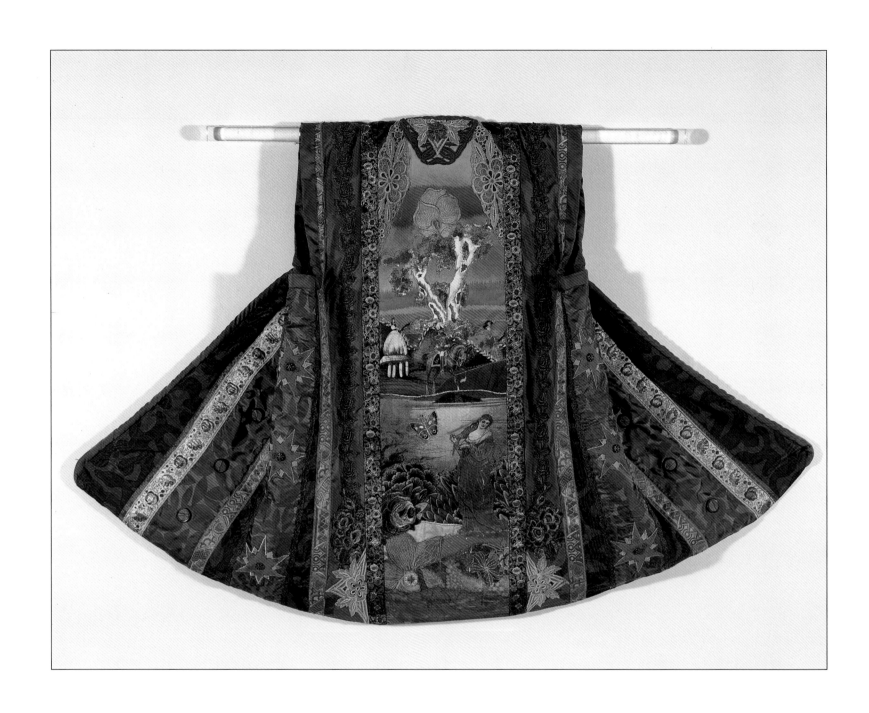

ROMANCE ROBE
1994

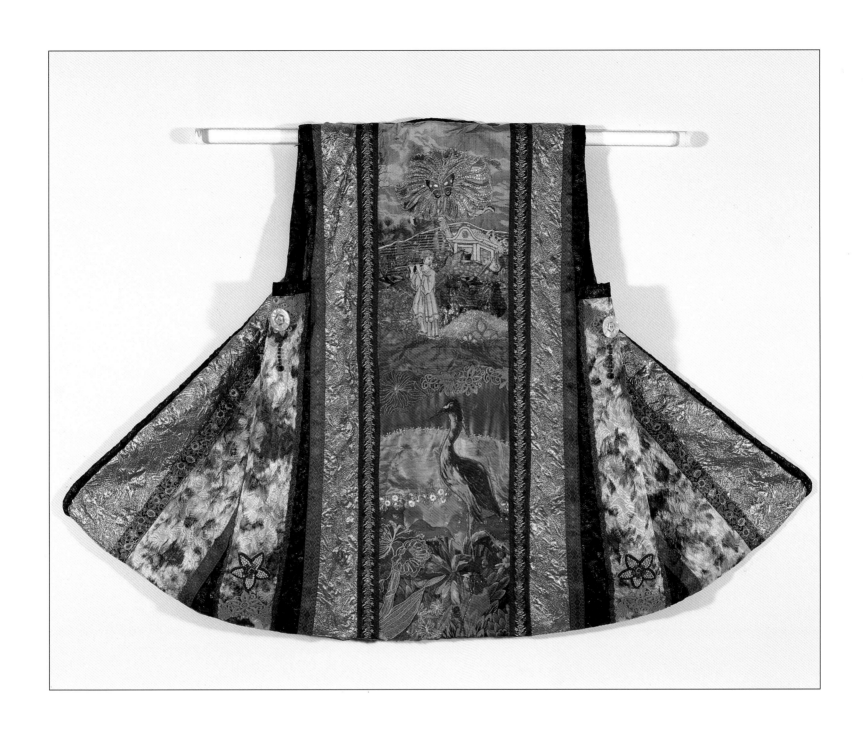

SERENADE ROBE
1994

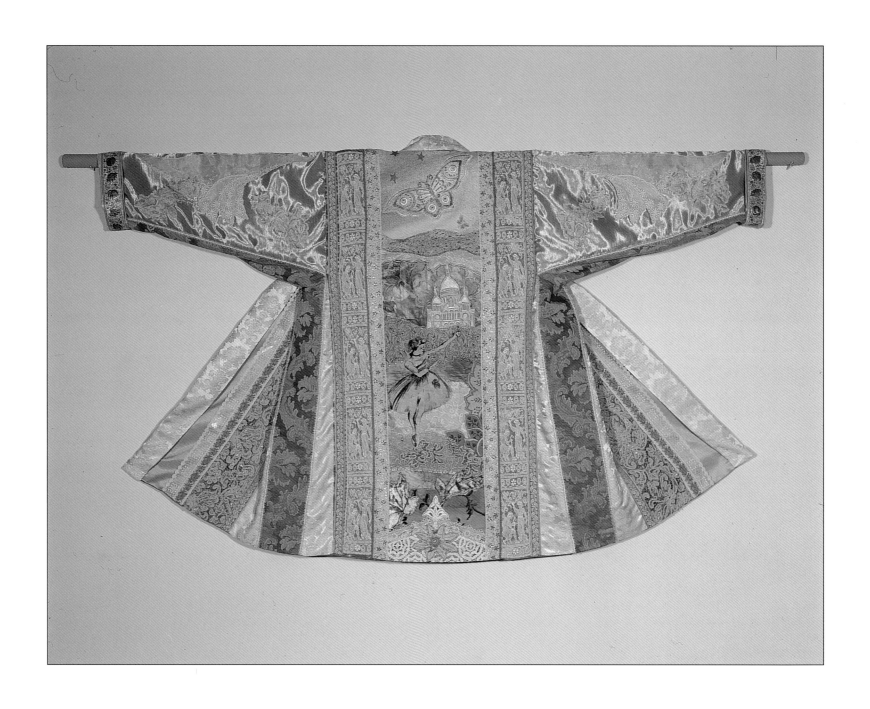

DREAM DANCER ROBE
1994

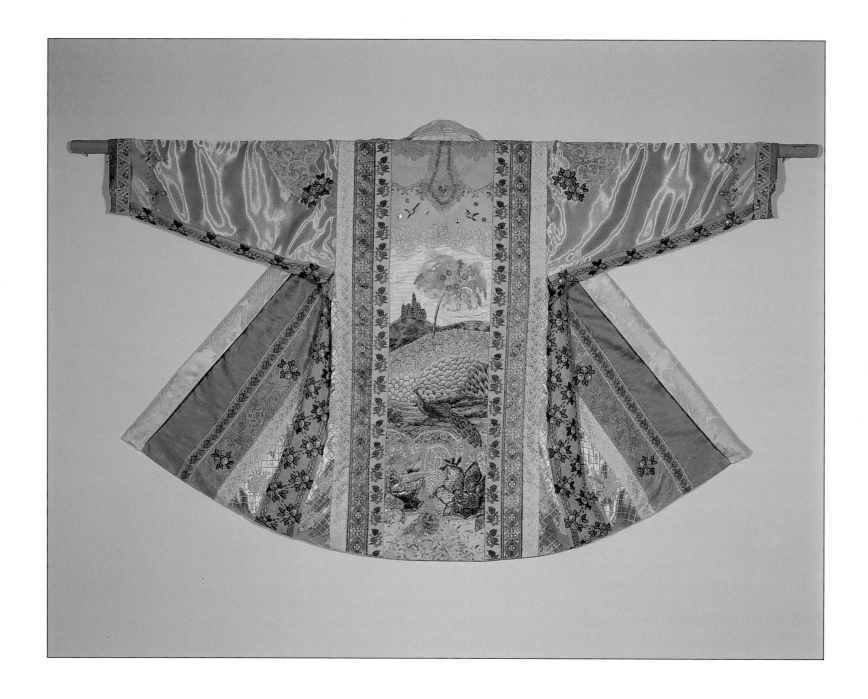

DREAM GARDEN ROBE
1994

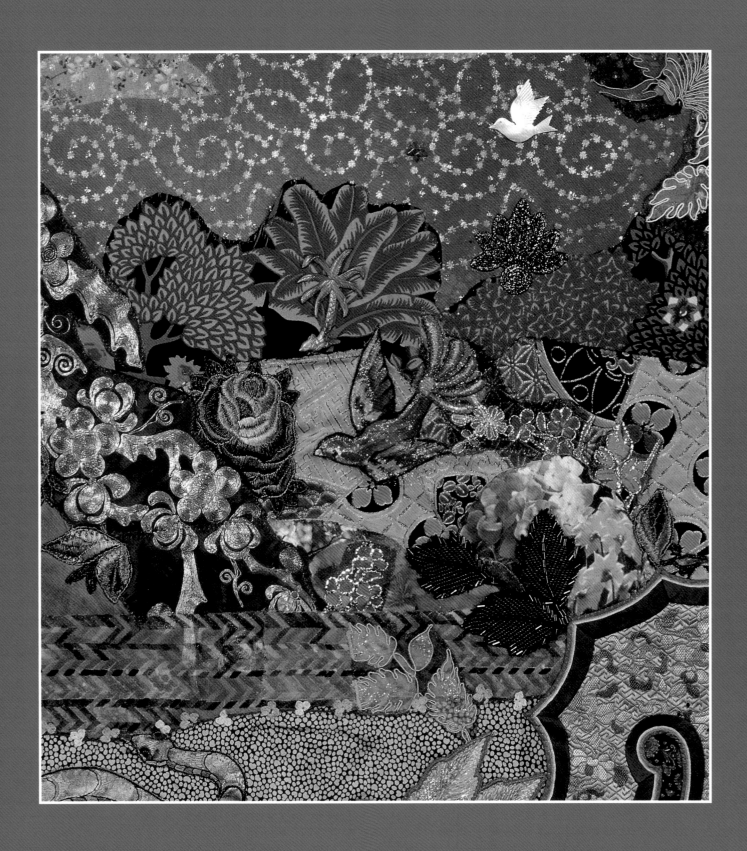

PARADISE FOUND (Detail)

PARADISE FOUND

Almost every religion throughout history has had a myth about Paradise, a Garden of Eden filled with the souls of only the righteous faithful. Paradise is always presented as that which has been lost and which needs to be recovered.

Amy Zerner's scenes of Paradise do refer back to the Garden of Eden, a special restorative and utopian place. However, they each possess a transformative power that suggests we are in the presence of the supreme bliss that beckons to us all. Here in her sacred sanctuaries is our ideal state, healthy and untouched by negativity and conflict. Amy's images are worlds of wisdom which, once experienced, have the power to inspire, educate, and most of all, to heal and empower us all as agents for positive change in our lives and in our world.Each intricate collage is a reminder that we can attain this state if we are willing to do the work to make it so.

When our search for Paradise on Earth becomes a very real and personal one, it immediately becomes apparent that the meaning of paradise is different for all who seek it. Within that fact is the secret of how it can be found.

Our own desires are the best antennas to guide us to our personal paradise. By looking within, we can identify our special, individual dreams, learn how to develop our personal creative power, make our base secure, and our dreams real. This crusade is not a selfish one. It is the only one justifiable in our time. Creativity is spirituality. By realizing and actualizing our creativity we become a spiritual human being, a most glorious occurrence. A world populated by such people can only make a paradise of our planet, a dream of the ages that is not only technologically possible at this time, but is crucial to our survival as a species.

Paradise Found is about the art of finding what you need in order to—as Joseph Campbell so eloquently put it—"follow your bliss." Our own evolution as a species has been a creative process: after we created the means to physically survive, we turned our creativity toward our spiritual survival. After our earliest ancestors hunted and gathered the basic necessities, they turned their creative attention toward finding a better life. It is as true today as it was then, that what you find along the way becomes part of the tapestry of your life.

To find anything—especially our own personal paradise—we must first believe it exists and that we can find it. We must support the prophecy that par-

adise can be found in order to inspire the true moral leadership, vision, and courage necessary to take us there. Like the flora and fauna inhabiting Amy's collages, we all have special gifts to bring to the greater tapestry of a paradise made up of us and all our hopes and wishes.

The snake, with its ability to shed its skin, symbolizes the power that aids us in transformations of all kinds. Also reminding us that we are subject to primordial cycles is the butterfly, used by many cultures to represent the human soul. They, as well as all of the birds and animals portrayed within the layered elements depicting these and all of Amy's sylvan glades, are our teachers. Their at-one-ness with the natural world perfectly illustrates Paradise in these pieces because it is the state of mind that can create Paradise in us all.

The images in this chapter achieve a power that is uniquely their own. Like a perfectly clear, starry night sky, they appear to be a timeless synthesis of pure, unending beauty and artistic sophistication. Special fabrics and objects reflect the spirit of the people and the times they were made in. In these works we see the culmination of Amy's work and a vision of what is possible for her and for us all, both now and in the future. These tapestries are symbolic proof that many different paradises can result from creatively blending the products of art, fashion, and technology.

There are striking similarities running thread-like through the incredibly diverse body of symbolic, visionary art of cultures throughout history. These similarities are the physical proof of Dr. Carl Jung's theory of the Collective Unconsciousness. He postulated a "place" in our racial memory where all the knowledge and emotions of our past, present, and future reside, eternally available to us and connecting us all with each other and All-There-Is. Throughout history, the themes found in the myths and legends of diverse cultures are more remarkable for their similarities than for their differences. There are stories from antiquity that are as applicable to life in the computer age as they must have been to those living in the Bronze Age.

For example, in Greek mythology, the heroine Ariadne spun a magical thread and used it to lead the hero, Theseus, out of the Cretan labyrinth and out of the clutches of the deadly Minotaur, the bull-headed, man-eating monster. The myth of Ariadne and Theseus alludes to the prehistoric discovery of spinning and weaving by the women wise enough to watch the nimble spiders. Furthermore, the weaving of cloth led mankind out of the necessity to kill animals for their skins, and civilization as we know it began. In spiritual traditions from the time of The Goddess, weaving is a metaphor for how we create the fabric of our lives from our desires and experiences.

In the mythology of our life together, Amy Zerner has used the thread of the ceaseless exploration of her artistic vision—symbolized by the literal threads of her fabric collage tapestries—to lead us both out of the confusing and potentially dangerous labyrinth of our early twenties to where we find ourselves today. We have both held on tightly to that never-ending thread, passing it back and forth between us to weave the tapestry of our lives. Upon that tapestry—and in all the collages of "Paradise Found"—is displayed the story of how we found our personal paradise of love, mutual respect, and artistic collaboration, for the advancement of our spiritual ideals.

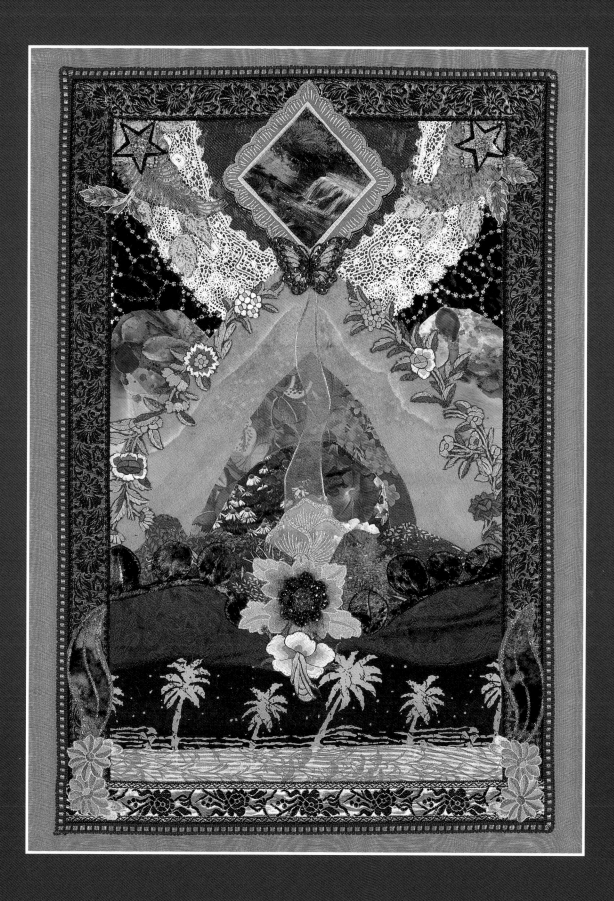

PARADISO

21½ x 31 inches, 1991

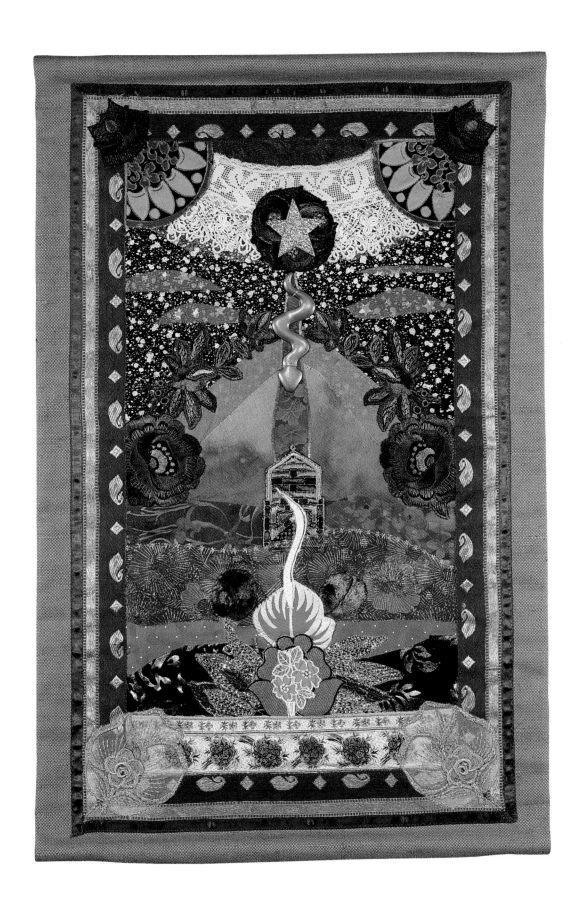

AS ABOVE, SO BELOW
14 x 26 inches, 1990

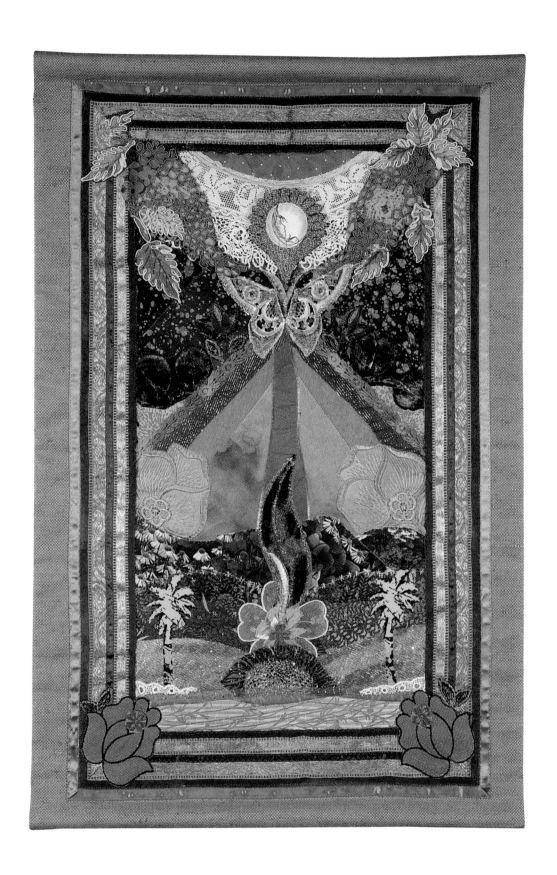

MOON GARDEN

14 x 26 inches, 1990

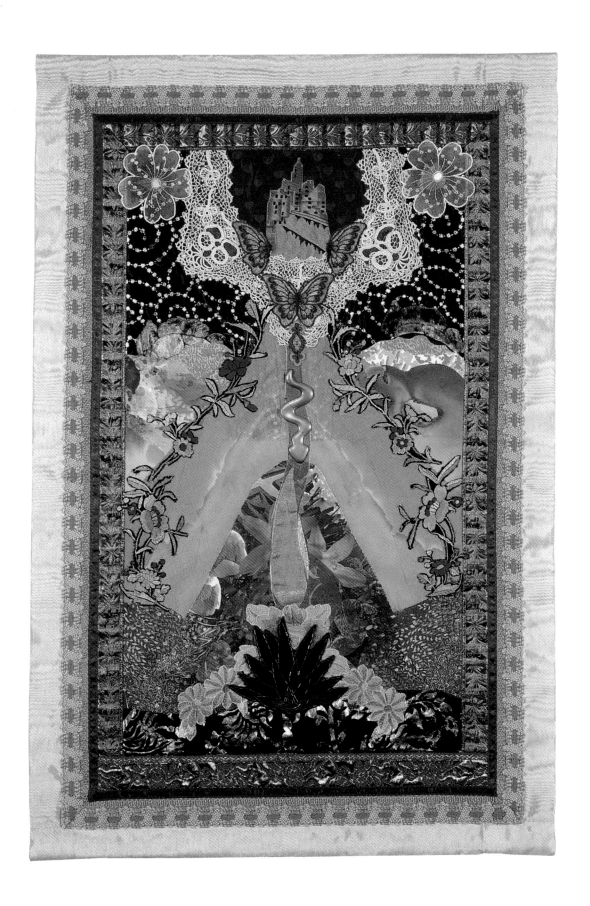

THE ALCHEMIST'S DREAM
14 x 26 INCHES, 1990

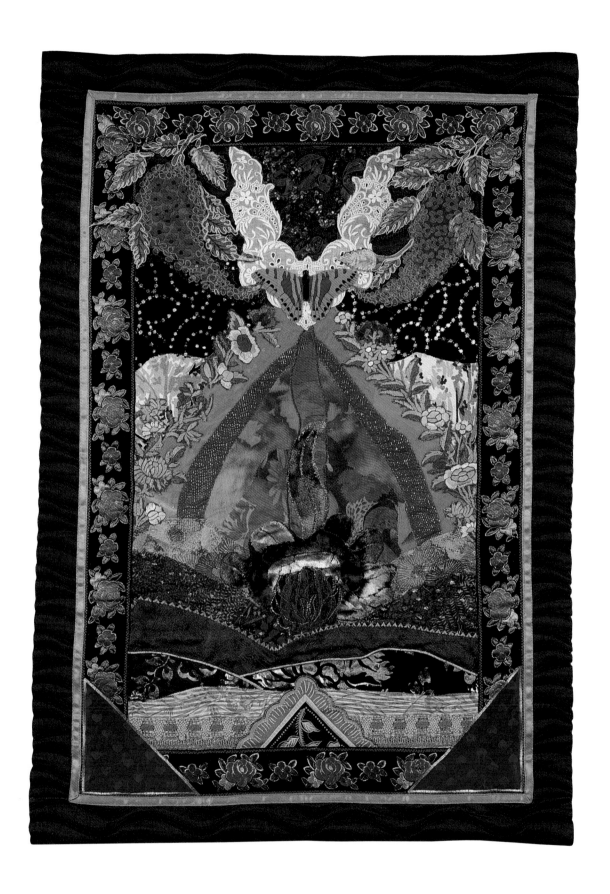

THE FINAL RESURRECTION
21¹/₂ x 31 INCHES, 1990

CENTRAL CASTING

49 x 36 inches, 1992

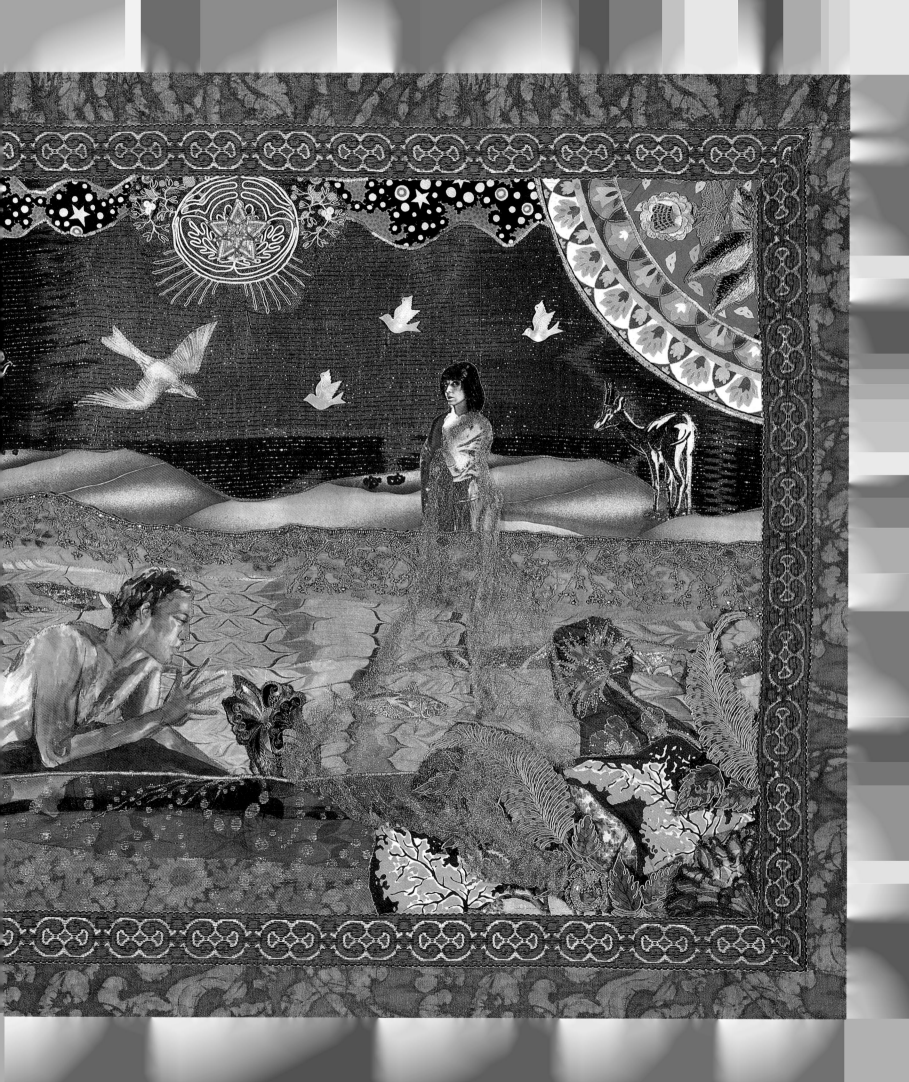

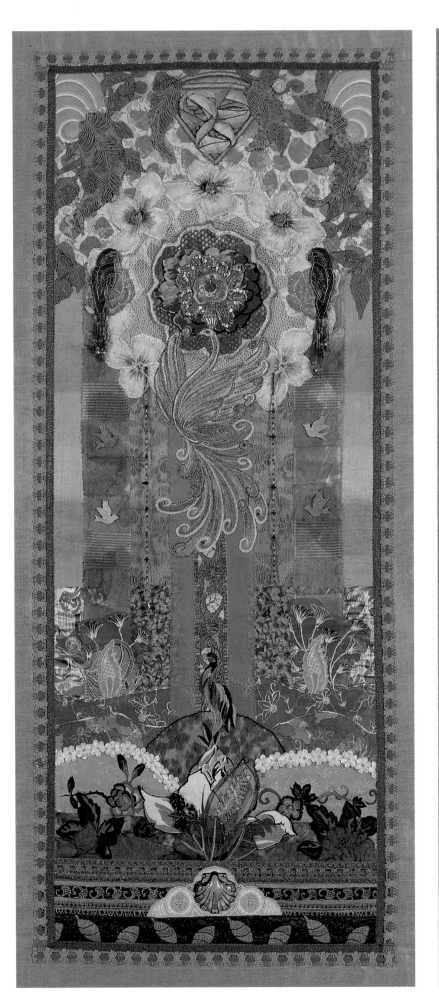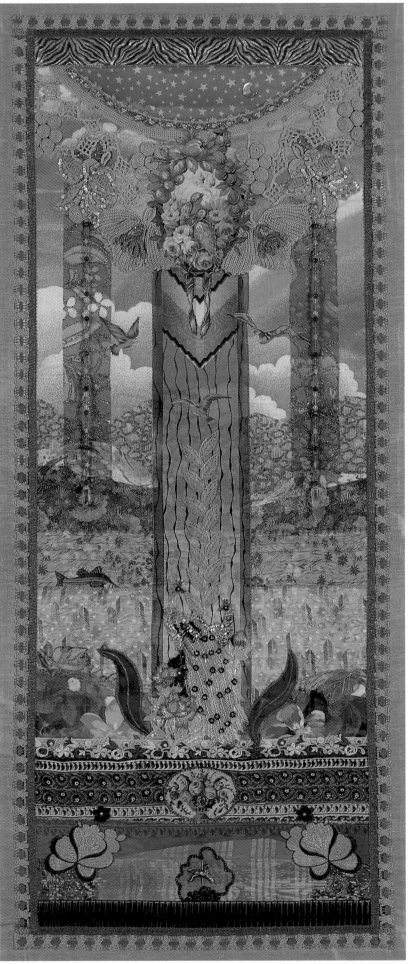

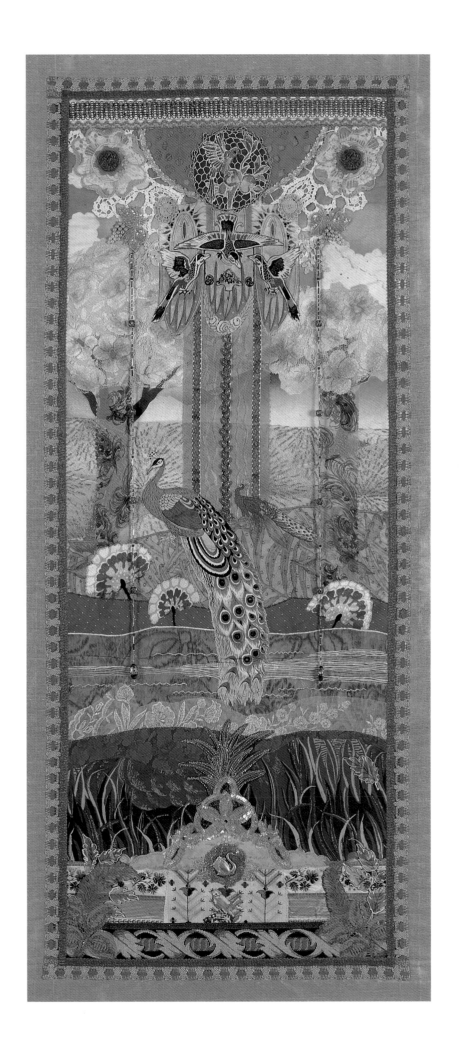

BIRDS OF PARADISE
1989

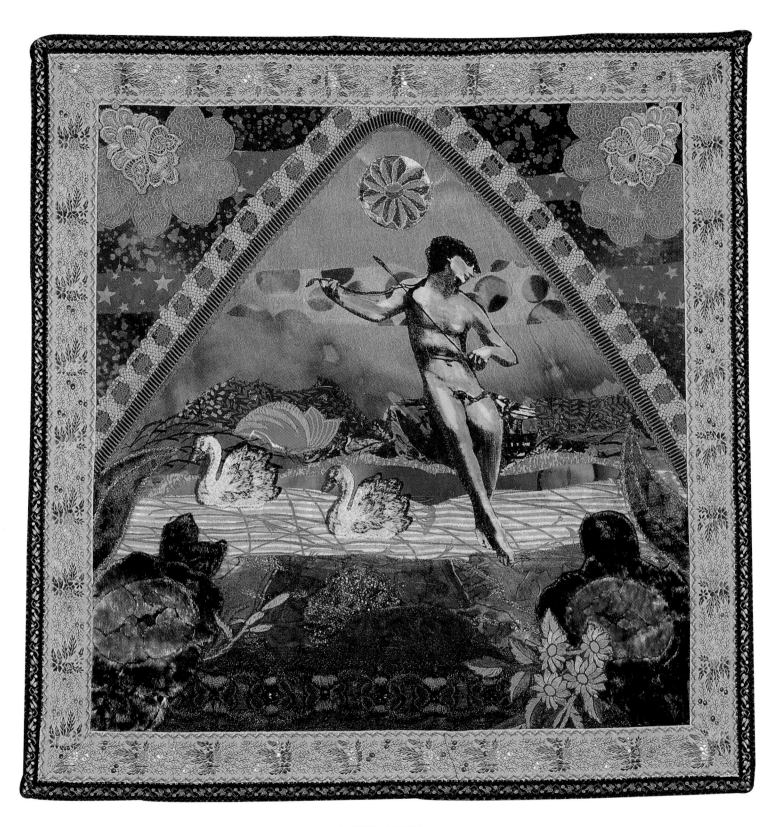

PURIFICATION

23 x 23 inches, 1990

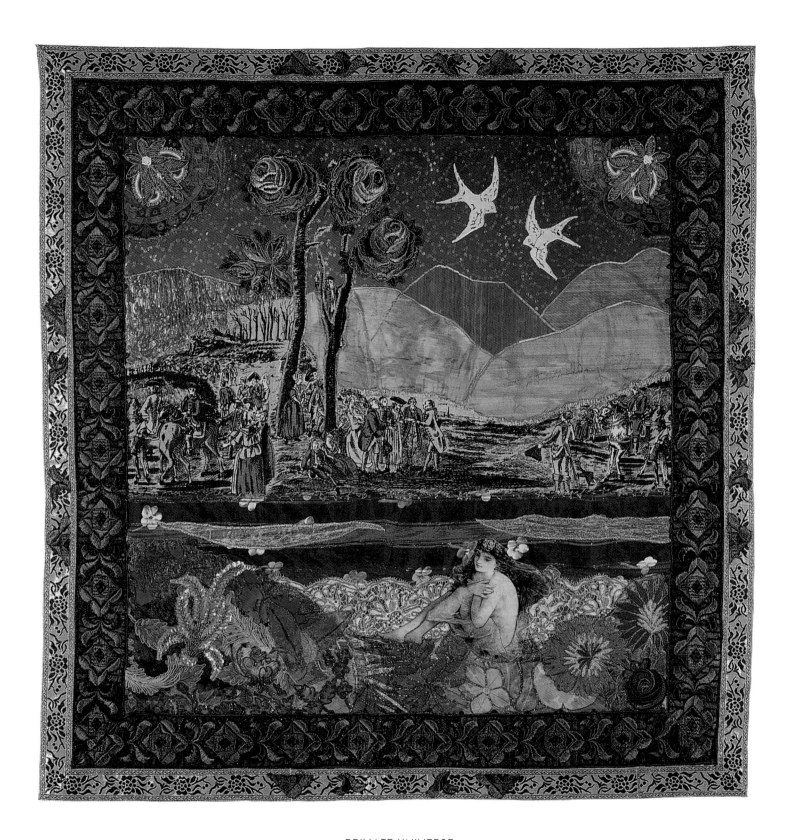

PRIVATE UNIVERSE
36 x 36 INCHES, 1994

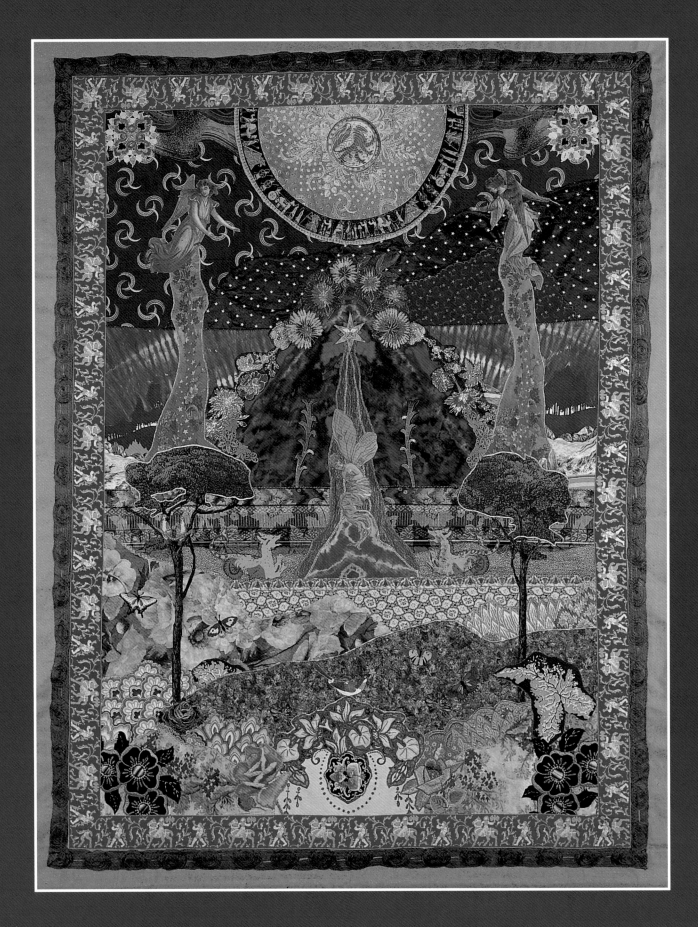

DIVINE ORDER
63 x 80 inches, 1994

LIST OF PLATES

CREDITS

Photo on page viii by Jon Reed; photos on page 13 by Elizabeth Glasgow; photos on pages 172 and 175 by Gary Bartoloni. Author photo by Renate.
Amy Zerner's works were photographed by: Gary Bartoloni, Bruce Bluedorn, Jon Reed, and Renate.

For information regarding exhibitions of Amy Zerner's work, as well as lectures and workshops, please write to:
 P.O. Box 2299
 East Hampton, NY 11937